Coast and Countryside

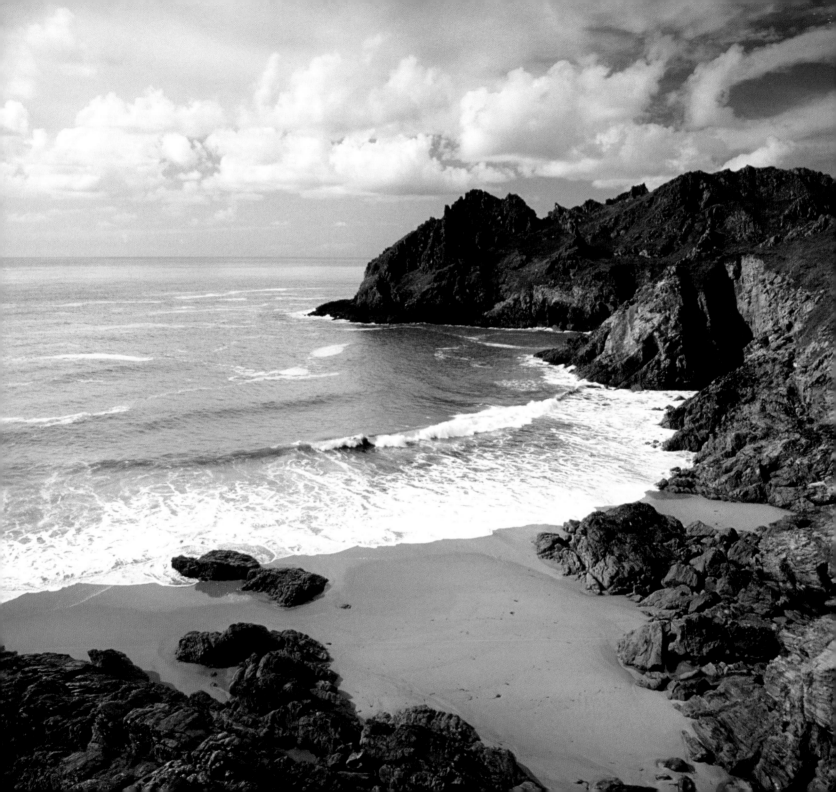

Coast and Countryside

A photographic tour of England, Wales and Northern Ireland
by Joe Cornish, David Noton and Paul Wakefield

With introductions by
Richard Mabey and Libby Purves

First published in the United Kingdom in two volumes,
Coast and *Countryside*, by the National Trust in 1998
This edition published in 2011 by National Trust Books
10 Southcombe Street
London W14 0RA
An imprint of Anova Books Ltd

ISBN: 9781907892196

A CIP catalogue record for this book is available from the
British Library.

20 19 18 17 16 15 14 13 12 11
10 9 8 7 6 5 4 3 2 1
Reproduction by Mission Productions, Hong Kong
Printed by Craft Print Ltd, Singapore

Captions compiled by Margaret Willes, with the help of Jo Burgon,
Richard Offen, Katherine Hearn and individual property staff.

This book can be ordered direct from the publisher at the website:
www.anovabooks.com, or try your local bookshop. Also available at
National Trust shops, including www.nationaltrustbooks.co.uk.

Page 2: GAMMON HEAD near Salcombe in Devon has
all the elements of the great British coast: rocky cliffs,
intimate sandy beaches, and glorious waves. [DN]

Right: The chimneys and thatched roofs of
SELWORTHY, part of the Holnicote Estate in Somerset.
Sir Thomas Acland rebuilt the village for his estate
pensioners in 1828 and planted trees in the steep valley
and on the hill to produce 'natural countryside' that is
in fact totally contrived by man. [DN]

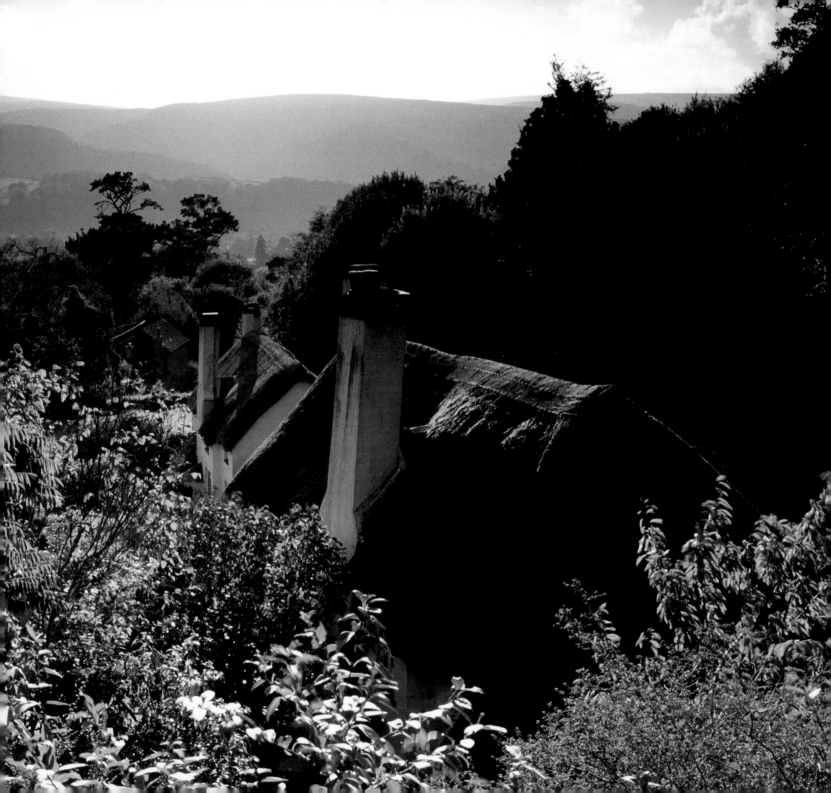

Countryside
by Richard Mabey

The popular movement for access to the countryside has marched almost step for step with the development of landscape photography. When the Ingleton Scenery Company opened up the country's first scenic reserve in the Yorkshire Dales in 1885, the Gibson family were already creating their extraordinary forensic images of the Scilly Isles, in which giant cider presses took on the look of megaliths, and Celtic field boundaries of garden hedges. In 1895, the very year the National Trust was formed, the Kearton brothers published their first historic portraits of birds in their own miniature landscapes – their habitats. The coincidence wasn't really surprising: we were hungry not just to go back to our heartlands, but to probe their innermost meanings.

These celebratory explorations have on gone hand in hand, and it is fitting that this portfolio of photographs of some of the wildest, most beautiful and historically rich places in the English, Welsh and Northern Irish countryside should be of the properties of that champion of public access, the National Trust. Joe Cornish, David Noton and Paul Wakefield have tracked across the vast and intricate range of landscapes which the Trust protects, from sowed-up cornices in Snowdonia to the lush summer marshes of Wicken Fen in Cambridgeshire – all of them as accessible to the public as to the lens.

Right: Autumnal mist over the LONG MYND in Shropshire. [JC]
Below: Ice formations on the river below LLYN IDWAL in Carneddau. [JC]

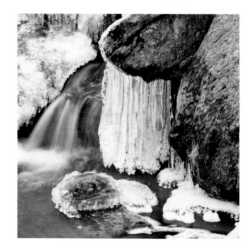

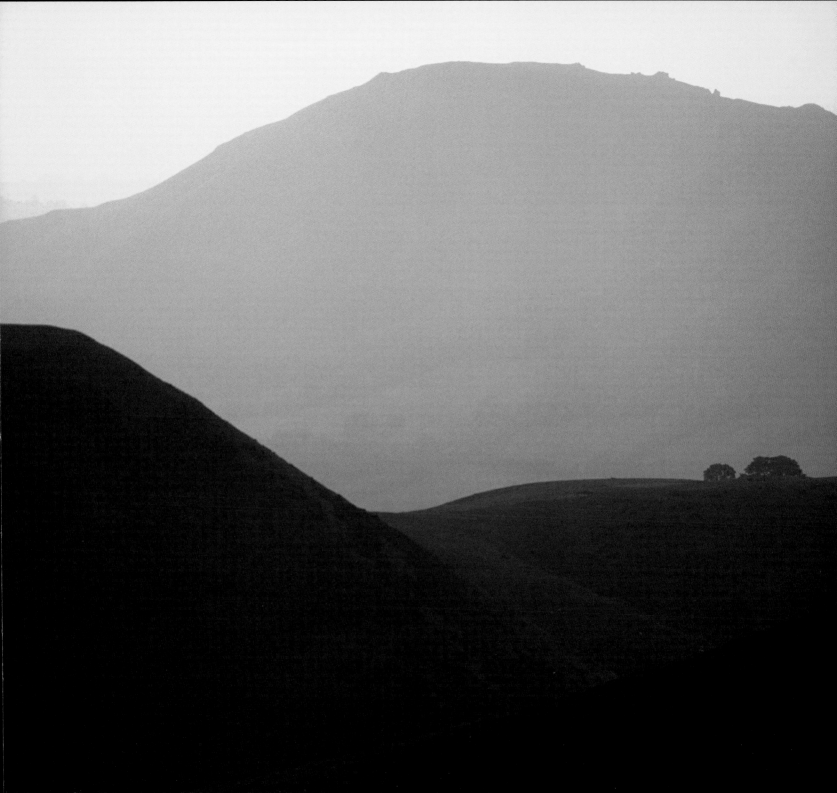

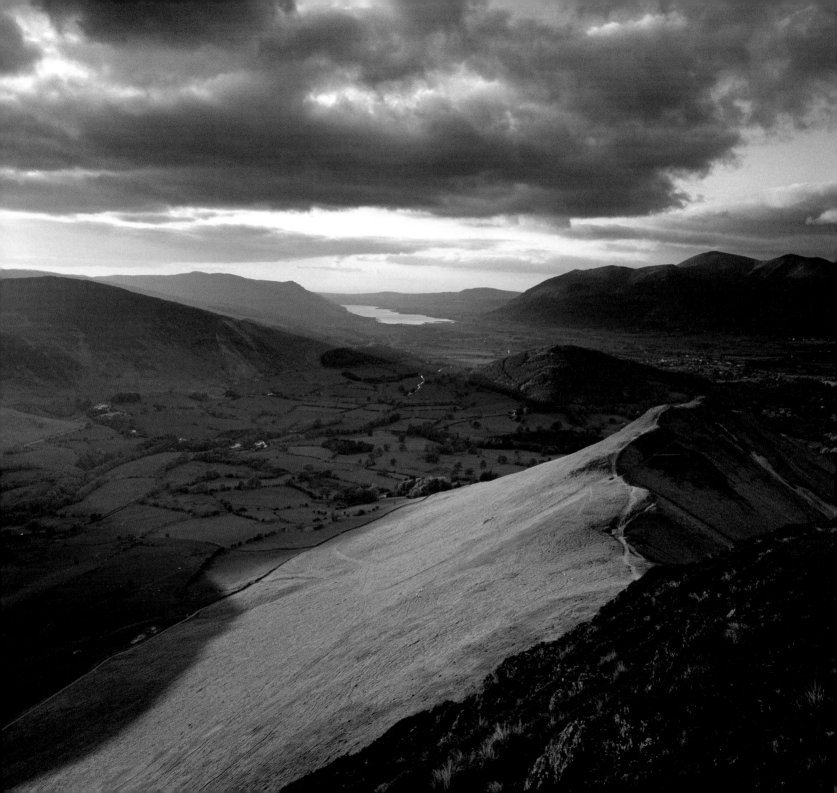

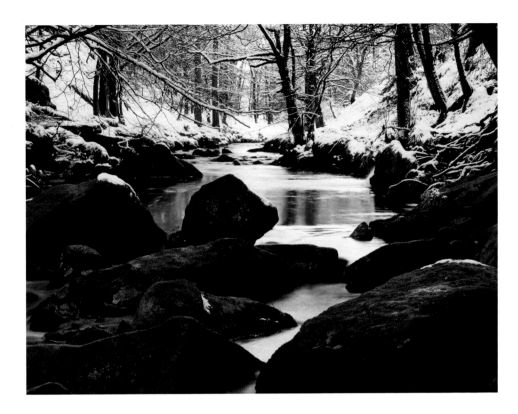

Left: The delicate beauty of winter: HEBDEN WATER in West Yorkshire. [JC]
Far left: NEWLANDS VALLEY in Cumbria, from the ridge of Catbells, with Bassenthwaite in the distance. [JC]

Yet for all the continuity in these twin traditions, there is something subtly new about this generation of countryside images – and something which has little to do with the awesome advances in photographic technology that have occurred over the past century. It has to do with the way we look at pictures and the places they represent, and at our place in them.

Photography in the Victorian period was energised with scientific and sociological curiosity, with a sense of the power achieved by knowledge and possession (even today, we still 'capture' a photographic likeness), and with a belief that through it we could come closer to the heart of what we saw as our greatest and most defining natural resource. If the camera did not lie and – as they said – the truth set you free, those penetrating glares into the distant green (the sharper the better) could be a way towards a true democracy of the countryside. As early as 1844 the pioneer William Henry Fox Talbot had dreamed of what might be achieved by the accuracy and fixedness of the photographic image:

'to reflect on the inimitable beauty of the pictures of nature's painting which the glass lens of the Camera throws upon the paper in its focus – fairy pictures, creatures of a moment, and destined rapidly to fade away... how charming it would be if it were possible to cause these natural images to imprint themselves durably, and remain fixed upon the paper'.

The Pencil of Nature

That durability was to become one of the greatest assets of photography. The brief glimpse could become a permanent archive.

But by the early years of the twentieth century, both professional landscape photographers and the increasing army of amateurs making their way into the hills and field with their box cameras were discovering that photographs did not just 'fix' scenes: in our imaginations, they could also liberate them. Each image reminded you of what had been there seconds, minutes before; of what might be there later, when the bird had flown, the sun set, the leaves fallen. They were part of an almost infinite series of possibilities – of close-ups, prospects, shifts of light; of patterns of labour and the slow workings of geology; of quick glances and long meditations. And, for that matter, of muffed shots, raindrops on the lens and wind-shaken tripods – all the animated chaos of the interaction between photographer and countryside. Photography 'catches', when we read it sensitively, the vitality and unpredictability of the living landscape. And for today's increasingly photo-literate snappers, even the most sharply focused scenes are redolent of Wordsworth's vision of a landscape teeming and unbiddable and, in the best way, fuzzy at the edges. And it is all ours. Landscape photography is, in a sense, a new right of common. As Wordsworth said, 'a wilderness is rich with liberty'.

So it is apt that this collection begins in Wordsworth's Cumbria, where the National Trust acquired some of its first countryside properties. These are archetypal pictures of an ancient human presence in a turbulent landscape. Mist rises over Blea Tarn. The ice at the edge of Derwentwater forms cobweb patterns like contour lines. And in David Noton's wide and airy panorama of Loughrigg Tarn you are in the water-lilies, up to your knees, with the faintest breeze blurring the tops of the sedges.

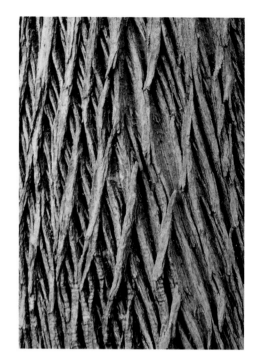

Above: Detail of bark on a horse chestnut tree on the ASHRIDGE ESTATE in Hertfordshire. [PW]

There are so many ways in which the capriciousness, the presence of nature interacts with the old rhythms and sense of historical continuity that give us our sense of place. The limbs of the ancient yew trees near Crom Old Castle in Northern Ireland are a thousand years old, but look as frisky and voluptuous as teenagers basking on a beach. A lake of bluebells floods a patch of downland on the Isle of Wight, the 'ghost' of what was probably once a wood. And everywhere the great set pieces of prospect and view remind you of the deep seated and common patterns of evolution in the natural world. Wind-blown snow on the summit of Pen Yr Ole Wen has the look of surf breaking on the shoreline. The 'river' at Croome Park in Herefordshire shot from low down, looks poised to one day reclaim Capability Brown's trim landscape. A view of a harvest field at Cherhill Down, Wiltshire, contains almost the entire sweep of European agricultural history, from late twentieth-century bales back to the outlines of an archetypal horse carved in the chalk. And Joe Cornish's long-focus view of the shingle ridges of Orford Ness in Suffolk reminds you of an immense cross-section of the annular rings of a tree.

These pictures take in the compressed variety of our countryside and the ways it has been shaped both by nature and humans – the Trust included. If there are few actual humans shown in the collection it is because they are always there implicitly in the landscape: in the ancient troglodyte dwellings in the red sandstone cliffs at Kinver Edge, Staffordshire; in the dry-stone walls on Cowside in Yorkshire, whose swirls and strata echo natural limestone formations; in the chequerboard of farmland round Bossington in Exmoor that will be given back voluntarily to the rising sea.

And there is one other persistent human presence – you, the viewer. The reader of a landscape image brings to it not just a reaction to its intense vision of the present, but to the echoes of history engrained in it, and to the unpredictable and exciting future that unravels from that moment when they were 'taken'.

Coast
by Libby Purves

In 1988, our family set out for what we called a summer's grace: a 1,700-mile voyage in a small sailing yacht, right around the coast of mainland Britain. It was a romantic enterprise and, despite the cold and the wet (it was not a good summer to choose), it became more enthralling and more romantic with every slow mile we sailed, and every small harbour in which we took refuge. By the end of three and a half months, we felt that in an obscure way we owned the place, from the jagged, eternal western rocks and headlands to the low, shifting, mournful mudbanks of the east. We knew the different shapes of the waves, the changing look of the cliffs, the enduring protectiveness of all the little harbours left behind by the age of big shipping. And we were very proud of our coast.

All the way round – and ever since – it has been a source of great comfort in changing times that we do own quite a lot of it; in a sense, at least. The National Trust's Enterprise Neptune campaign was founded in 1965 as an appeal to save our remaining fine coastline from pollution, destruction and crass development. The Trust has owned coastal property since its foundation in 1895 – its very first acquisition was Dinas Oleu, overlooking Cardigan Bay – but Enterprise Neptune for the first time brought forward the idea that in a crowded,

Right: The gorse-covered cliff at DINAS OLEU in North Wales, the first property to be given to the National Trust in 1895, a few weeks after the organisation had been founded. Mrs Talbot presented four and a half acres to halt the inexorable spread of the seaside resort of Barmouth, which can be seen to the right of the picture. [JC]
Next page: Seething waves breaking over the basalt rocks of the GIANT'S CAUSEWAY on the North Antrim coast of Northern Ireland. [PW]

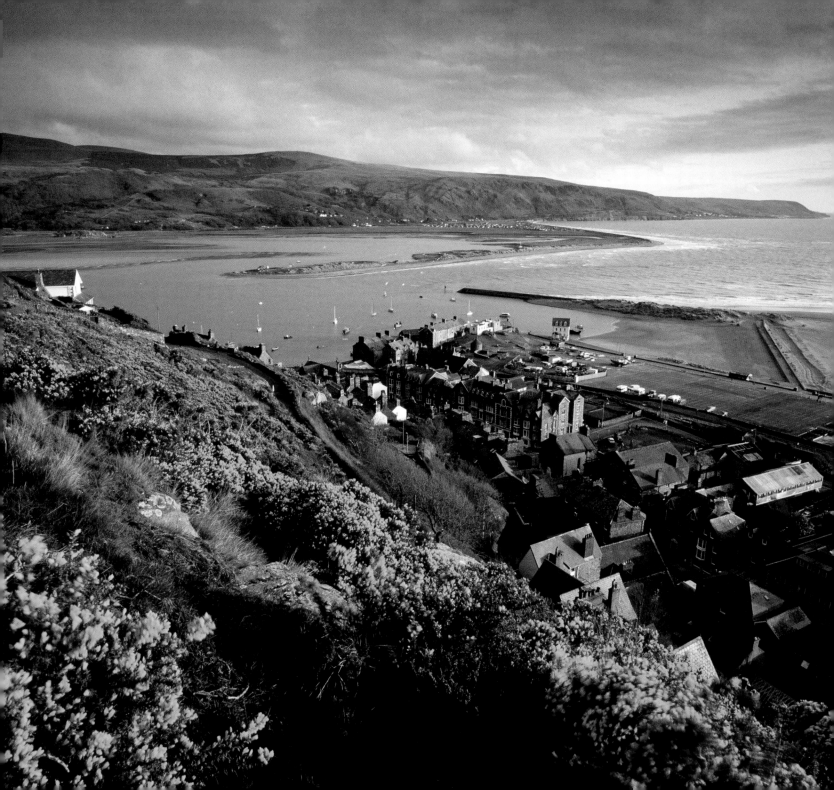

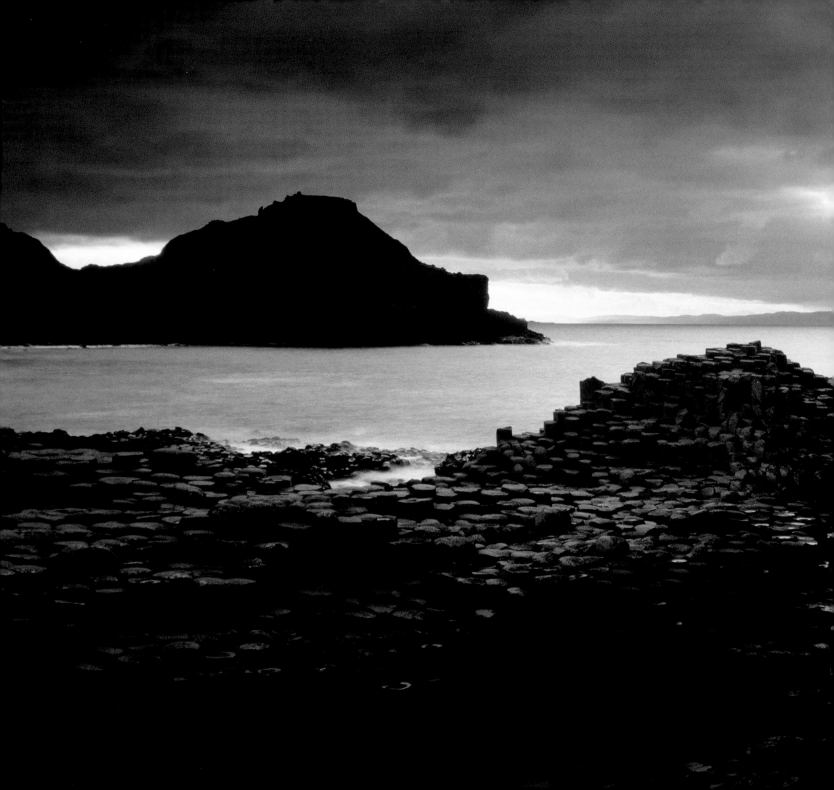

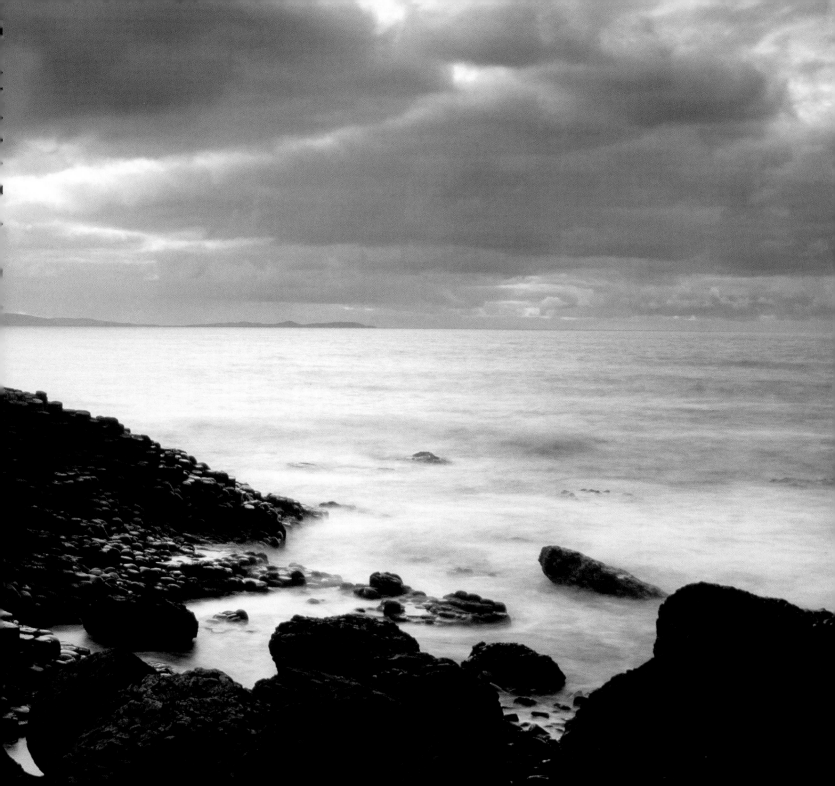

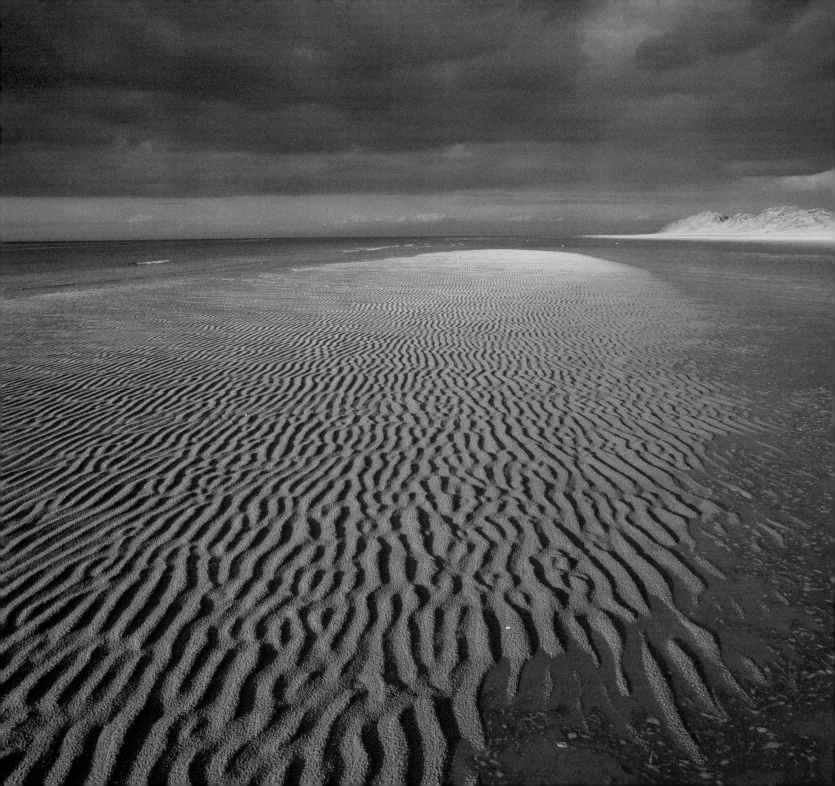

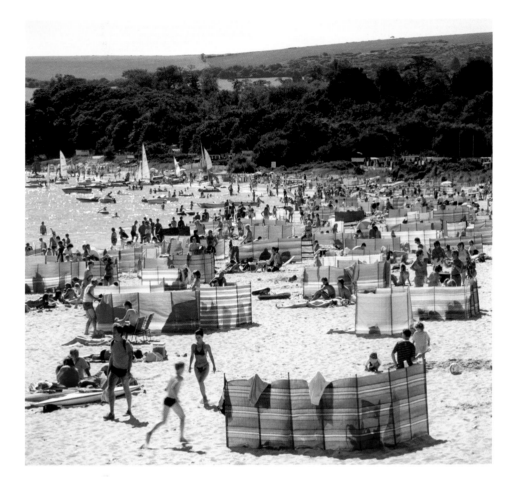

Left: Most of the photographs in this book show the landscape without people, but the Trust welcomes visitors, as shown in this picture of high summer at STUDLAND BAY, Dorset. [JC]
Far Left: The rippling sands of the beach at FORMBY POINT in Merseyside. [JC]

fast-developing world, the coastline would always have particular needs and stand in particular danger.

Neptune's first treasure was Whitford Burrows, on the Gower Peninsula in West Glamorgan. Since then, energetically raising funds additional to the Trust's efforts, it has acquired 700 miles of coastline, and has its eye on many miles more. So cliffs and beaches, headlands and mudflats, simple farms and noble stone breakwaters have come to be recognised, as they should be, for part of an irreplaceable, treasurable national inheritance. The Trust – long a landowner, farmer and housekeeper – has become a longshoreman and harbourmaster as well.

One of the strengths of the project has been the Trust's realisation that it is not only pretty cliffs, sandy holiday beaches and the habitats of birds which are worth looking after. It has these, of course: mile upon mile of them facing every one of our seas: the Gower Peninsula is unmatchable; the approach to Land's End one of the great paths of Europe; and along the wild North Antrim coast there are sights to compare with any wilderness in the world.

But the works of man matter too, and they matter particularly by the sea, where the great breakwaters and stone harbours left to us from earlier centuries bear witness to one of the most important aspects of our history: the islander's confident, painstaking determination to reach out into the sea, to send out sailors and bring them safely home. Lighthouses, piers or whole fishing villages like Cushendun and Strangford in Northern Ireland need as much protection as rare seaweeds or voyaging birds. Otherwise the century of quick-drying cement and fast-buck business would rapidly hide from us forever all that they represent: the values, and the craft, and the lives of our forefathers.

Most surprisingly of all, to some, was the Trust's decision to buy Orford Ness from the Ministry of Defence in 1993. This is a bleak spot, on the seaward bank of the extraordinary River Ore, which the Trust conserves not only for its rare shingle plants and bird life but for the all-too-obvious leftovers of secret wartime research. Against the bleak winter skylines of the Suffolk coast you can see the 'pagoda' buildings for testing missile warheads and the humble huts where radar was born.

And it is right that they should be kept, to make the Ness a place of sombre reflection as well as aesthetic beauty. For that is part of our history too: alongside the natural history we cherish and the seafaring and shore-dwelling crafts we now find picturesque, we have a right to contemplate the ugliness and ingenuity of more recent warfare. We can watch as its mark on a wild, remote place fades, and the wilderness of sea and shingle takes over once again. It is as much a part of our identity as the greatest sea-cliff or the prettiest estuary.

Right: ORFORD NESS in Suffolk, bought from the Ministry of Defence by the National Trust through Enterprise Neptune in 1993. [JC]

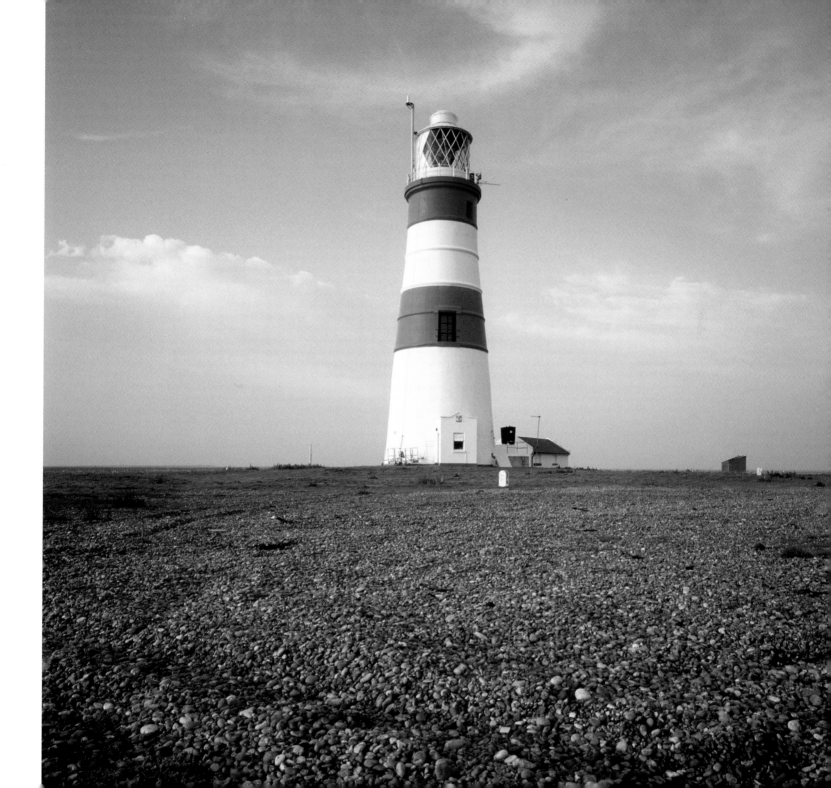

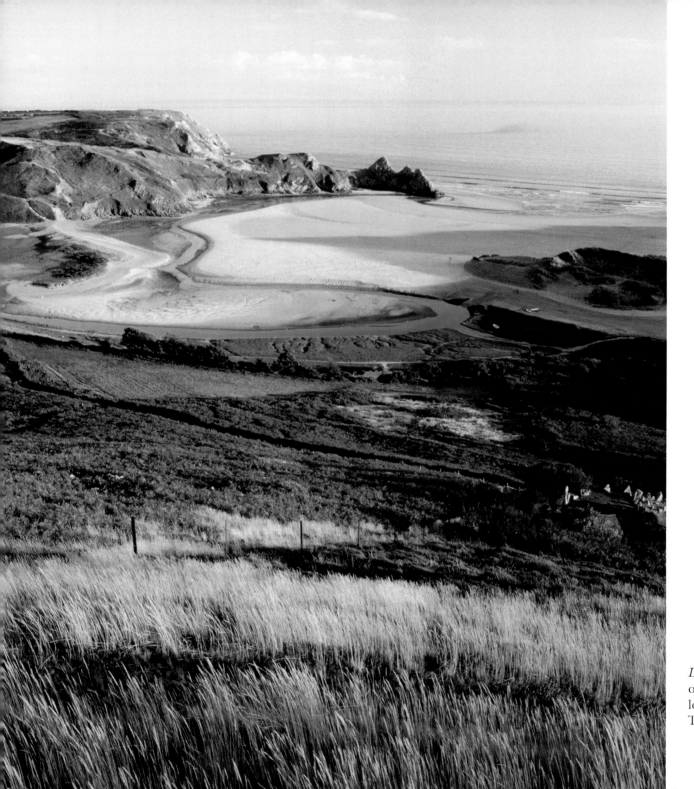

Left: PENNARD CLIFF on the Gower, looking towards Three Cliffs Bay. [JC]

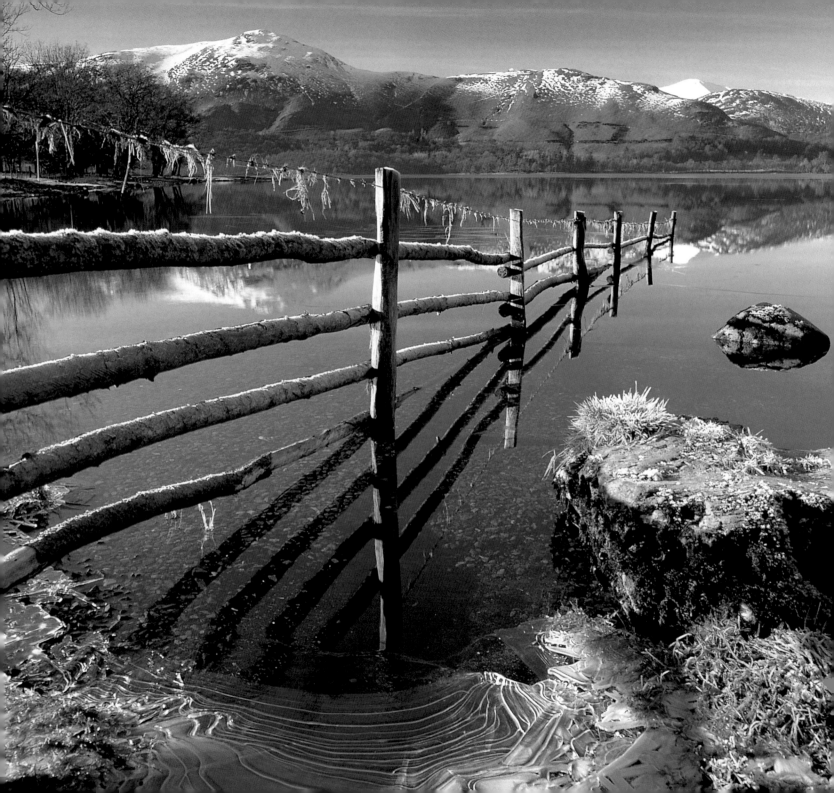

Previous page: DERWENTWATER, looking towards Catbells. This is quintessential Lake District landscape, cherished by millions of visitors who come to admire and enjoy it in every season. [JC]

Popularity has its price: not only is the Cumbrian landscape cherished, it is threatened too. In the early nineteenth century William Wordsworth was concerned about summer homes of Manchester businessmen appearing on the shores of Windermere. In his *Guide to the Lakes*, published in 1810, he suggested the area be designated 'a sort of national property in which every man has a right and interest who has an eye to perceive and a heart to enjoy'.

This theme was taken up eighty years later by the founders of the National Trust, Octavia Hill, Robert Hunter, and Hardwicke Rawnsley, Vicar of Crosthwaite and guiding spirit behind the Lake District Defence Society. One of Rawnsley's early, successful campaigns was against the building by slate quarry owners of a railway to the heart of Borrowdale. *Right:* An abandoned slate quarry on HONISTER PASS, with Buttermere in the distance. [JC]

Far right: DERWENT ISLE on Derwentwater. Responding to Wordsworth's concern about ugly development, the National Trust bought Brandelhow Park on Derwentwater in 1902 by public subscription. Octavia Hill wrote, 'you can see the whole space of the lake set with its island, it has crags and meadows and wood, on it the sun shines, over it the wind blows, it will be preserved in its present loveliness and it belongs to you all and to every landless man, woman and child in England'. [JC]

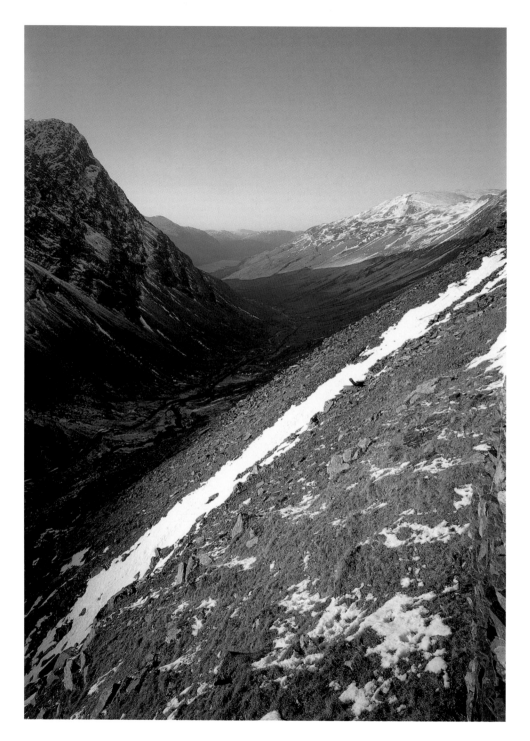

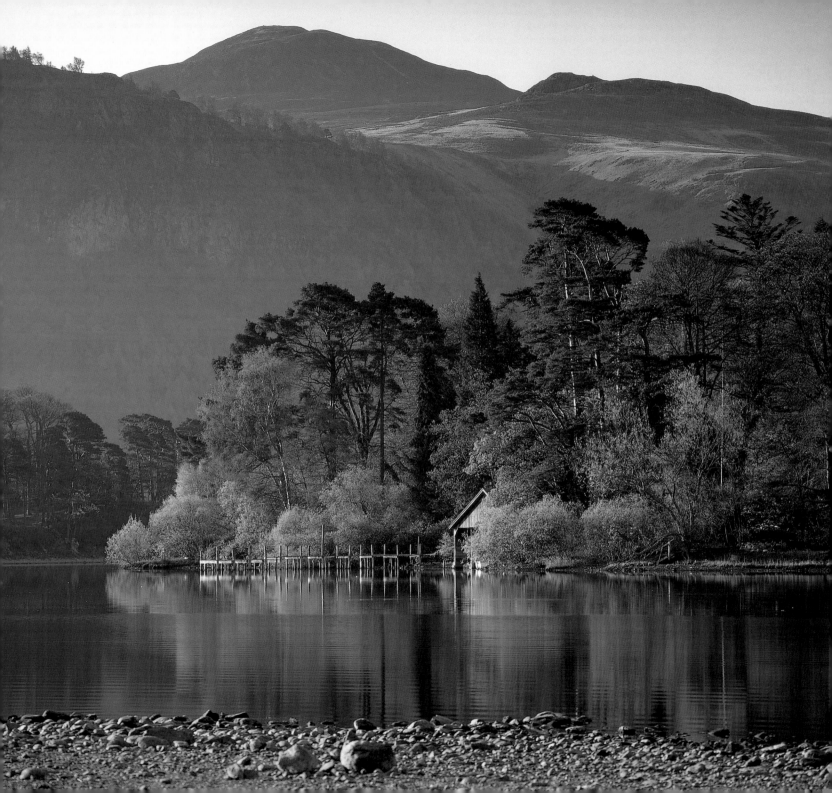

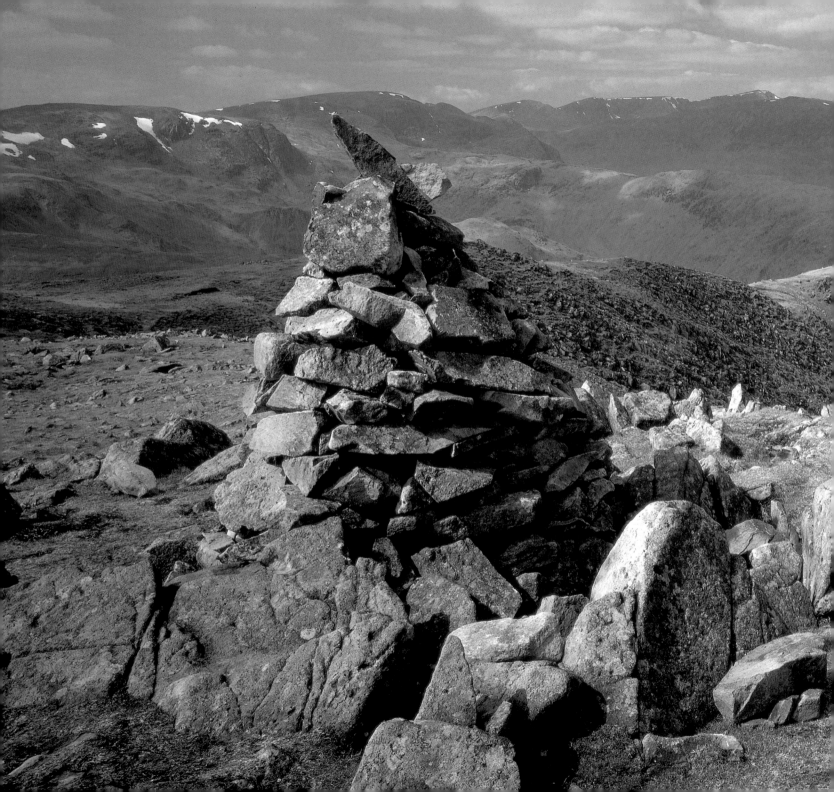

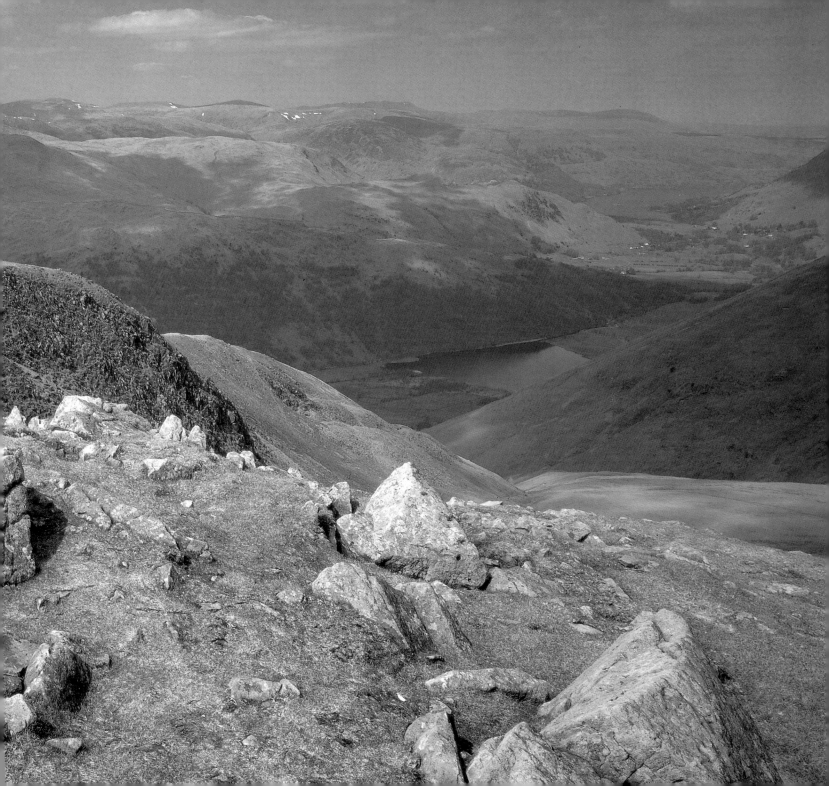

During its long geological history, the Lake District has been mountain range, clear sea, swamp and desert, but it took on its present form during the last Ice Age, when glaciers gouged out its valleys and created the lakes.

There are sixteen major lakes, ranging from huge Windermere, ten and a half miles in length, to Brotherswater, less than half a mile long. The National Trust protects over one-third of the Lake District National Park, some 140,000 acres, almost 60,000 ha.

Previous pages: A magnificent panorama of the lakes from Caudale Moor, with BROTHERSWATER in the middle distance, and ULLSWATER beyond. [JC]

Right: Fells in shadow, BUTTERMERE VALLEY. Enjoyment of the high places has always been part of the Lake District's attraction, and the National Park now receives over twelve million visits annually. One of the main tasks shouldered by the National Trust is coping with footpath erosion and repair, with teams of full-time workers supported by volunteers. [JC]

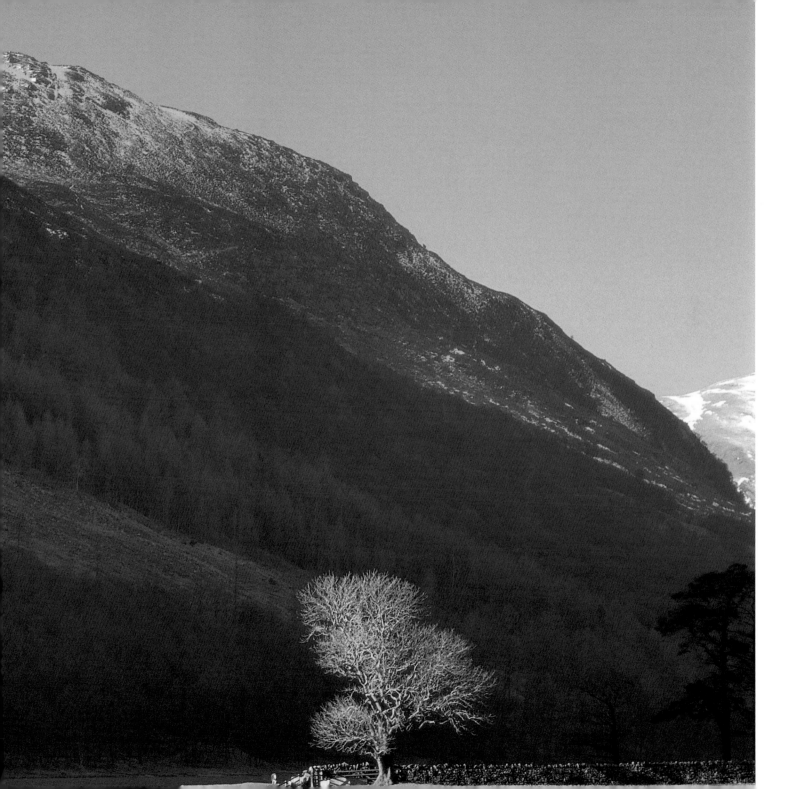

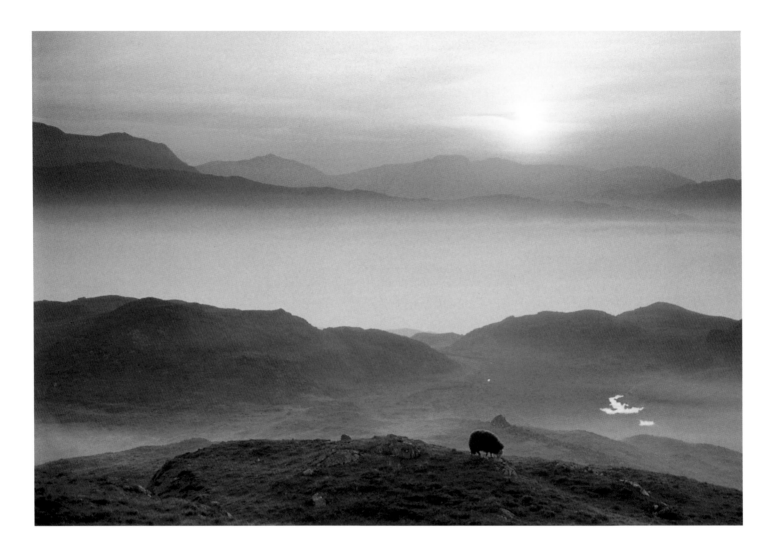

For early tourists, especially eighteenth-century travellers, the Lakes represented Nature in the raw, with awful landscapes enhanced in their awfulness by Claude glasses, piano-convex mirrors which miniaturised the view and tinted it to resemble an engraving. But man has long left his mark upon this apparently natural landscape, especially in farming patterns.

Farms were sited in valley bottoms, with fields climbing to the limit of the good ground and known as *inbye* land. Above were the open fells, where the hardy Herdwick sheep could graze at will, being *heafed*, naturally remaining in a defined area. In 1943, the children's writer Beatrix Potter stipulated in her will that the farms she left to the National Trust should be let at a moderate rent and that the landlord's flocks of sheep on the fell farms should be pure Herdwick in breed. *Above:* A Herdwick grazing in the early morning mist by Blea Tarn, Eskdale. [DN]

Right: The lakes are rich in resources. Their clear, clean water, allows unusual fish like the charr to live in their depths. The smallest member of the salmon family, the charr is now very difficult to find because it is not fished commercially, but it tastes delicious. In the late seventeenth century, Daniel Fleming of Ryedale wrote that Coniston Water produced 'many pikes or Jacks, Bass or Perch, Trouts, Eels and Charrs; which last is much esteemed and valued'. This photograph shows Derwentwater at dawn. [DN]

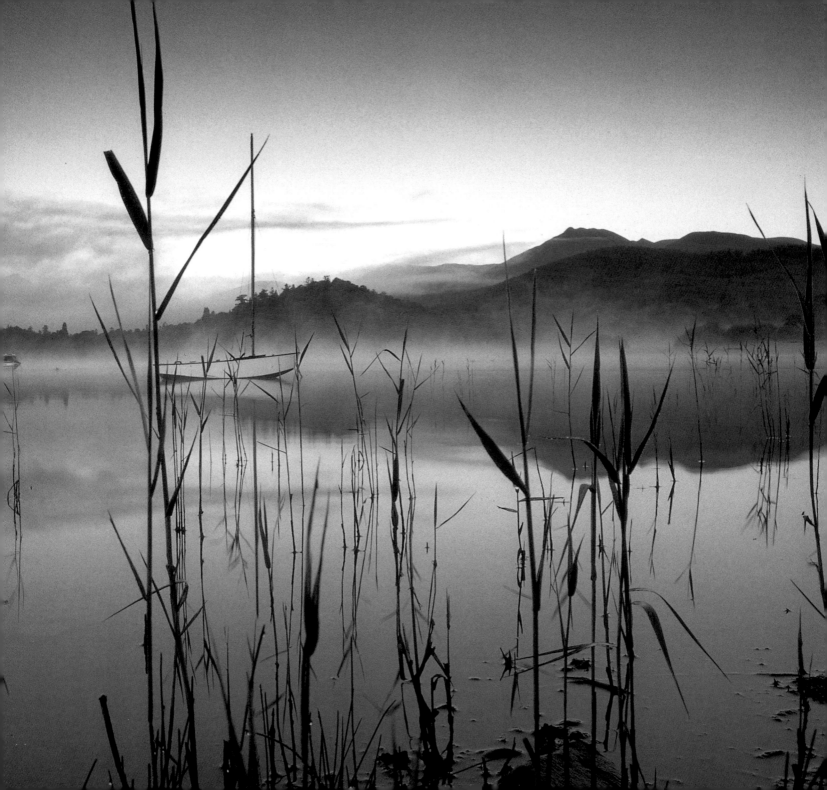

ULLSWATER, one of the 'eastern protectorates of the Trust's Lake District Empire' according to the *National Trust Guide*. In 1911 the threat of building development spurred the Trust to buy Gowbarrow Park, a medieval deer park with the picturesque waterfall of Aira Force, on the west side of the lake. Additional acquisitions now mean that the National Trust owns the south quarter of Ullswater, forever linked with Wordsworth's famous lines, 'I wandered lonely as a cloud'. [DN]

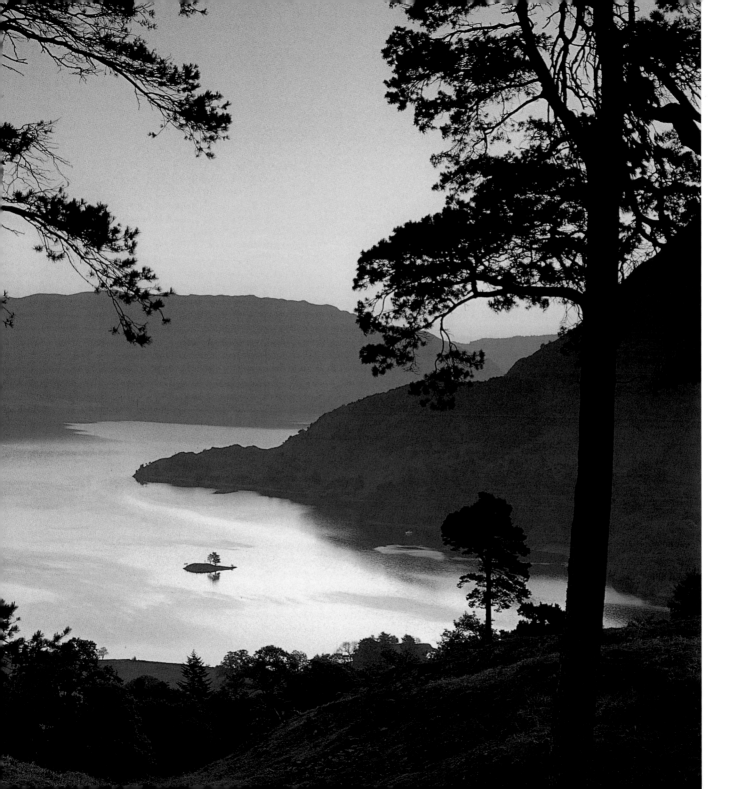

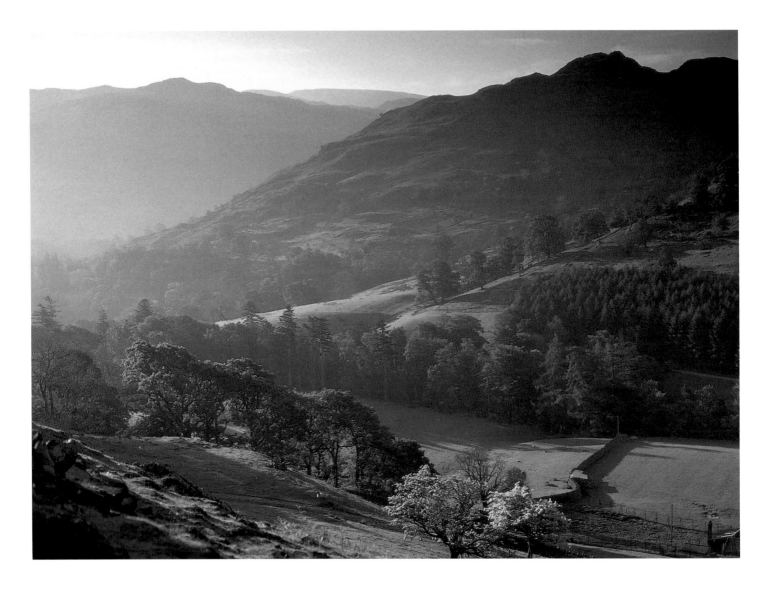

Man has not only left his agricultural mark on the Lake District landscape, he has also 'improved' nature. Perhaps the most well-known example is Tarn Hows, an artificial lake created and planted in the Swiss style in Victorian times. GRISEDALE near Patterdale (*above*) is also a designed landscape. Although it escaped the fate of becoming a reservoir for Manchester, its natural deciduous woodland planting was 'improved' with the addition of blocks of conifer. This environmentally damaging practice is, luckily, on the decline. [DN]

Right: AIRA FORCE, cascading down to Ullswater. The natural features of the waterfall were enhanced in the early nineteenth century. [DN]

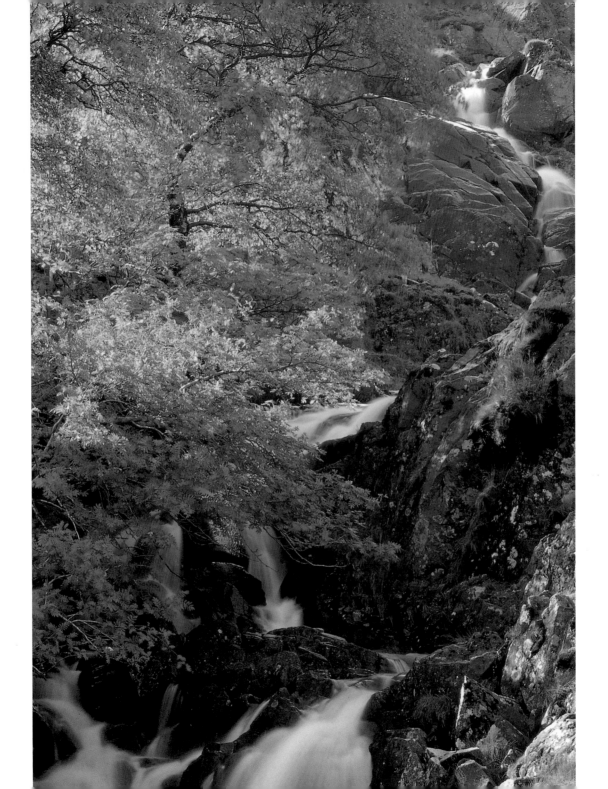

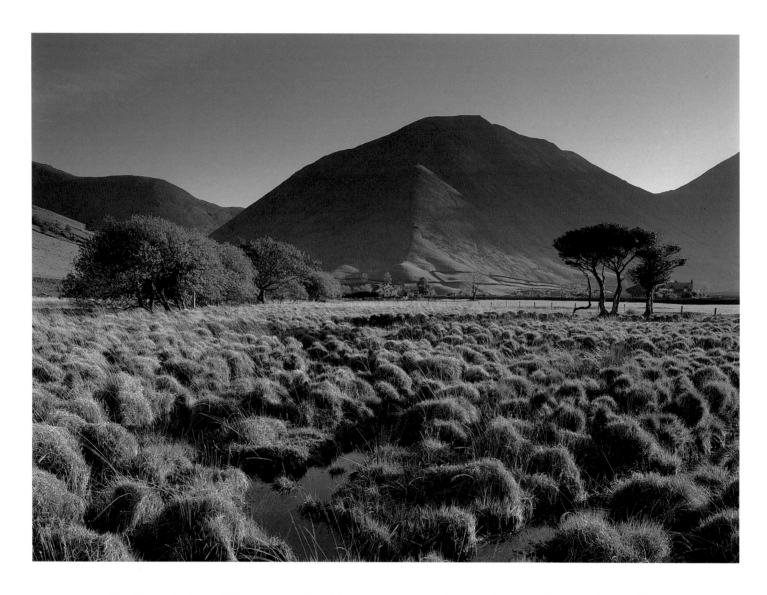

The delta at the head of WASDALE is a flat plain across which several streams flow on their way to the lake. The vegetation is tussocky purple moor grass mire, a valuable area for marsh plants. Where the land has been put to agriculture the fields are divided by dry-stone walling. Originally cattle were grazed here, now it is almost entirely sheep farming. [JC]

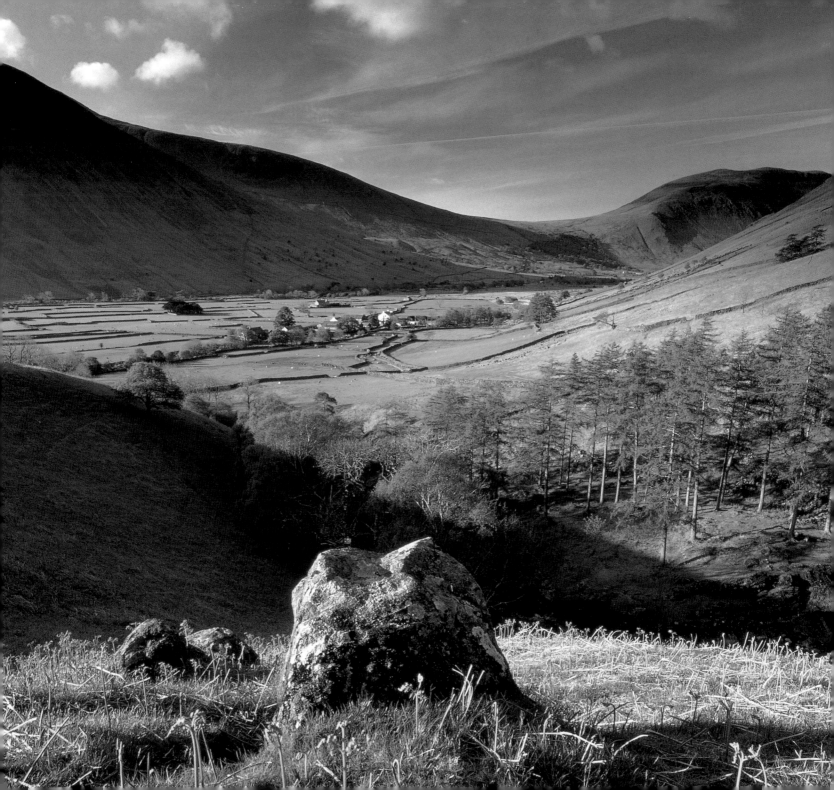

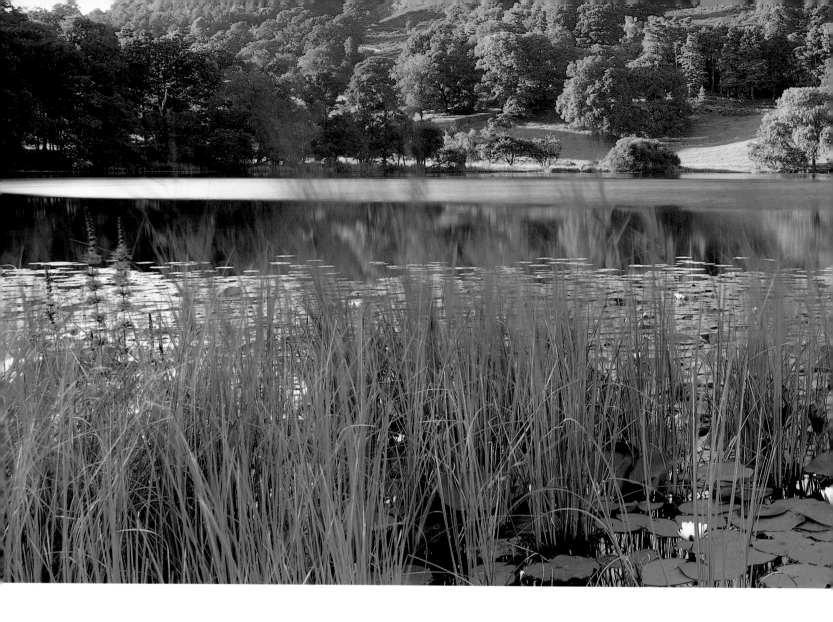

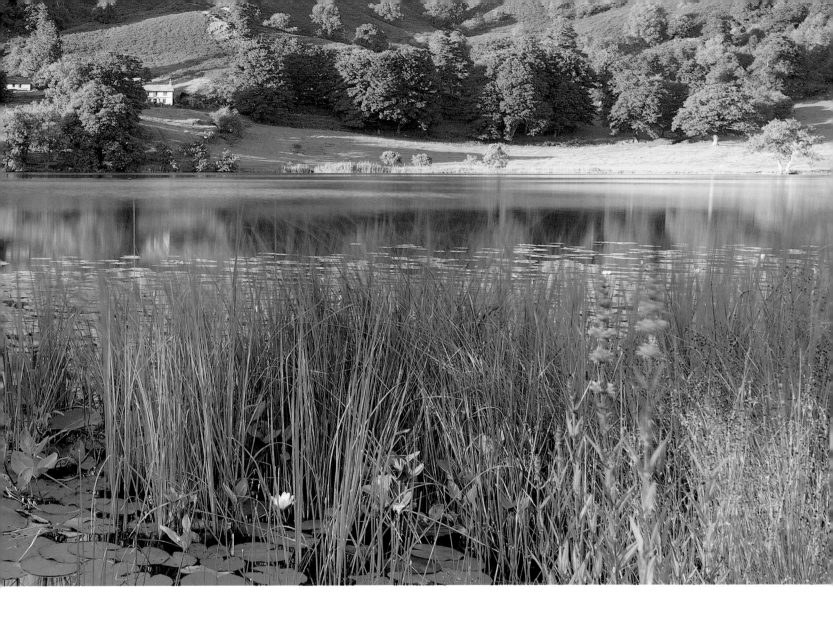

LOUGHRIGG TARN, at the foot of Great Langdale, near Ambleside. One of the more nutrient rich of the hundreds of pools, lakes and tarns scattered liberally across the Lake District fells, Loughrigg can support white water-lilies and a rich aquatic vegetation. Sedges and spikes of purple loosestrife form a fringe of plants around the edge of the water, important for dragonflies. [DN]

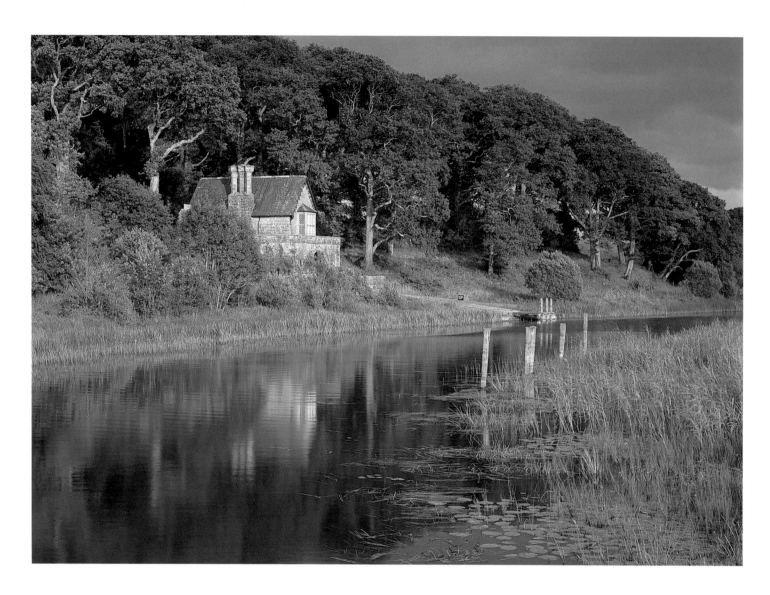

While Strangford is a sea lough, on the east coast of Northern Ireland, LOUGH ERNE is an inland lough, part of the CROM ESTATE, lying at the very western edge, in County Fermanagh. The lough is linked up to the Shannon, and is a popular site for visitors with boats. *Far right:* The National Trust has provided places to park, and facilities for the hire of boats at Crom and Enniskillen, but also has to try to preserve the tranquillity of the place. [JC]

The Crom Estate, spread over 1,900 acres (770 ha), is a patchwork of land and water with little wooded islands, mostly of oak. Lord Erne continues to live in the New Castle, built in 1832–8 by Edward Blore, while the National Trust looks after the Old Castle, a seventeenth-century tower house, and various other eye-catchers in the park. *Above:* Crom Castle boathouse. [JC]

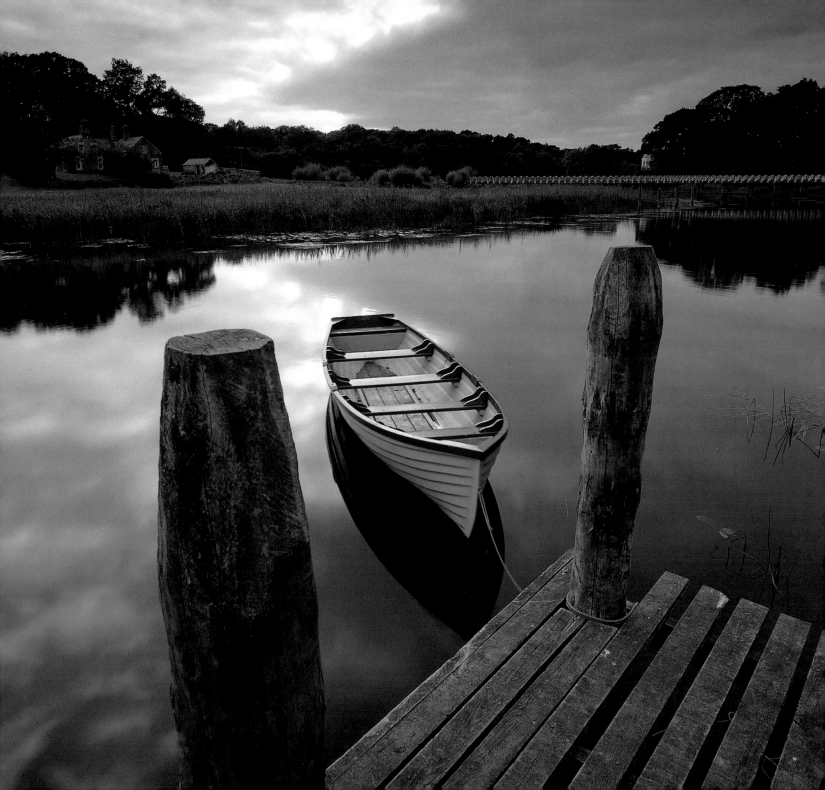

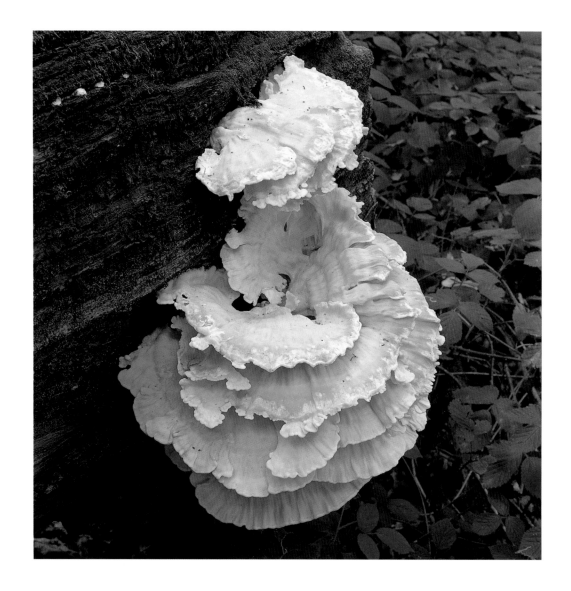

Detail of sulphur polypore fungus on a fallen tree in the woodland on Inisherk Island, Crom. Fallen trees are deliberately left to decay, so that fungi and insects can thrive on their dead wood. [JC]

An ancient yew near Crom Old Castle – possibly over a thousand years old. [JC]

CARNEDDAU is a spectacular mountain range in Snowdonia National Park in North Wales. It came to the National Trust in 1951 as part of the endowment for the Penrhyn Estate, so mountains created in the Ice Age were donated to support the upkeep of a Victorian castle.

Far right: The ridge of GLYDER FAWR, with snow-capped hills in the distance. [JC]

Right: Constant frost action over the centuries has produced a plateau on the summit of PEN YR OLE WEN, over which the winter winds blow the snow in dramatic formations. [JC]

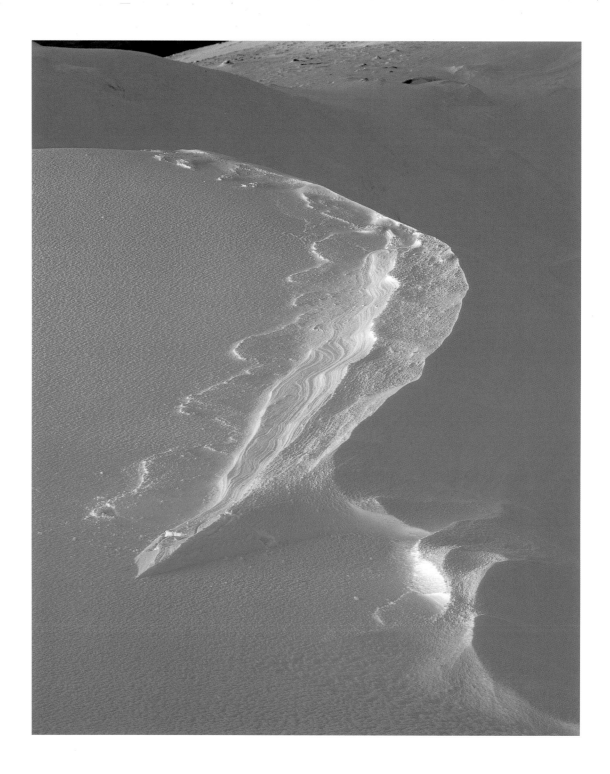

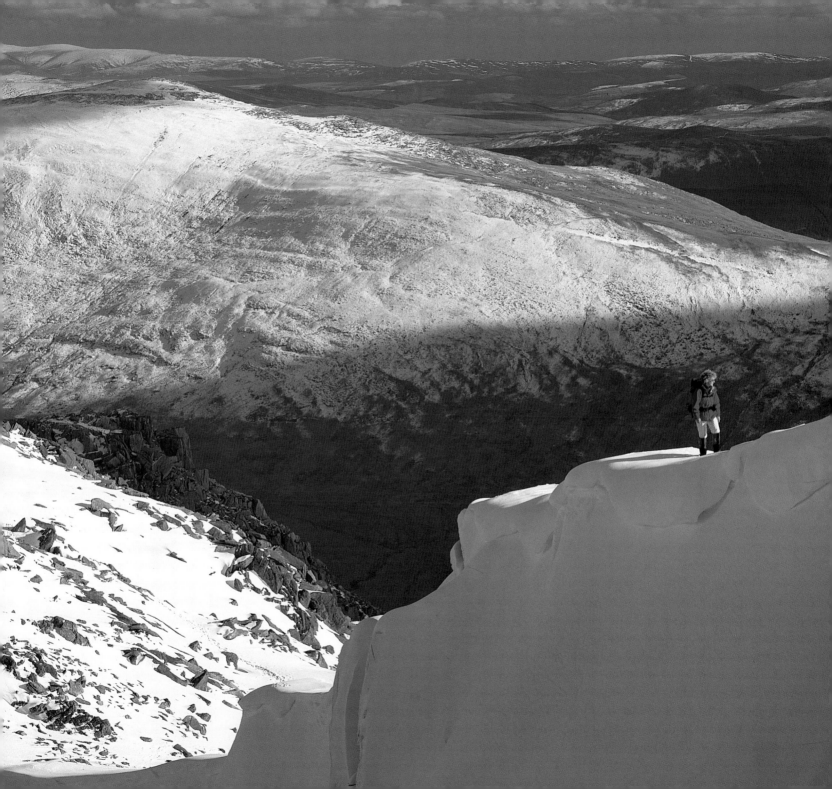

Frost action at work in the Carneddau. Despite this hostile environment, lichens and moss survive on the rocks.

Right: Snow-covered ice formations on the river below Llyn Idwal, with Y GARN looking out of the mist. [JC]

Far right: The sun setting over sheet ice, looking towards Y Garn, with PEN YR OLE WEN to the right. [JC]

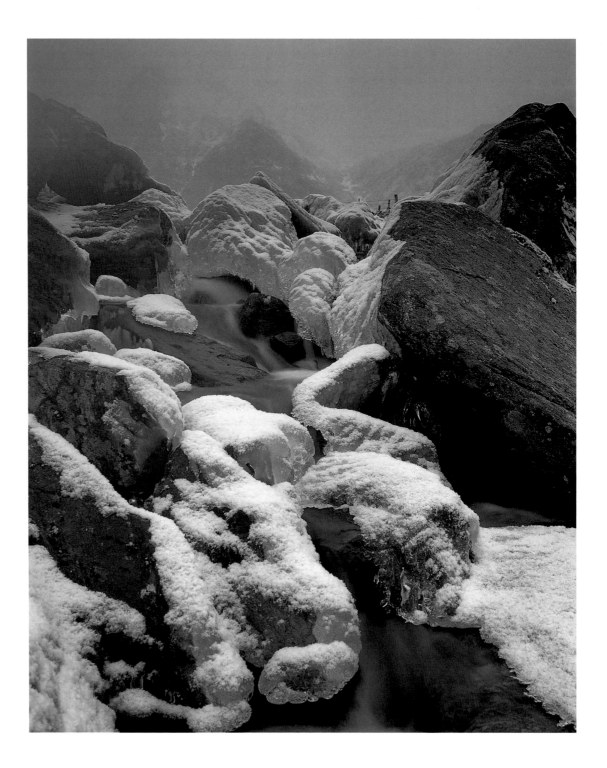

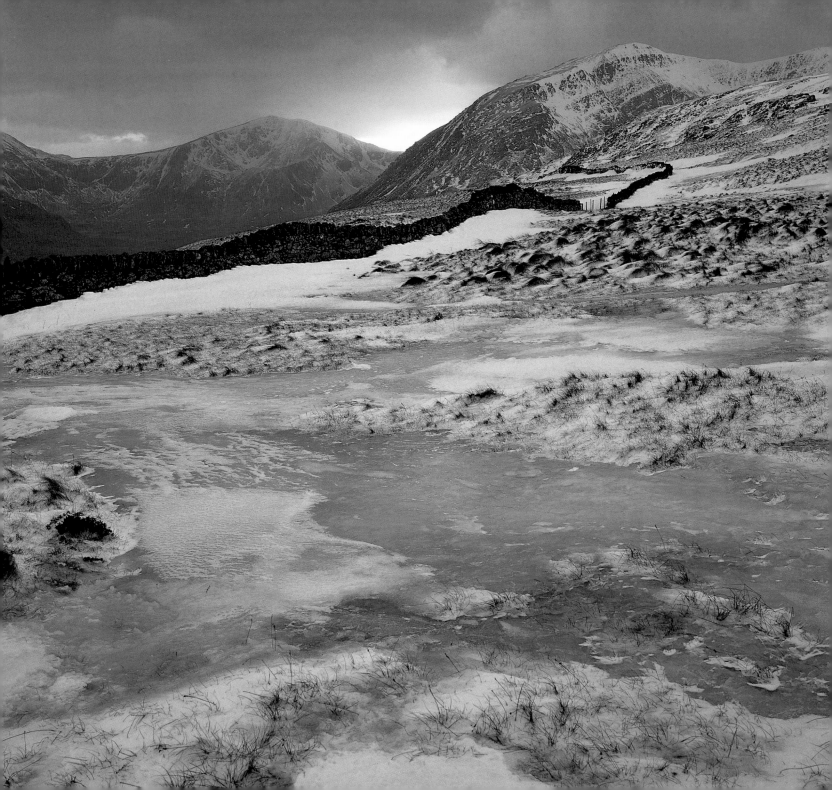

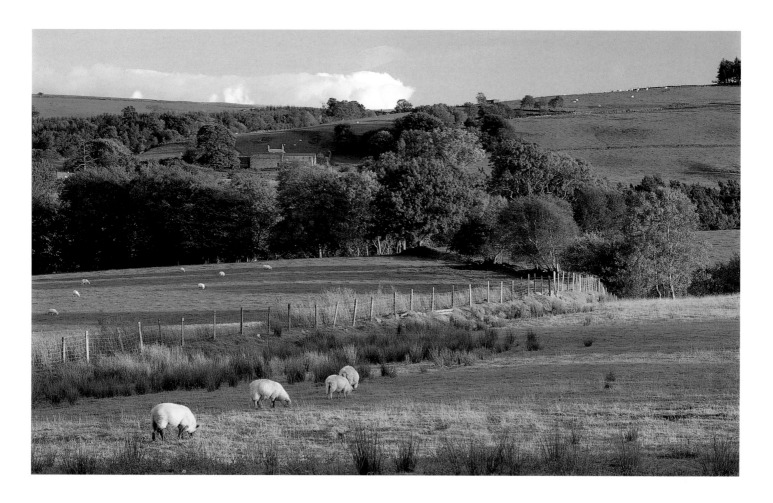

Previous pages: A bright winter's day in the CARNEDDAU, looking towards, left to right, Tryfan, Glyder Fach and Y Garn. The glacial formation has created a U-shaped cwm with a lake. Here Alpine flora flourish, including the Snowdon lily, while sheep from six high valley farms graze the mountain slopes. Carneddau is home, too, to thousands of visitors, drawn by the mountaineering and rock climbing, the classic mountain geomorphology, and the glorious scenery. [JC]

The Penrhyn Estate consists of 36,700 acres (14,860 ha), the largest owned by the National Trust. It comes in three parts: Carneddau, Tŷ Mawr and YSBYTY IFAN. In comparison with the icy peaks of Carneddau, the hills and valleys of Ysbyty are gentle, with villages and hill sheep farms. Nevertheless the farming here is on marginal land, with the Trust supporting the farmers to retain the environment by giving them extra income through hedge-laying and dry-stone walling.

Above: Looking south to PEN-Y-GENLAN from Bryn Bras Farm. [JC]

Right: A footbridge over Afon Eidda at PADOG. [JC]

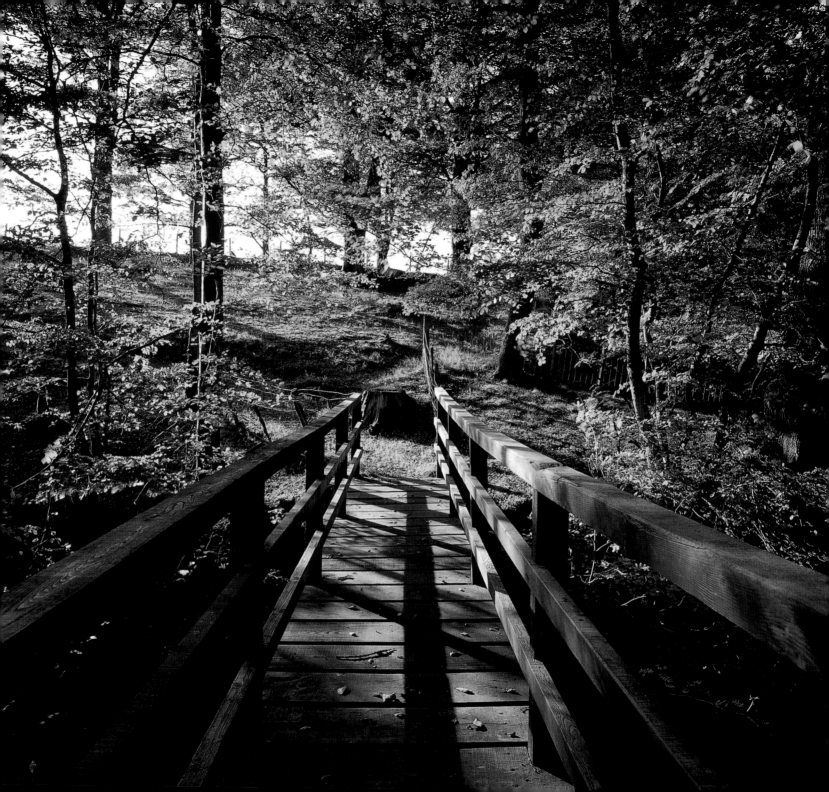

Dry-stone walls surround the ancient woodlands of HAFOD GARREGOG, an area of about 420 acres (170 ha) of undisturbed countryside near the Aberglaslyn Pass in Snowdonia. The woods and wetlands provide the habitat for the rare Silver Studded Blue Butterfly which exists nowhere else in the area and has probably been isolated here since the last Ice Age. [JC]

Far right: The typical subdivisions of a Snowdonian hill farm can clearly be seen at HAFOD Y PORTH. The open mountain gives way to the enclosed *ffridd*, rough grazing, below the mountain wall. Ancient oak woods grow on the less exposed rocky parts of the farm and the level ground has been cultivated.

In the centre of the lower parts of the farm is the rocky hill of Dinas Emrys, the site of an ancient British fort. The scene of many legends, it is the home of the Welsh Dragon. [JC]

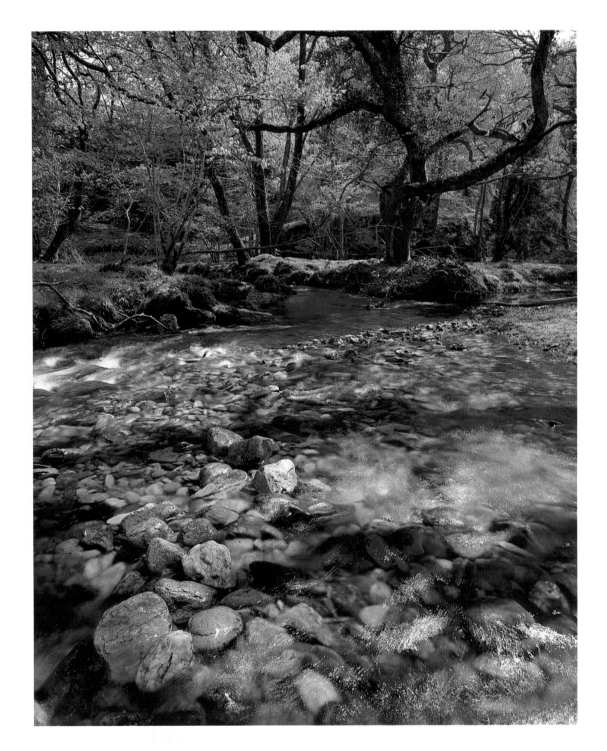

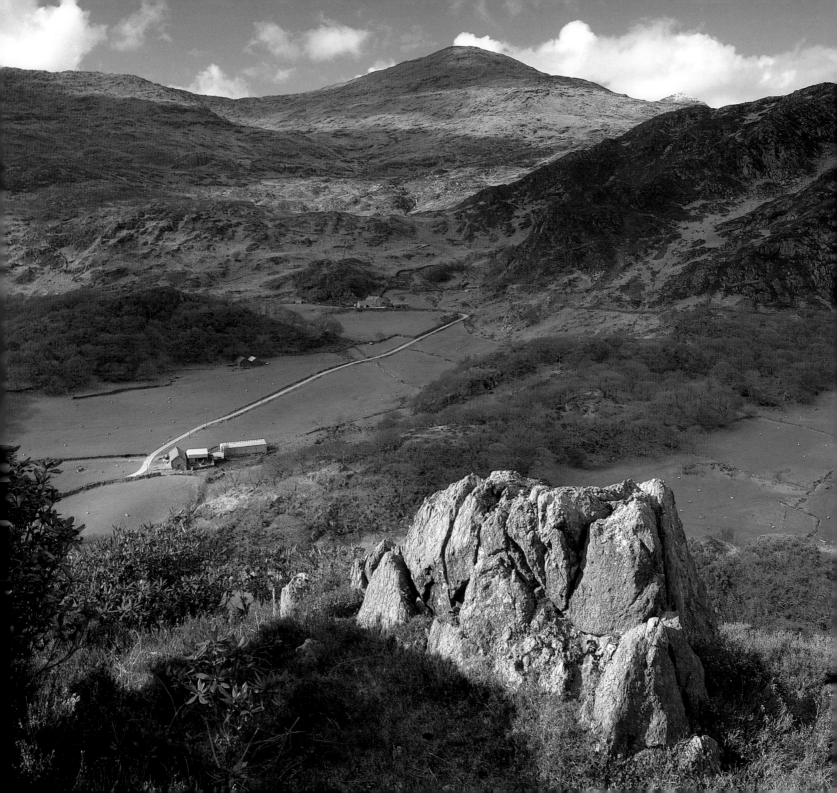

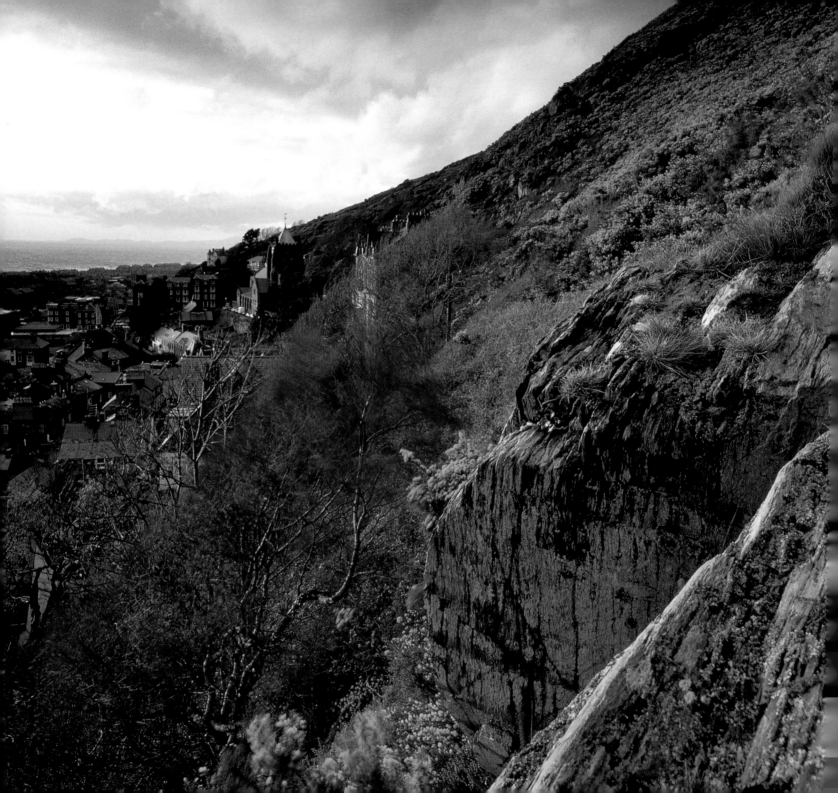

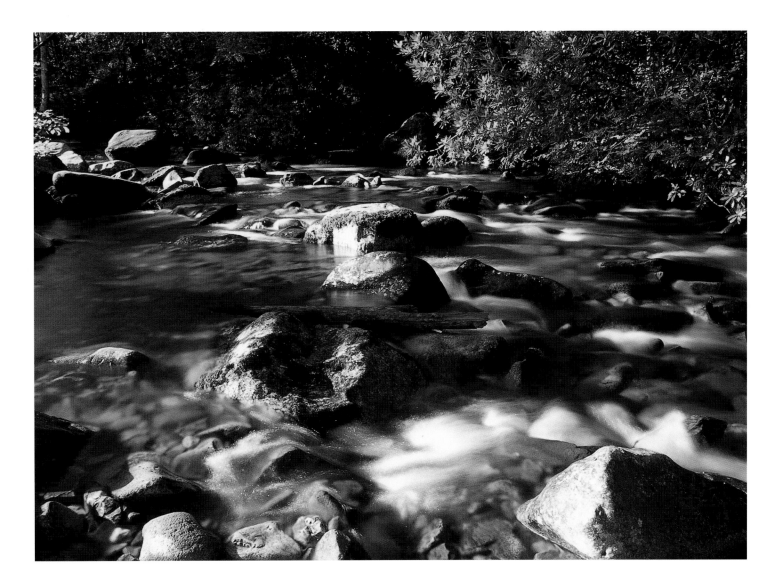

Left: The steep, gorse-clad fell of DINAS OLEU, Gwynedd, the National Trust's first property. Four and a half acres came to the Trust only weeks after the organisation's official formation in 1895, given by Fanny Talbot to prevent the spread of the seaside town of Barmouth along the coast. Octavia Hill's reaction to Mrs Talbot's generosity was to note, 'We have got our first piece of property, I wonder if it will be the last'. Little did she know. [JC]

Above: The DOLMELYNLLYN ESTATE lies in the upper part of the Mawddach Valley, one of Snowdonia's best kept secrets. The National Trust has provided a way-marked footpath through ancient oak wood-land, past the dramatic Rhaeadr Ddu waterfall to the melancholy remains of a gold mine. [DN]

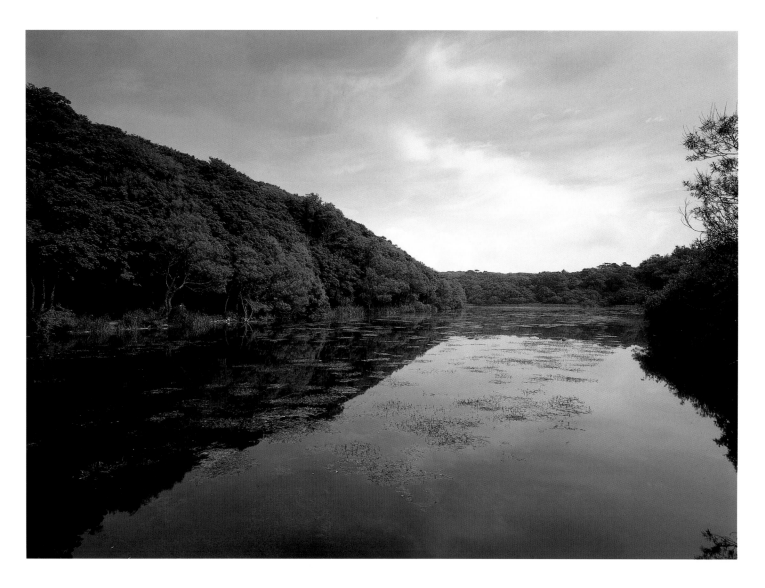

STACKPOLE in Dyfed. For three centuries this estate in South Wales, looking out over the Atlantic, was owned by the Scottish Earls of Cawdor. In *Macbeth* Shakespeare alludes to the prosperity of the Thane of Cawdor, and this prosperity can be seen at Stackpole, where the family landscaped the estate by planting woodlands and damming valleys to make freshwater lakes.

Above: One of the lakes, now part of a National Nature Reserve and well-known for its water-lilies. [JC]

Right: Trees overlooking the lake. [JC]

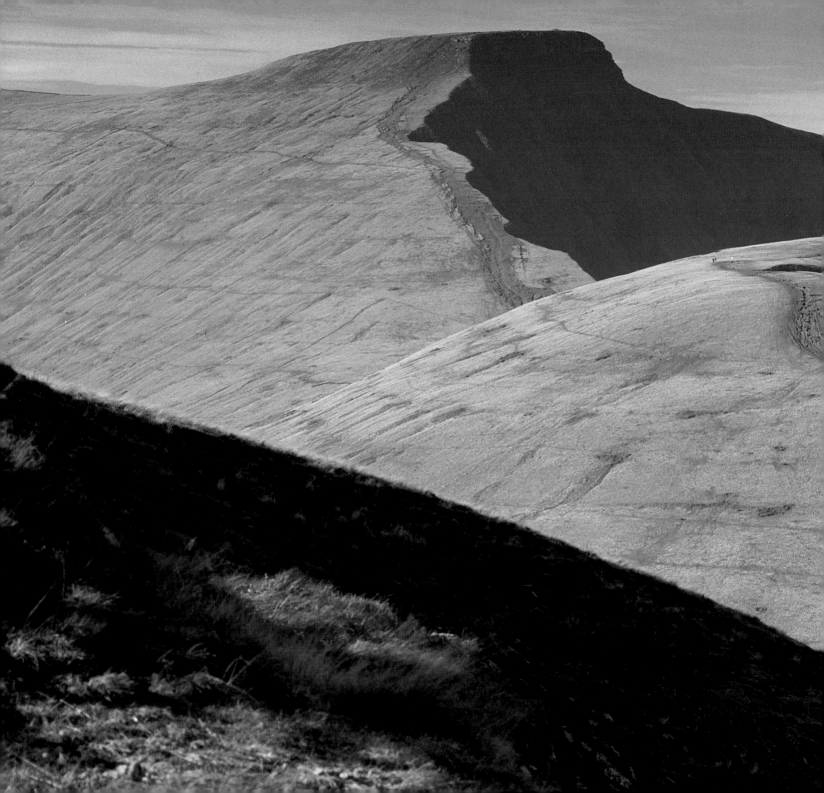

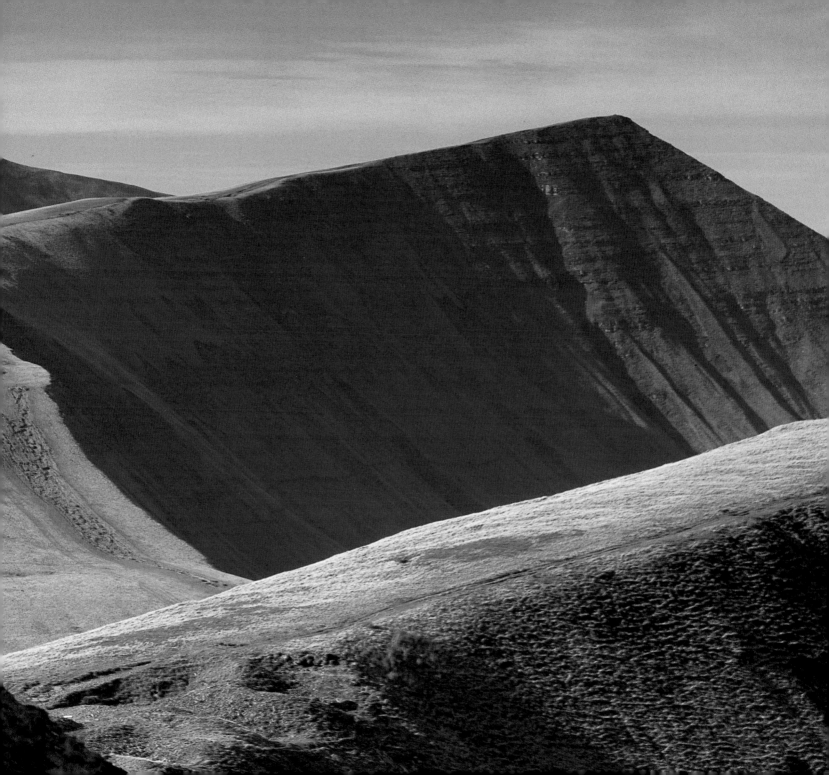

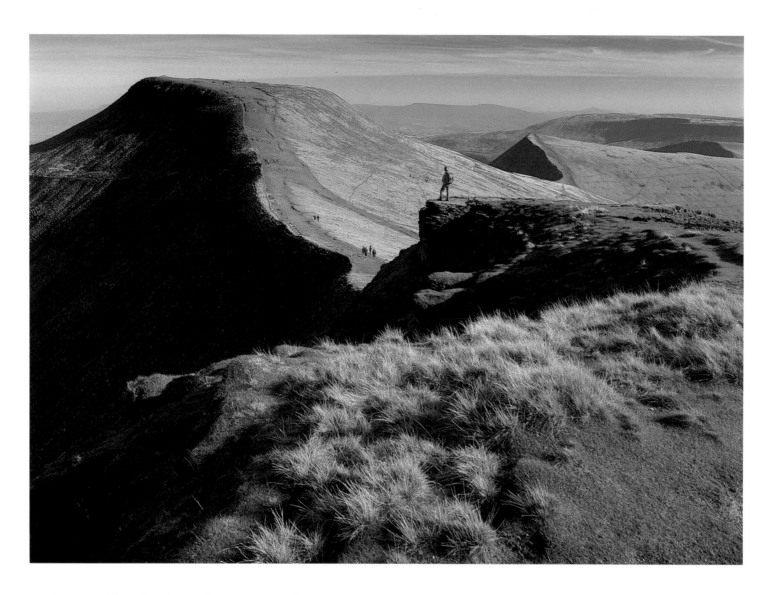

Previous pages: The red sandstone of the BRECON BEACONS makes for a much more open landscape than Snowdonia, and man has long inhabited even the peaks. Neolithic and Bronze Age relics have been found, along with inscribed stones dating from the fifth and sixth centuries when this area formed part of the Irish principality of Brycheiniog. This photograph looks from Craig Cwareli west towards Pen-y-Fan and Cribyn. [JC]

The Brecon Beacons are now a National Park, just one valley across from the mining valleys, and thus a playground for South Wales.

Above: So many walkers use the footpaths that they have become badly eroded. [JC]

Right: The land is farmed for sheep, with open fields and no walls, because the sandstone is not suitable. Looking south west from Llechfaen, over the Usk Valley to the Beacons. [JC]

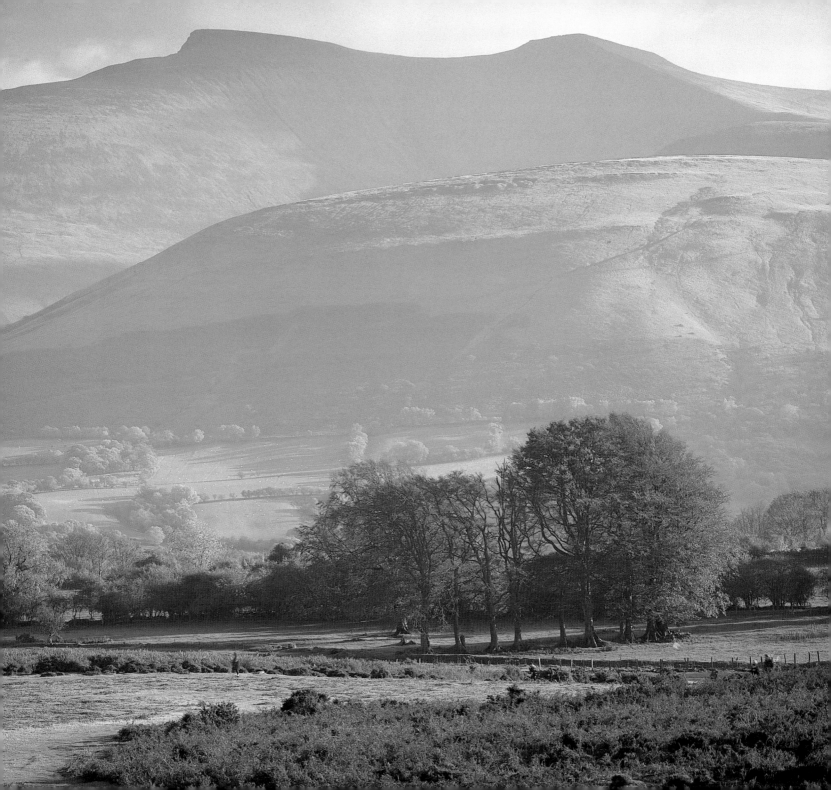

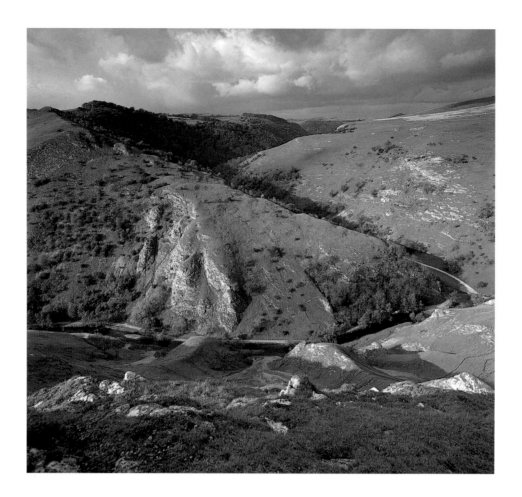

The PEAK DISTRICT, spreading across Derbyshire, Staffordshire and Yorkshire, is completely surrounded by the great industrial cities of the North and Midlands of England. DOVEDALE, in the South Peak, for instance, has to accommodate more than two million visitors each year, staunchly fulfilling Octavia Hill's desire to provide an open-air lung for town dwellers.

This is limestone country, good for walking and climbing, with a subterranean landscape for caving, and the River Dove a place of pilgrimage for anglers since Izaak Walton wrote the *Compleat Angler* in 1653.
Above: The crags of Bunster Hill, from the summit of Thorpe Cloud. [JC] *Right:* Looking south-west over farmland from South Head Hill. [JC]

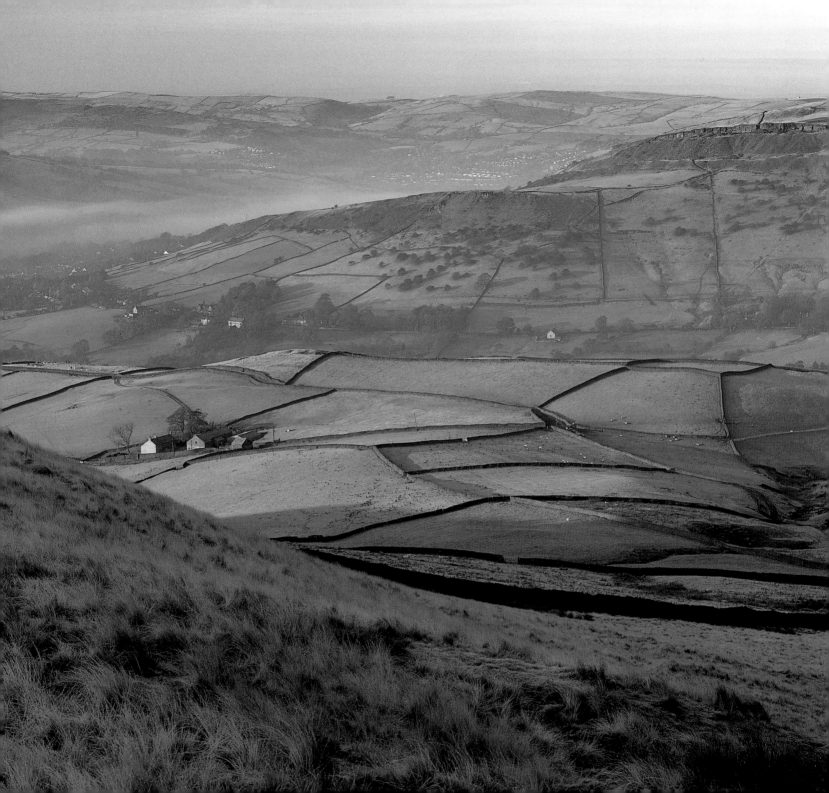

Right: Thor's Cave, one of the spectacular limestone caves in the MANIFOLD VALLEY. Excavations in the nineteenth century confirmed that it was in use in Romano-British times, while investigations in neighbouring caves have revealed flints and animal bones from the Upper Palaeolithic period, twelve thousand years ago. [DN]

Far right: Farmland near WETTON, in the South Peak. Taking advantage of the limestone, the fields are divided by dry-stone walls. The field barn is designed to store hay in the upper part and to house livestock below. [JC]

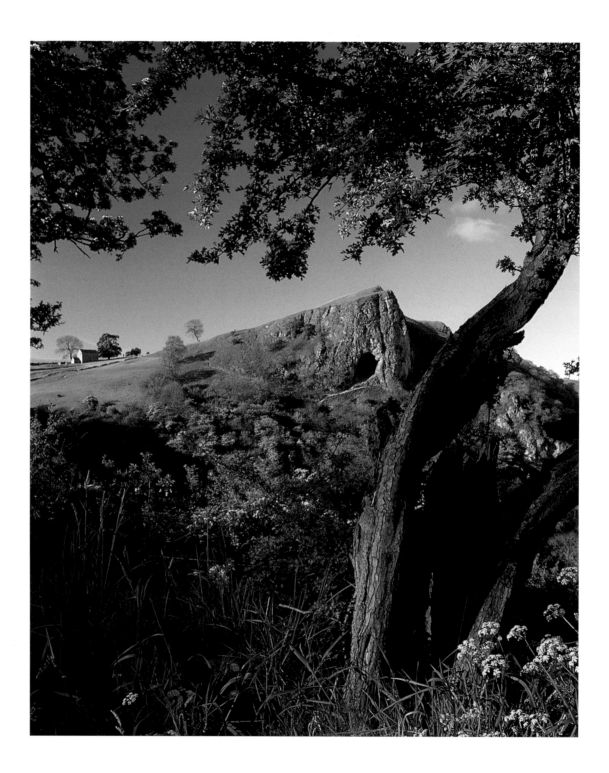

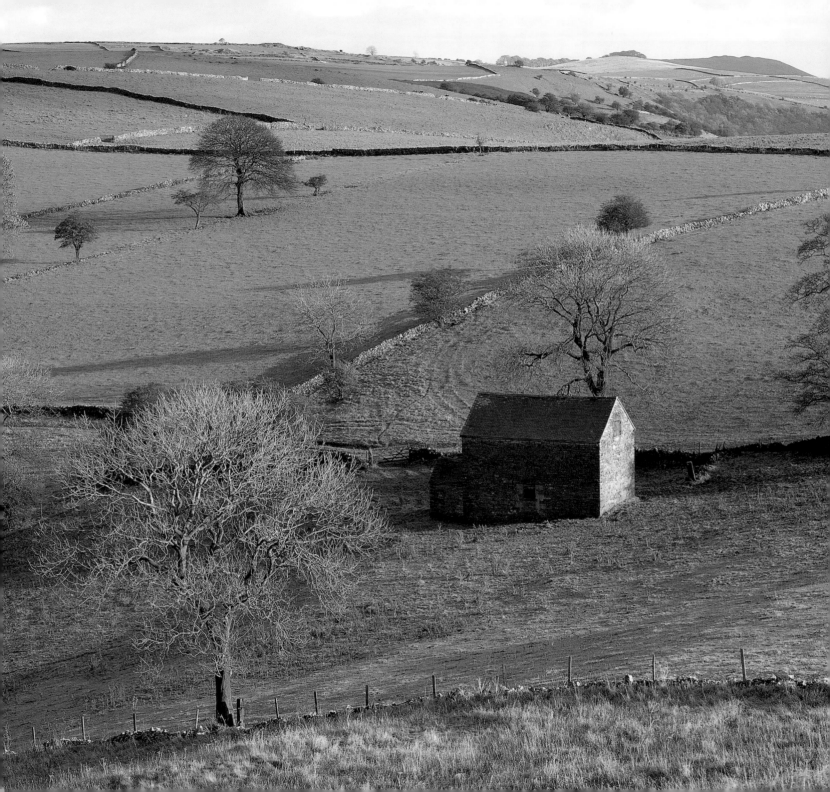

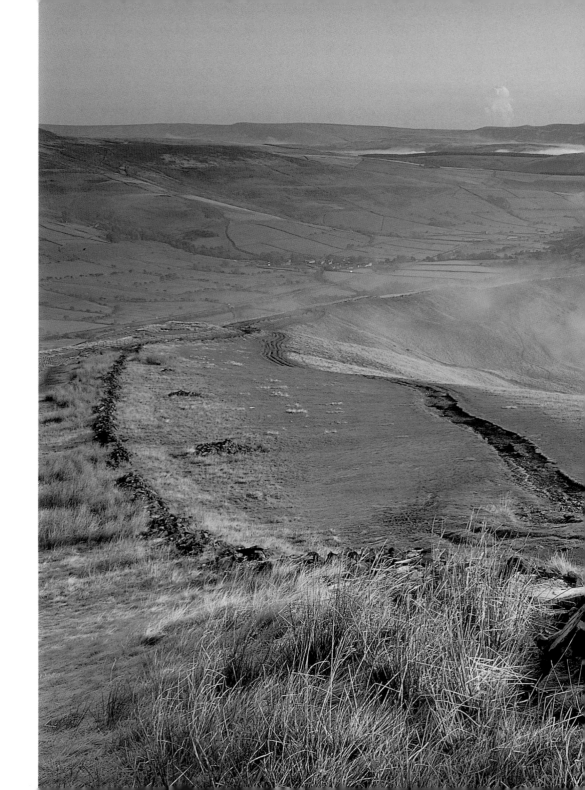

MAM TOR in the Dark Peak. Mam Tor is known as the shivering mountain because of continual landslips over the centuries: its east face now looks like a gigantic quarry. This gritstone landscape is grim and ancient, with evidence of prehistoric barrows. It is also superb walking country, with wonderful views: this picture looks north-east along the ridge to Hollins Cross, Back Tor and Lose Hill Pike. [JC]

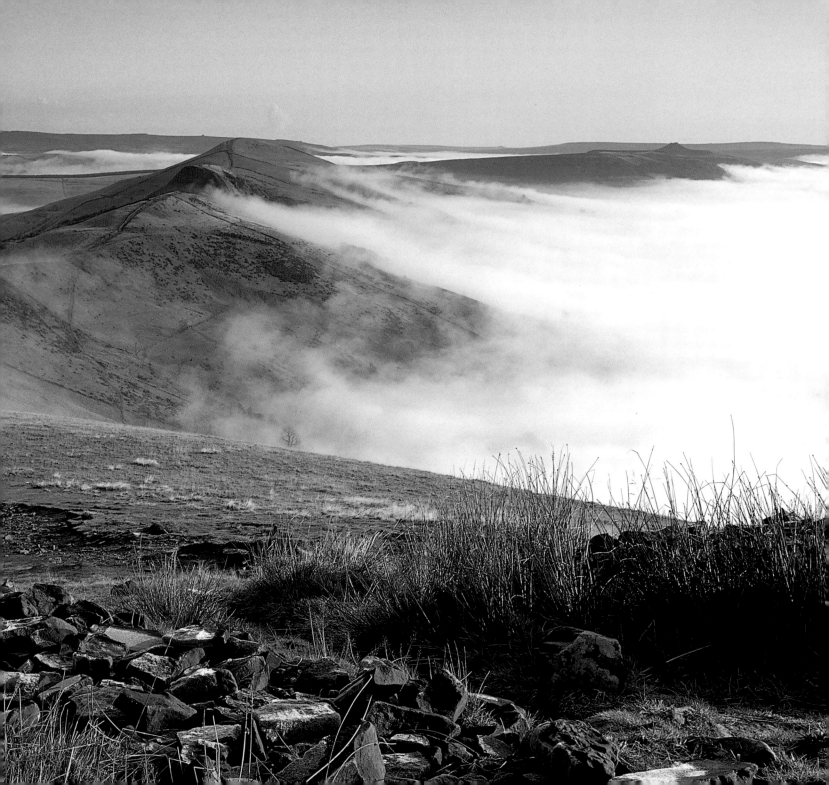

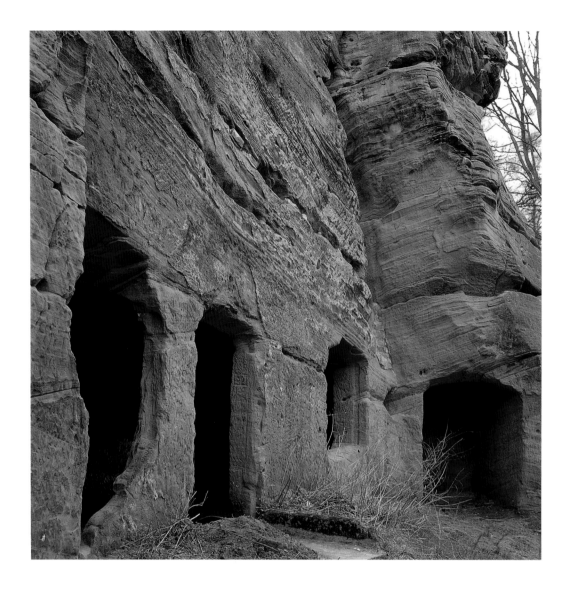

KINVER EDGE in Staffordshire is a prominent sandstone escarpment. From the top there are dramatic views of Shropshire and the Clent Hills, but equally striking are the dwellings cut into the soft stone of the Edge itself. The earliest records of these houses date back to the seventeenth century, and by the end of the last century upwards of one hundred people were living in Kinver Edge. The cave dwellers fitted their accommodation with all the comforts they could aquire, taking advantage of the warmth in winter and enjoying the cool in summer. [JC]

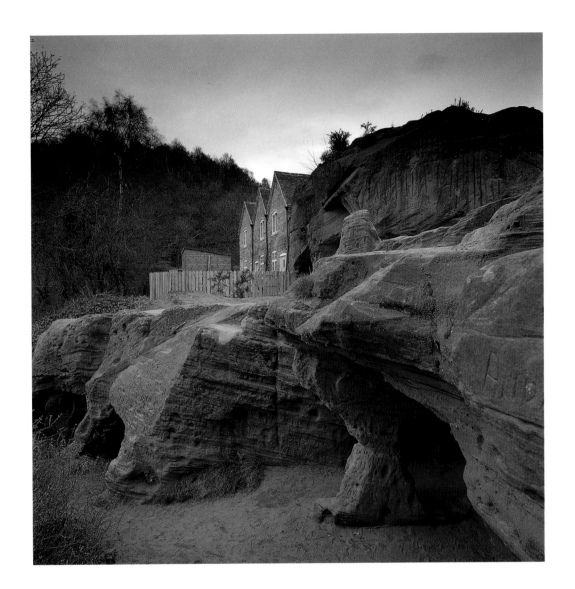

The Kinver dwellings were abandoned in the early 1960s when some of the upper levels with brick frontages were demolished. The National Trust has recently recreated the top tier to enable a warden to offer twenty-four hour protection to the site from vandals. [JC]

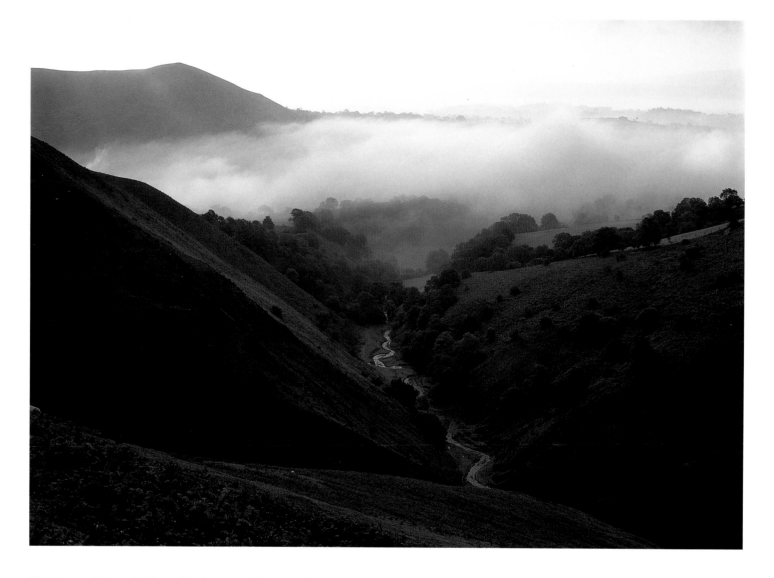

The LONG MYND in Shropshire is a great ridge, running some ten miles from south-west to north-east, separating England and Wales – mynd is probably derived from the Welsh *mynydd* for mountain. The ridge is made up of some of the oldest rocks in England, pre-Cambrian shale, creating a landscape of steep valleys known as hollows or batches. For centuries this has been common-land, heavily grazed by sheep.

Along the spine of the ridge runs the Portway, originally a Bronze Age route, later used by cattle drovers bringing their animals from North Wales through to market in the English Midlands and South.

Trying to cross the Long Mynd on a winter's day can be a dangerous experience, as proved by the Rev. Carr who, on 29 January 1865 set out to return from a service at one of his outlying parishes. A furious gale blew up and snow fell 'as if they were throwing it out of buckets'. The unfortunate cleric wandered around for over twenty-seven hours, even unwittingly managing to evade a search party. Eventually he found his way home, thankful for his 'most wonderful preservation'.

Right: Dawn mist rolling off Hazler Hill from the Long Mynd. [JC]

Above: Ashes Hollow with Ragleth Hill to the left. [JC]

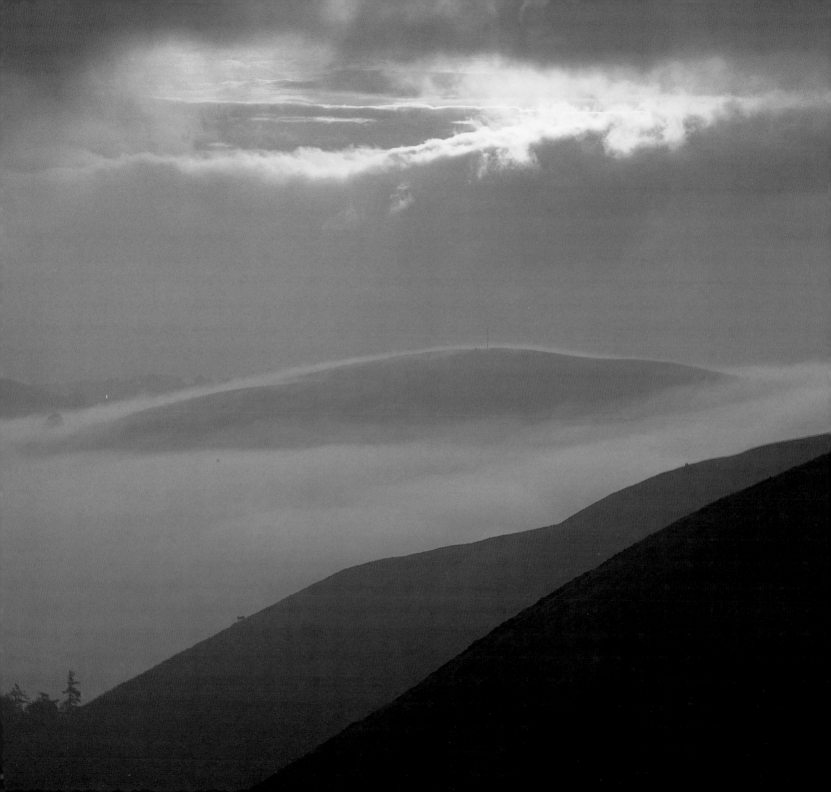

The MALVERN HILLS, Hereford and Worcester. Much of the countryside here is covenanted land, rather than owned by the National Trust. Protection from development can be provided by covenant: the owner, after consultation with the Trust, puts restrictions on the use of their land, and such restrictions remain with the deeds, even if the land is sold or let.

To many, the Malverns are the quintessential English landscape, with their gentle, quiet beauty, evoked by Sir Edward Elgar in his music. *Right:* Looking north to the Worcestershire Beacon. [JC]

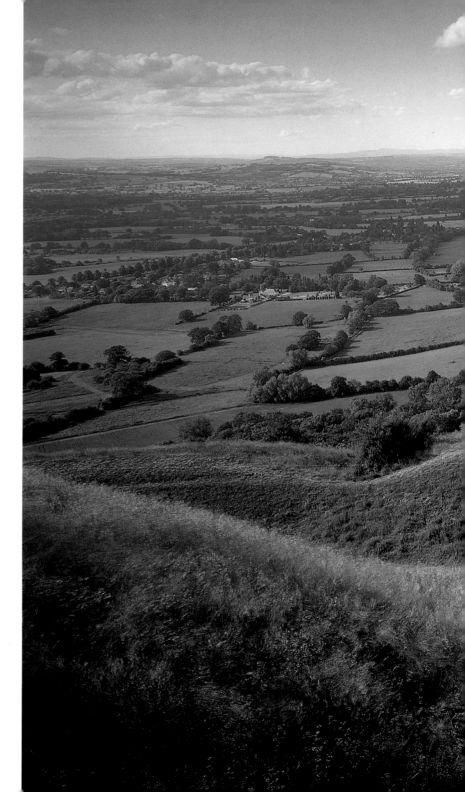

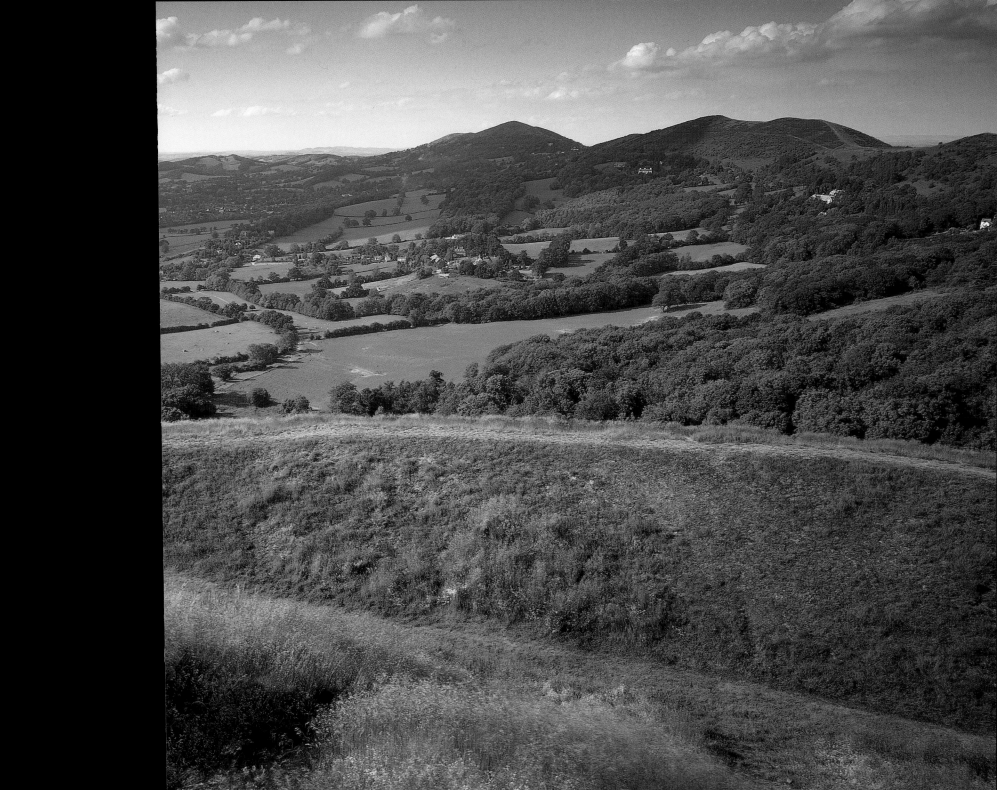

The CLENT HILLS lie just south of Birmingham, providing the Black Country, in the words of Edgar Marriott's *Albert & the Lion*, with 'fresh air and fun'. *Right:* The sandstone hills, woody in parts, are steep but easy to climb, with superb views. [DN]

Far right: Looking towards the whaleback of the Malvern Hills rising abruptly from the Severn Plain. [DN]

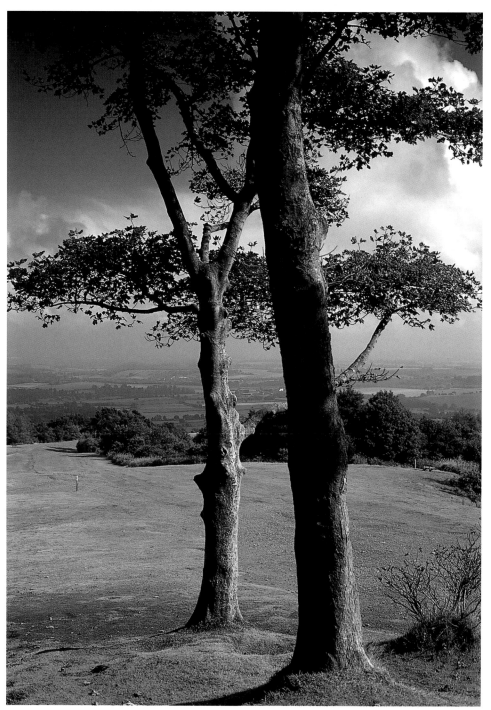

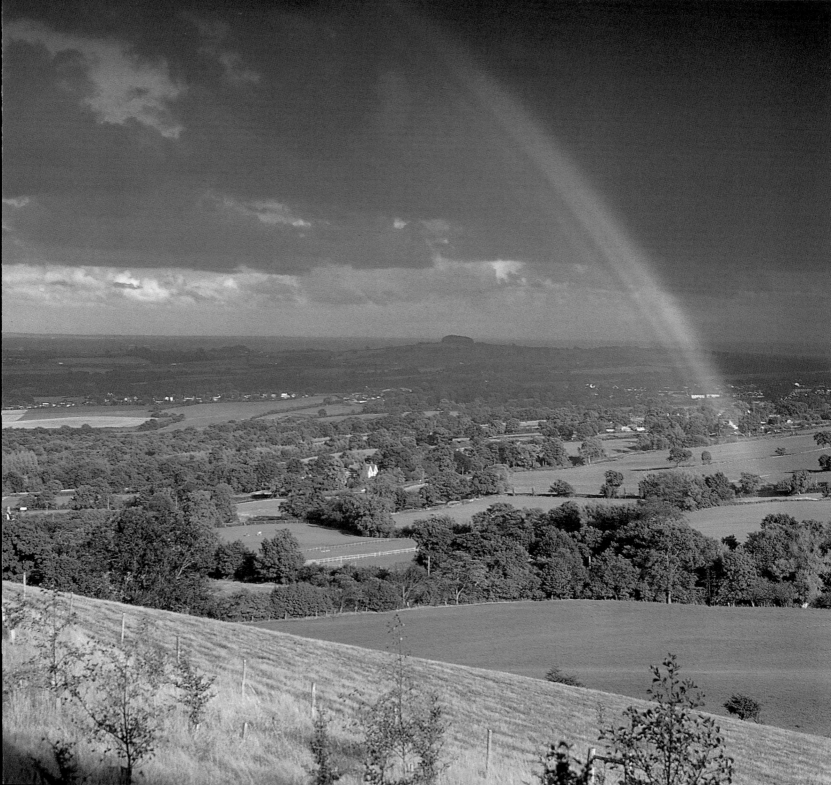

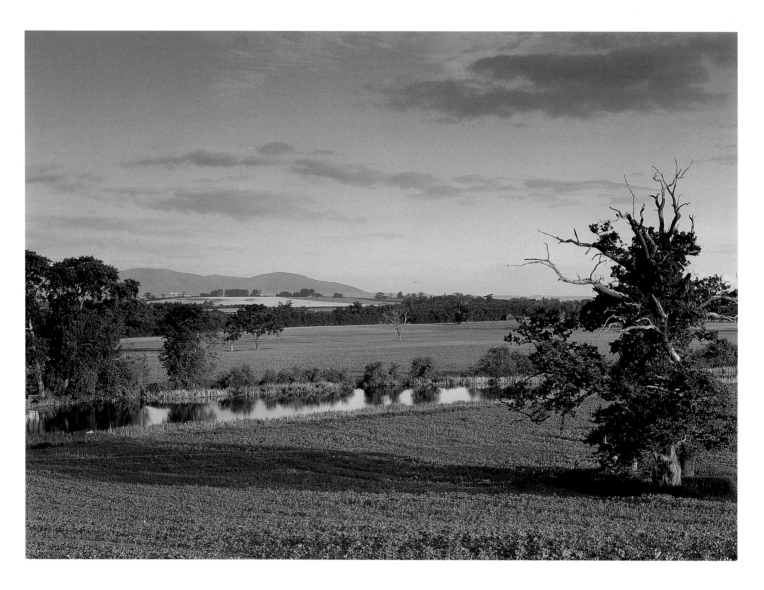

CROOME PARK in Hereford and Worcester. Between 1747 and 1809 the 6th Earl of Coventry commissioned a series of leading garden designers and architects to lay out his landscape garden: Sanderson Miller, John Phipps, Lancelot 'Capability' Brown, Robert Adam and James Wyatt. But it is Brown's work, producing a 'natural landscape', that is most evident today.

In 1996 the National Trust purchased the central part of the parkland, which includes most of the significant parts of the landscape. Former grazing regimes are being reintroduced, including the reinstatement of the deer park, and restoration of the park to its early nineteenth-century appearance is underway. *Right:* View over the 'river', a serpentine lake, in early summer. [DN] *Above:* The landscape park with the Malvern Hills in the distance. [DN]

Following pages: Looking towards Croome Court, Capability Brown's earliest architectural work, 1751-2, probably following the designs of Sanderson Miller. [DN]

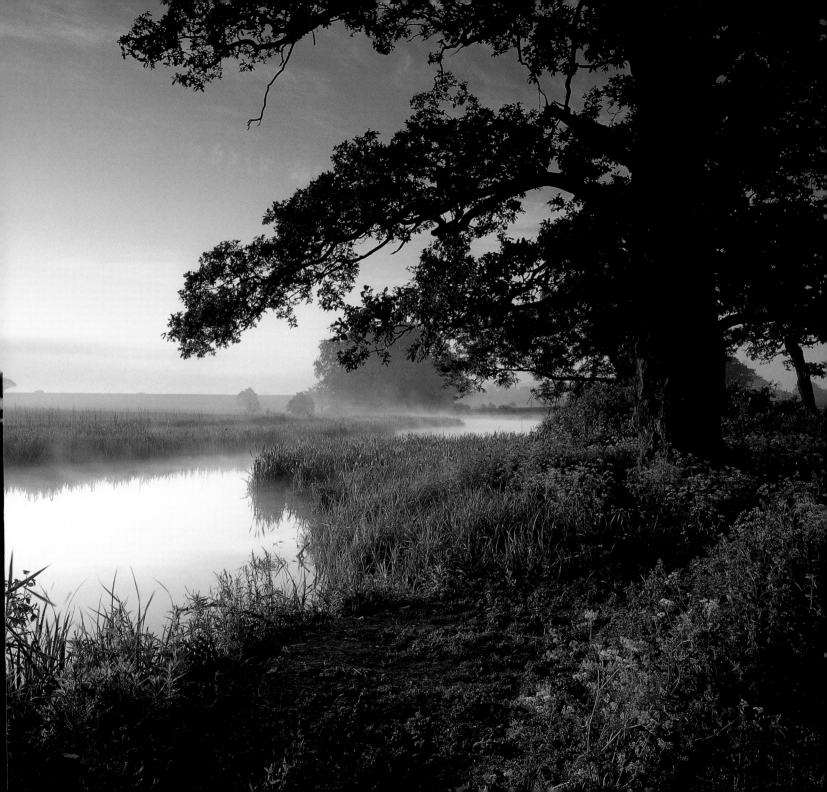

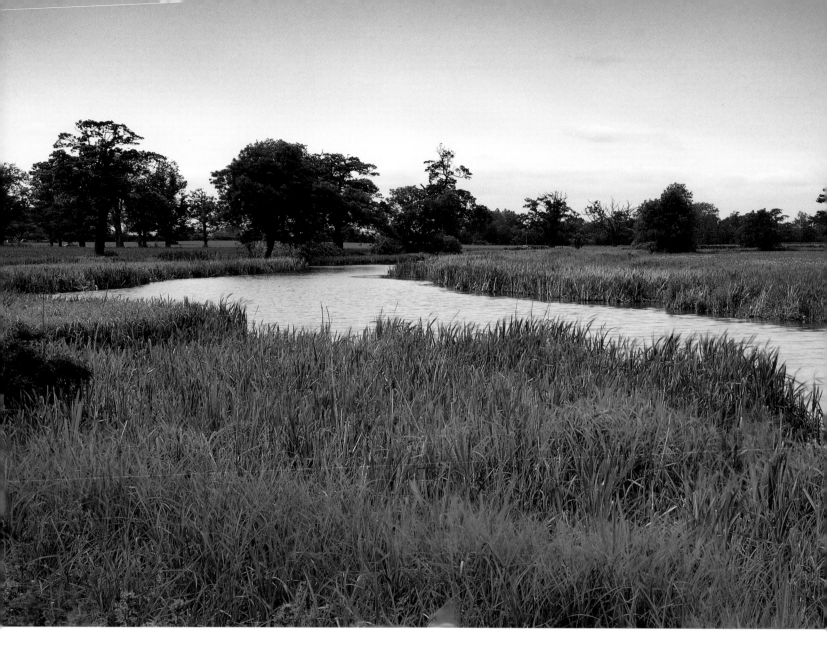

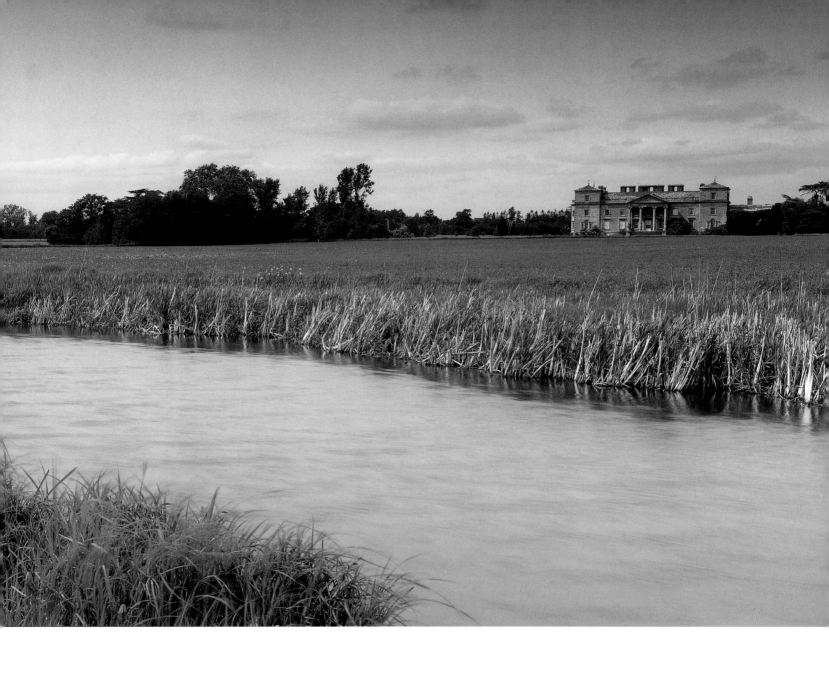

The way through the woods at Leigh, Bristol. The first section of LEIGH WOODS, within the city boundaries on the banks of the Avon, was given to the National Trust in 1909 by the Wills tobacco family, and other parts have been added over the years. Today it is a National Nature Reserve, where the Trust works in cooperation with English Nature, Forest Enterprise, and the Avon Community Forest to maintain the remains of a semi-natural ancient forest of wych elm, ash, oak, small-leaved lime and, uniquely, two species of whitebeam. [DN]

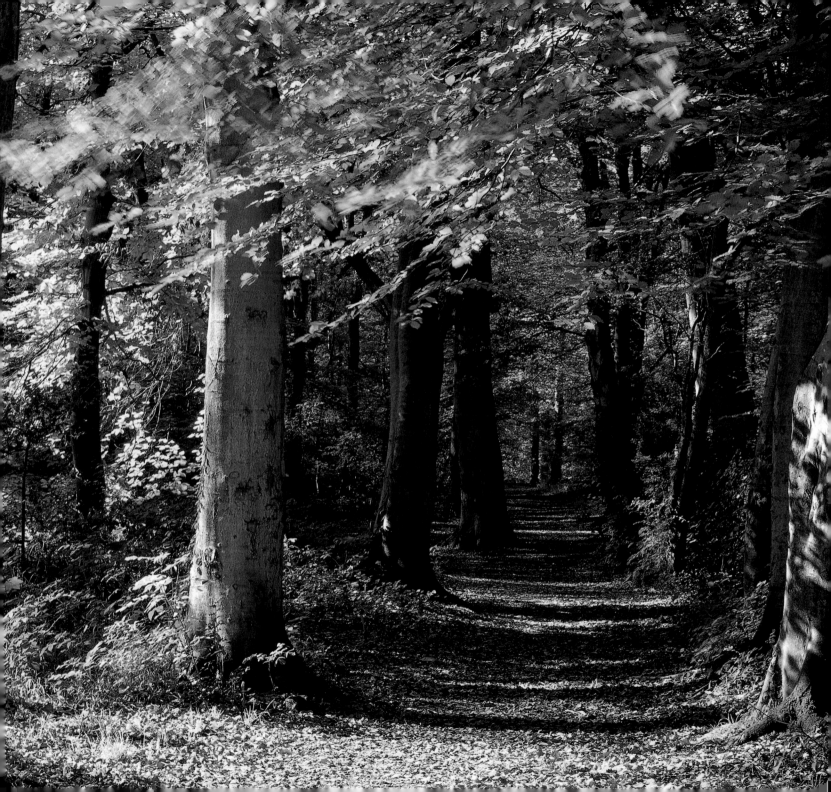

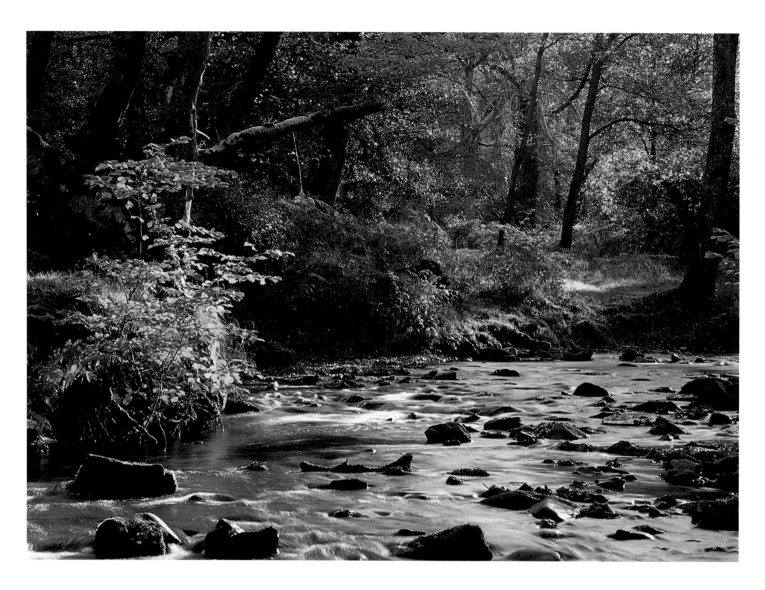

In 1944 Sir Richard Acland gave the National Trust all the land in his possession – the Holnicote Estate in Somerset of 12,400 acres (5,000 ha), and the Killerton Estate in Devon, of 6,400 acres (2,600 ha). At the time this gift roused considerable antagonism, and Sir Richard ruefully remarked that there was a feeling that donors were supposed to be dead. Now however, his gifts are much enjoyed by thousands of visitors, especially those to the Exmoor countryside of HOLNICOTE.

The Horner River, with its fine oak woods, rises on DUNKERY BEACON and runs through Exmoor National Park. [DN]

Horner Water in
Horner Wood on
the HOLNICOTE
ESTATE. [PW]

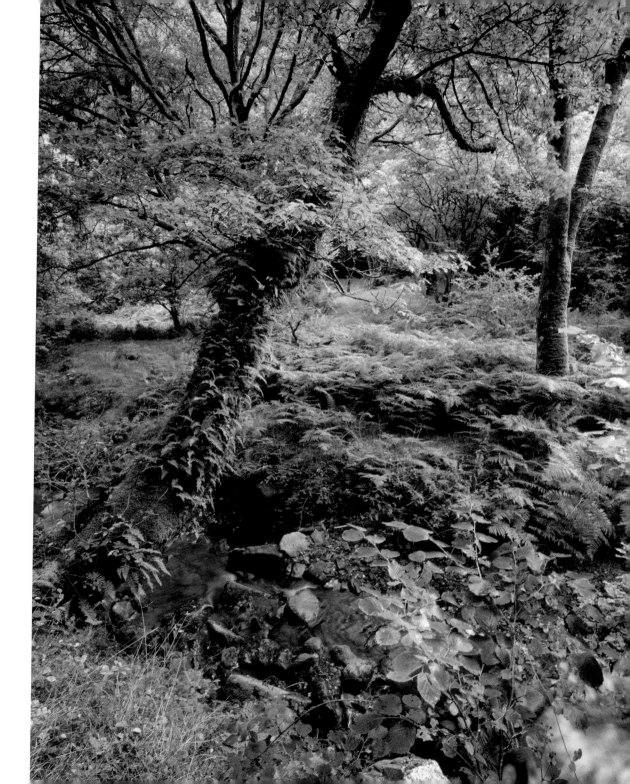

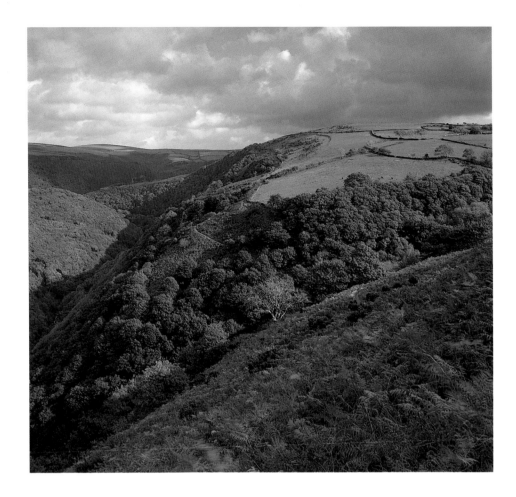

Above: WATERSMEET in Devon is so called because two rivers join here: the East Lyn and the Hoar Oak Water, with their oak hanging woodlands where for centuries coppicing took place to provide pit props for the coal mines of South Wales. From Watersmeet the united rivers flow swiftly to the sea at Lynmouth, beneath Lyn and Myrtleberry Cleave. This photograph shows the two Cleaves. [JC]

Right: Abandoned engine houses are connected irrevocably with the Cornish landscape and tin mining, but this example, WHEAL BETSY, is in Devon, and was used for lead mining. Set romantically on Black Down, on the west edge of Dartmoor, Wheal Betsy is a reminder that this area was once a heavily industrial site. [DN]

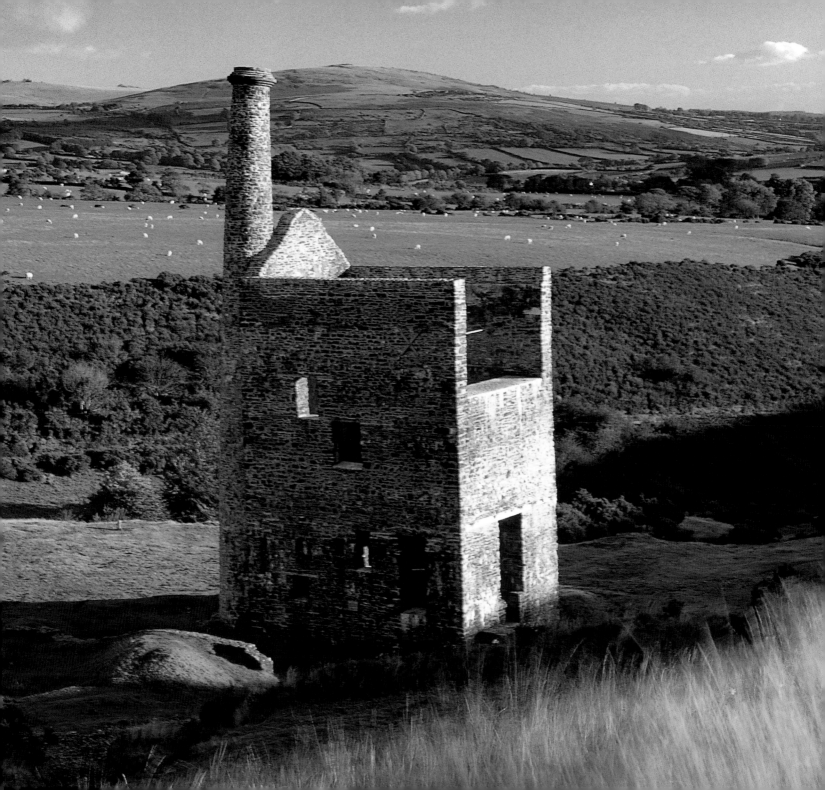

Above: FONTMELL DOWN in Dorset, taken in midsummer. This is Thomas Hardy country, and Fontmell was acquired by the National Trust in 1977 as a memorial to him. The chalk downlands provide habitats for butterflies, especially the small blue, common blue and chalk-hill blue, orchids and sheep-grazing flowers such as cowslips. [DN]

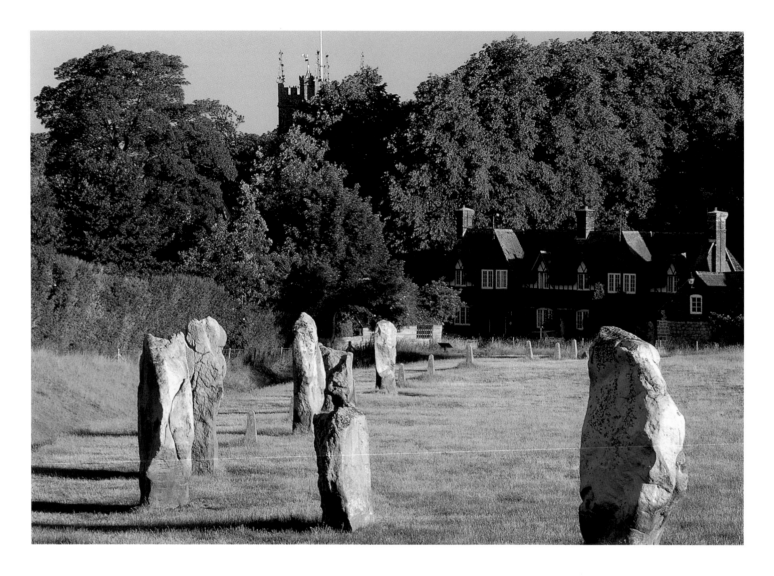

AVEBURY in Wiltshire is perhaps the most important prehistoric monument in Europe, with a Neolithic causewayed enclosure at Windmill Hill, and a megalithic site of *c*.1800 BC that includes circles of sarsen stones enclosed by a bank and ditch, approached by an avenue of more stones. Unlike Stonehenge, where the stone circle stands isolated on a hill, at Avebury the medieval village is enmeshed with the stones, giving the impression that the houses are surrounded by a sculpture park (*above*). [DN]

That is not to say that Avebury lacks atmosphere. On a late winter's day, or at misty sunrise, the sarsen stones of the Avenue are a haunting sight (*right*). [DN]

Following pages: CHERHILL DOWN, overlooking the Vale of Pewsey, in Wiltshire. While the Vale is given over to large-scale arable farming, the downland above is a prehistoric landscape with tumuli, barrows, and strip-fields from an earlier agricultural system. The Trust takes care to maintain this landscape, using neither plough nor chemical spray and encouraging chalkland flowers which attract butterflies. To the right of the picture can be seen the Lansdowne Monument, built by the 3rd Marquess in 1845 in memory of the economist, Sir William Petty. Below is a fine white horse carved into the shoulder of the down. [DN]

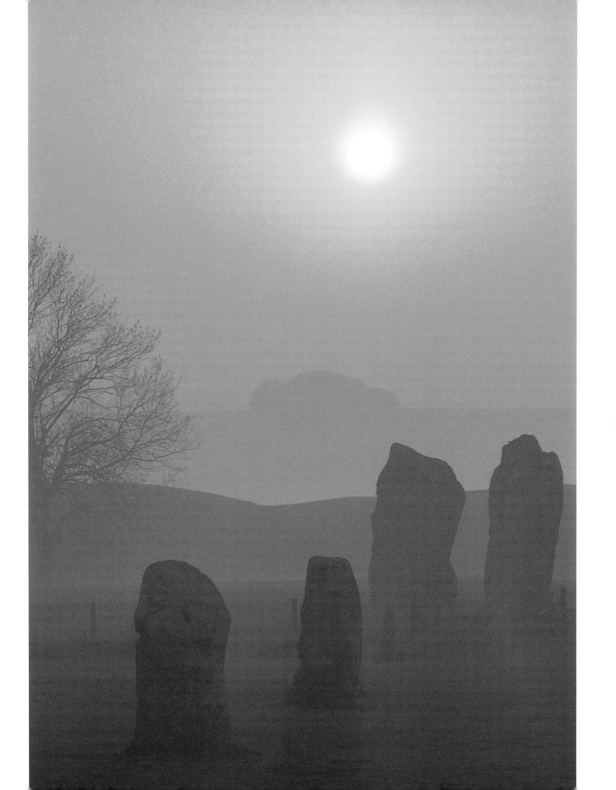

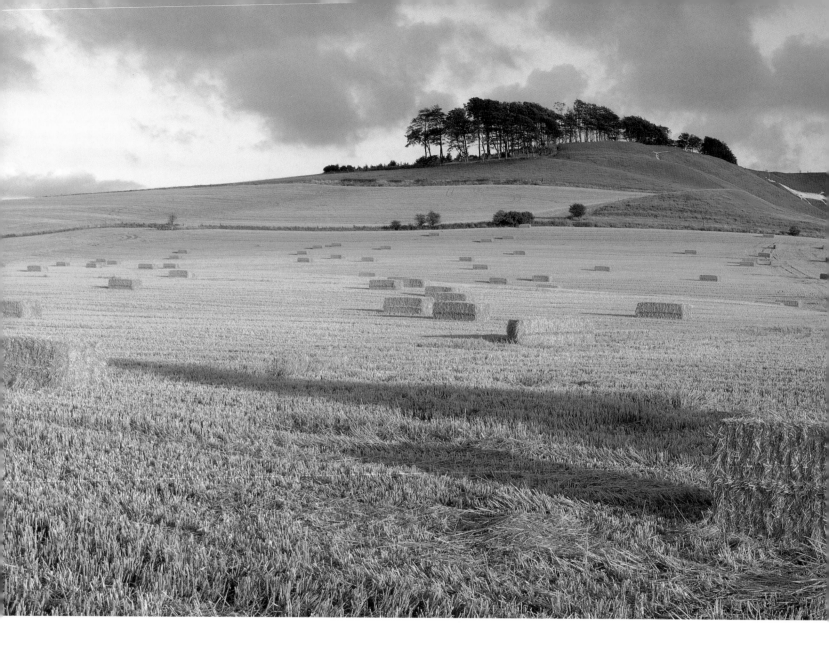

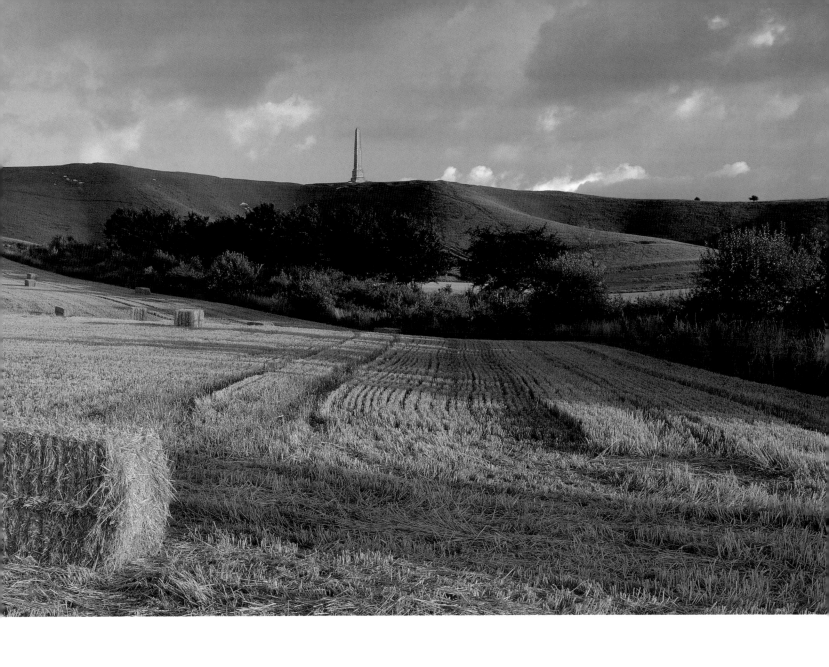

Right: VENTNOR DOWN, at the south-east end of the Isle of Wight. This is coastal heath laid on top of the chalk. The bracken provides sufficient cover for bluebells, which would normally not survive the competition with other more virulent sun-loving plants. [JC]

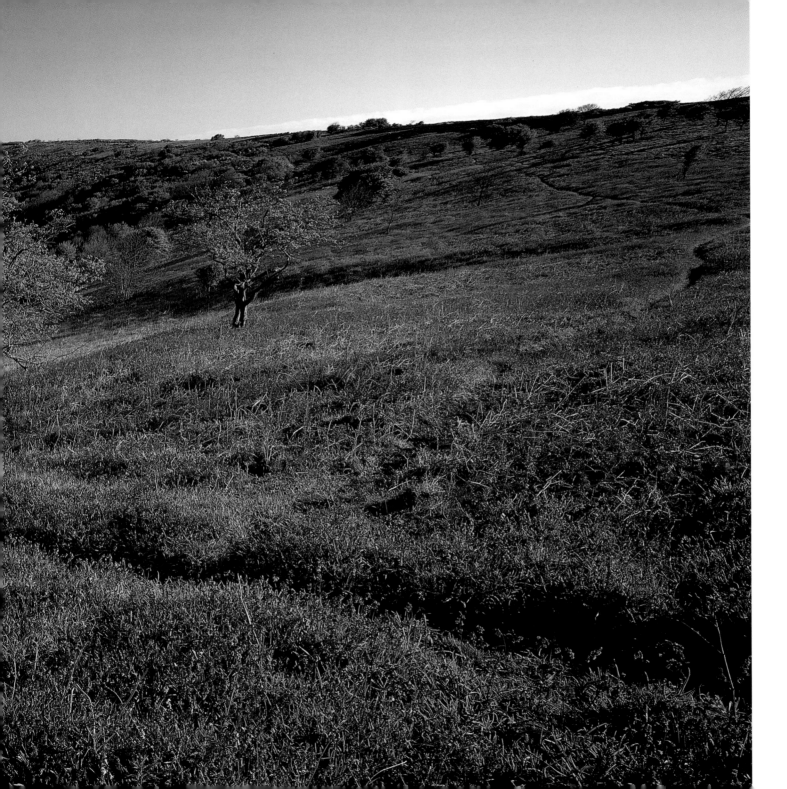

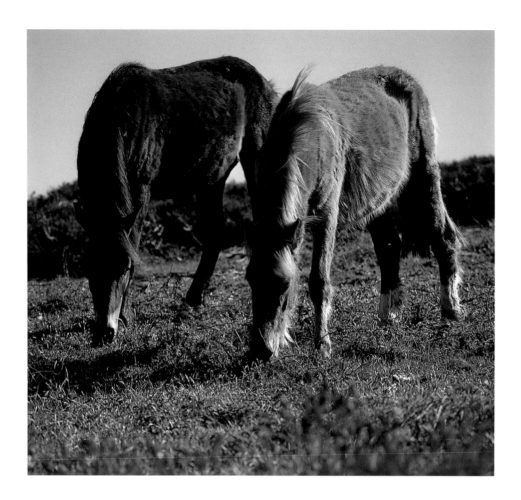

There has been a serious decline of traditional heathland habitats in south-east England over recent years because this type of landscape is particularly vulnerable to the development of scrub. The National Trust is reversing this decline by grazing the land and thus encouraging former habitats to return.

Above: Semi-wild New Forest ponies were recently introduced to VENTNOR DOWN. [JC]

Right: A similar solution is being applied at LUDSHOTT COMMON in Hampshire. [JC]

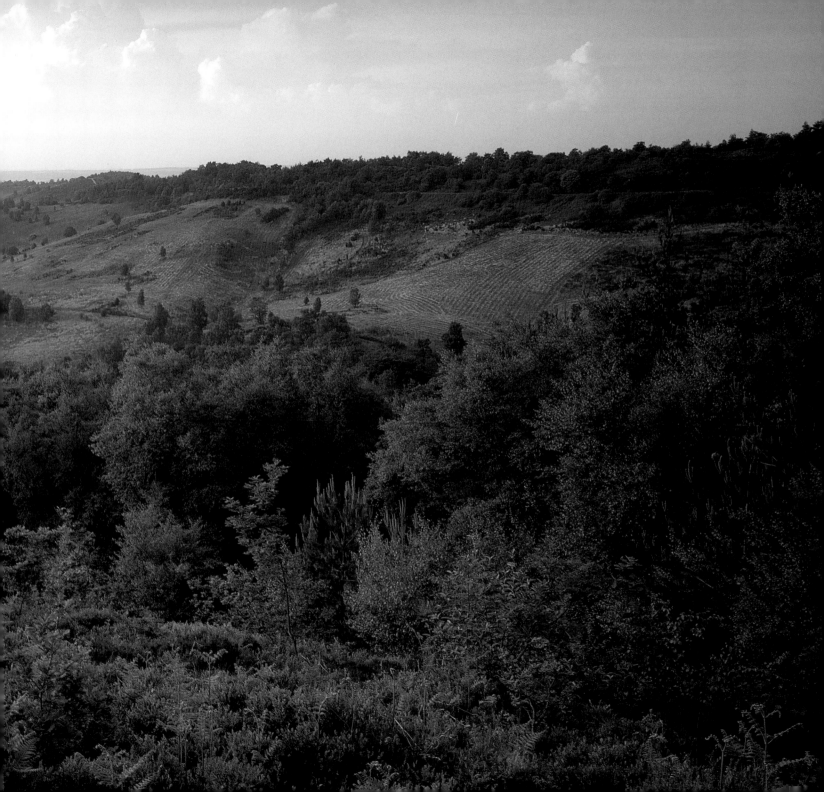

Previous pages: Sir Robert Hunter had fought many battles to save open spaces around London when he was Honorary Solicitor to the Commons Preservation Society in the 1860s, 70s and 80s. After he had helped to found the National Trust, he continued his efforts to protect open land, especially around Hindhead, close to his Surrey home. With its easy access by rail to London, this area was particularly desired for stockbroker development. In 1906 the Hindhead Preservation Committee bought up and presented to the Trust the Devil's Punch Bowl and Gibbet Hill, with Inval and Weydown Commons to the south-east. This photograph shows HINDHEAD COMMON from the Punch Bowl. [JC]

Right: The Gothic folly of LEITH HILL TOWER stands on the highest point in south-east England, with glorious views of the Weald and the South Downs. The slopes of the hill are wooded, with some stands of ancient oak and hazel amongst replanting. On the southern slopes is a rhododendron wood including many early-flowering species and hybrids, planted in the nineteenth century by Josiah Wedgwood, grandson of the famous potter. [JC]

Far right: GIBBET HILL rises to 895 feet above the Devil's Punch Bowl. It derives its name from a murder that took place on the old A3 road which can still be seen, now a quiet leafy lane, but once the main highway from Portsmouth to London. Here, in 1786, a sailor was set upon, robbed and left for dead. His three murderers were hanged on the top of the hill and then their corpses were preserved in tar and hung from the gibbet as a dire warning to others. [JC]

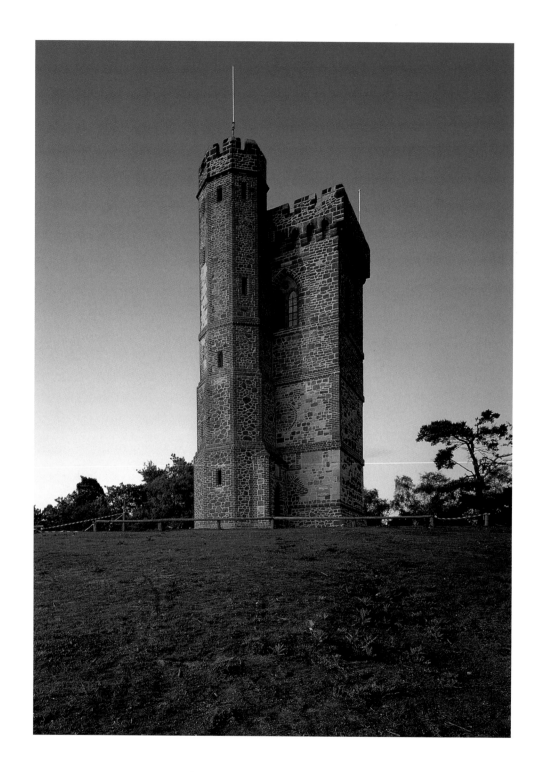

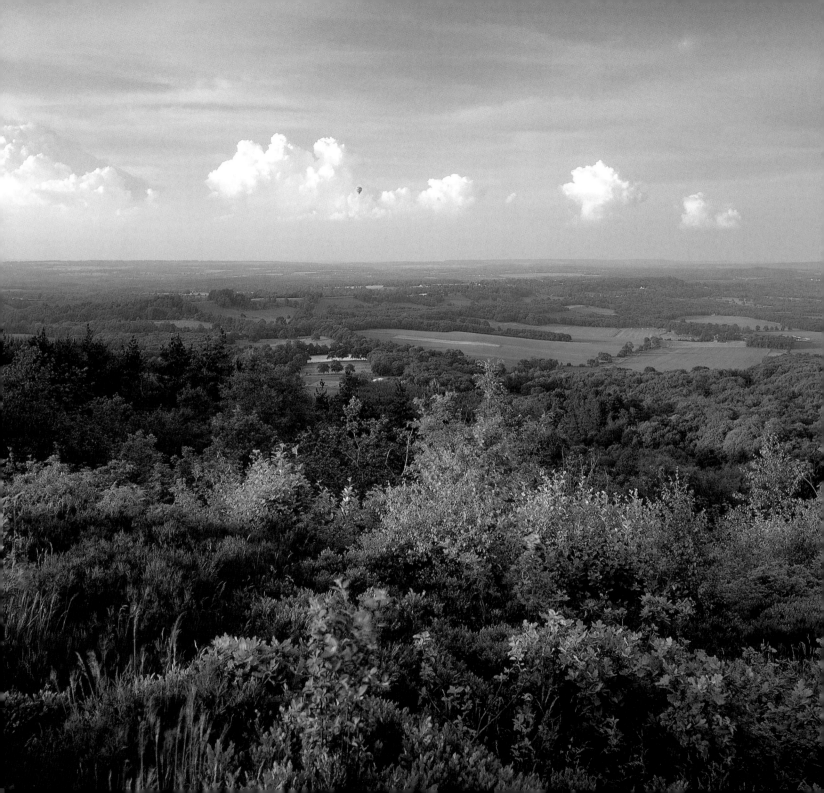

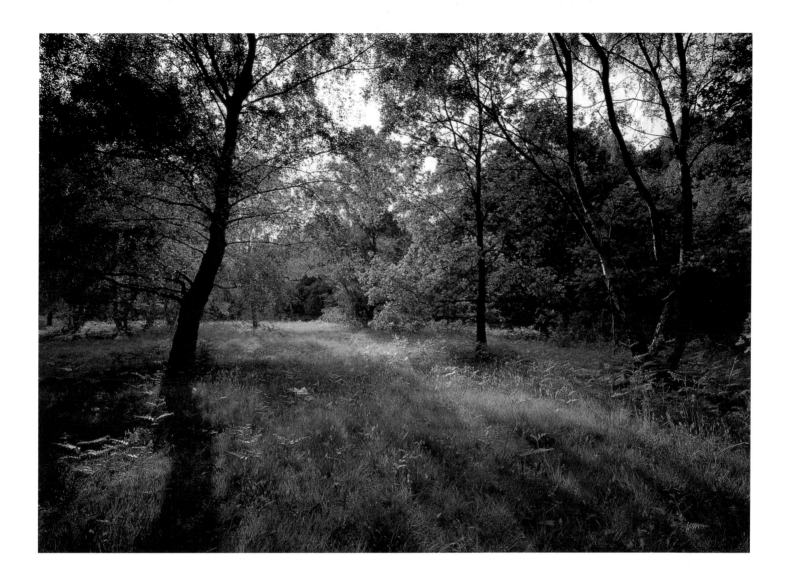

Left: Little Pond on FRENSHAM COMMON in Surrey. The presence of water in a sandy area is explained by the fact that this was an iron pan, used as a hammer pond when Frensham, on the edge of the Weald, was an industrial site in the seventeenth century.
 Now the two ponds at Frensham are visited by migrant birds. The famous naturalist, Gilbert White of Selborne, recorded in a letter dated 7 May 1779, ' In the last week of last month, five of the most rare birds, too uncommon to have obtained an English name, but known to naturalists by the term of *himantopus* were shot upon the verge of Frensham Pond.... These birds are of the plover family, and might with propriety be called stilted plovers'. [JC]

Above: BOOKHAM COMMON is a large area of wooded common-land linked by a network of ancient routes. In the Middle Ages it belonged to the monks of Chertsey Abbey who grazed their pigs here and stored their fish in the ancient ponds. Now it is an area rich in natural history, renowned particularly for its insects, birds and wetland plants. [JC]

The ASHRIDGE ESTATE on the north-eastern end of the Chilterns in Hertfordshire consists of 4,000 acres (1,600 ha) of wonderfully varied landscape including farmland, common, down and woodland. It came to the National Trust in 1925 after Stanley Baldwin, then Prime Minister, made valiant appeals to the vendor's trustees, wealthy donors, and local people – including the children of the six village schools. Their response sealed the success of one of the great conservation campaigns of the day.

Right: One of the ancient pollarded trees that makes up Frithsden Beeches at Ashridge. [PW]

Far right: Grassy tracks invite walkers through the woods near Coldharbour Farm. [PW]

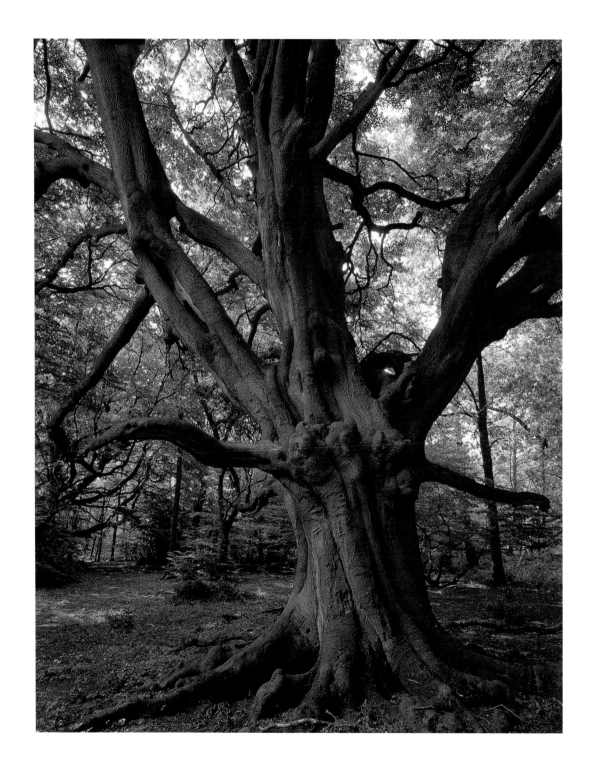

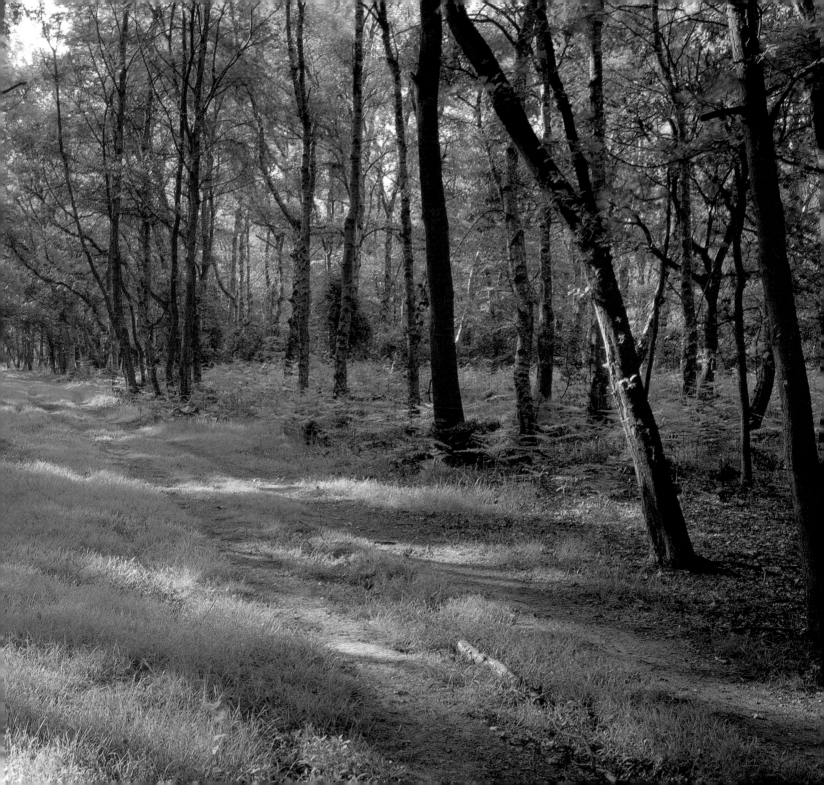

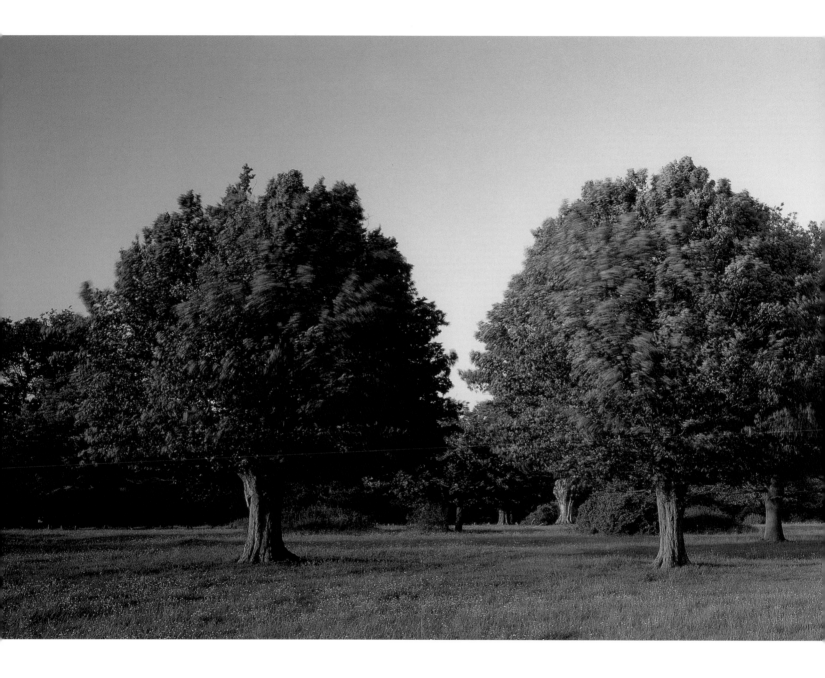

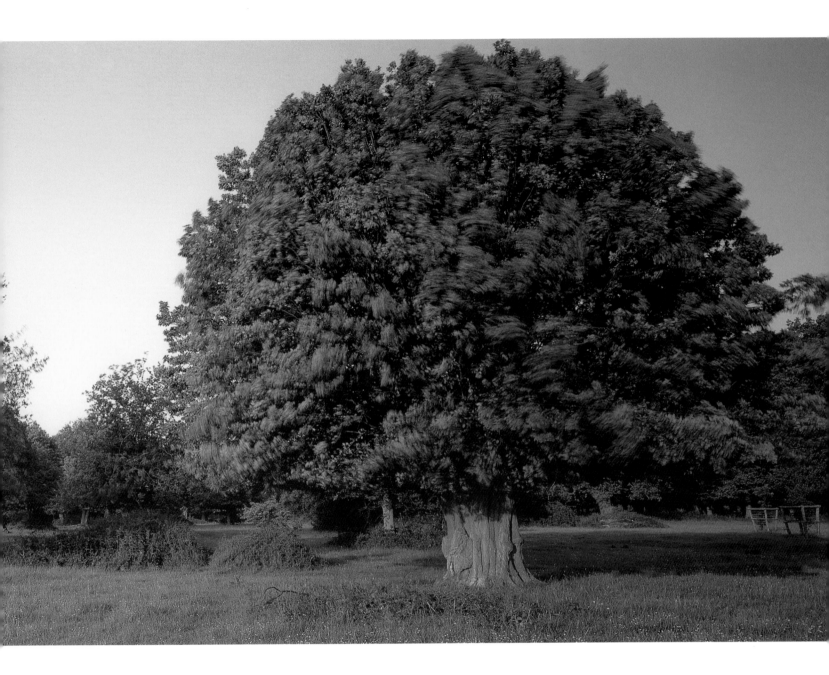

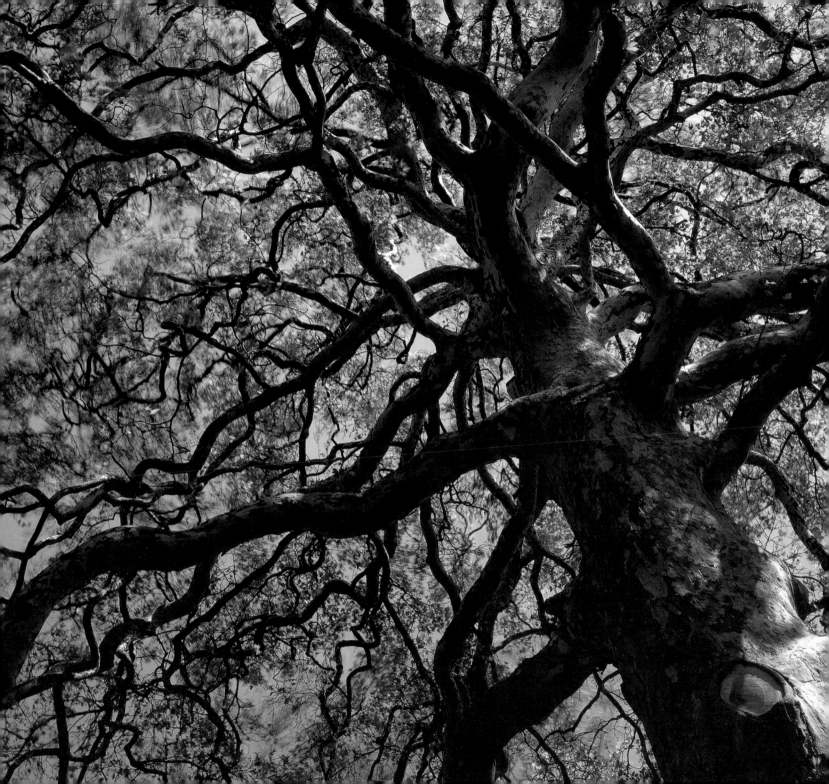

Previous pages: HATFIELD FOREST is the last remnant of the great medieval Forest of Essex, hunting preserve of the Norman kings. Just over 1,000 acres (400 ha) of woodland survive, broken up into sections separated by permanent wood banks and chases, wide grassy rides. The forest's long continuity has resulted in a wide variety of native trees and shrubs. This photograph shows three of the pollarded hornbeams that are such an important feature of the forest.

Right: Sunlight viewed through a horse chestnut. [PW]

Left: Looking through the branches of an ornamental plane tree. These trees provide habitats for a variety of rare insects. [PW]

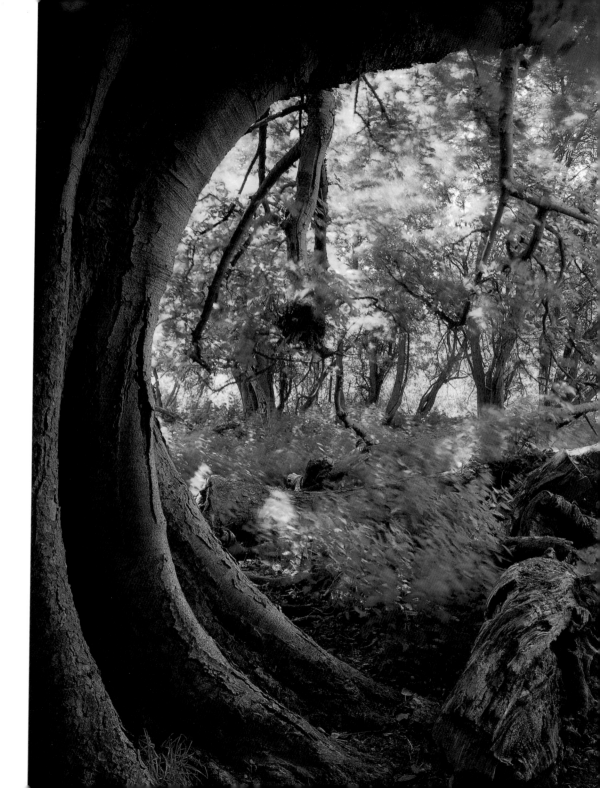

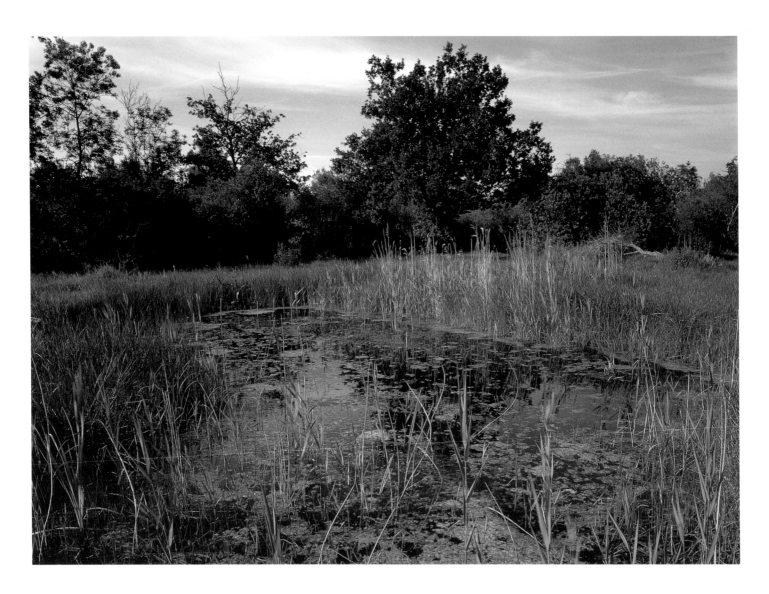

One of the first properties discussed by the National Trust was WICKEN FEN in Cambridgeshire. Wicken represented the only substantial area of undrained East Anglian fenland. Its proximity to Cambridge meant that it had become an outdoor laboratory for enthusiastic entomologists, who were inadvertently destroying the very wildlife they sought to study. The first two plots of Wicken were bought in 1899, and the Trust duly acquired its first nature reserve.

Right: Pink hemp agrimony and white meadowsweet growing up through the common reed which lines Wicken Lode. The reed is the dominant species of the fens, cut annually for thatching. [PW]

Above: The pond viewed from the hide. With the help of the RSPB, the Trust has inaugurated a Fenland Restoration Project to encourage the proliferation of birds such as bittern, warblers, heron and water rail. [PW]

Overleaf: The Tower Hide at Wicken. This photograph shows a habitat now extremely rare in the fens, a 'litter' field. 'Litter' is a mixture of grasses and some reed which is cut every year, or once every two years, for hay. Such a regime provides a wealth of wild flowers: seen here are purple and yellow loosestrife and pink hemp agrimony. [PW]

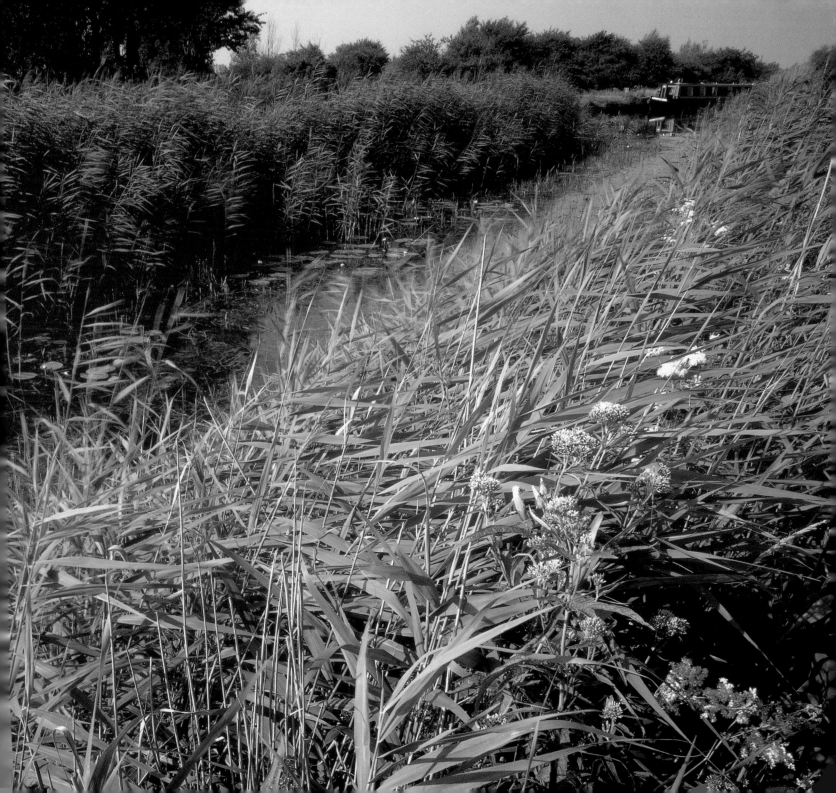

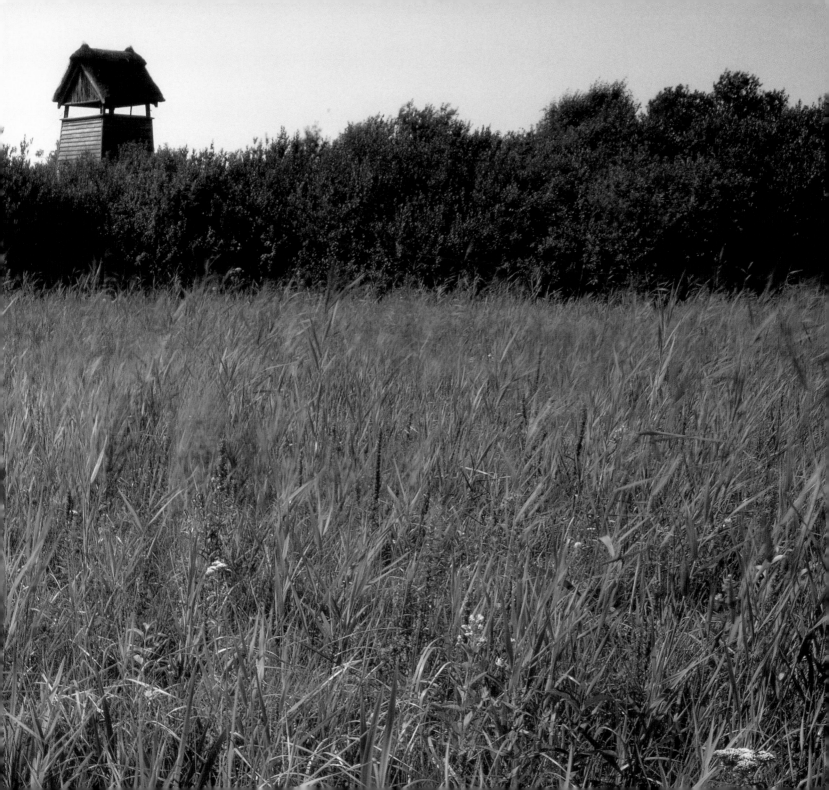

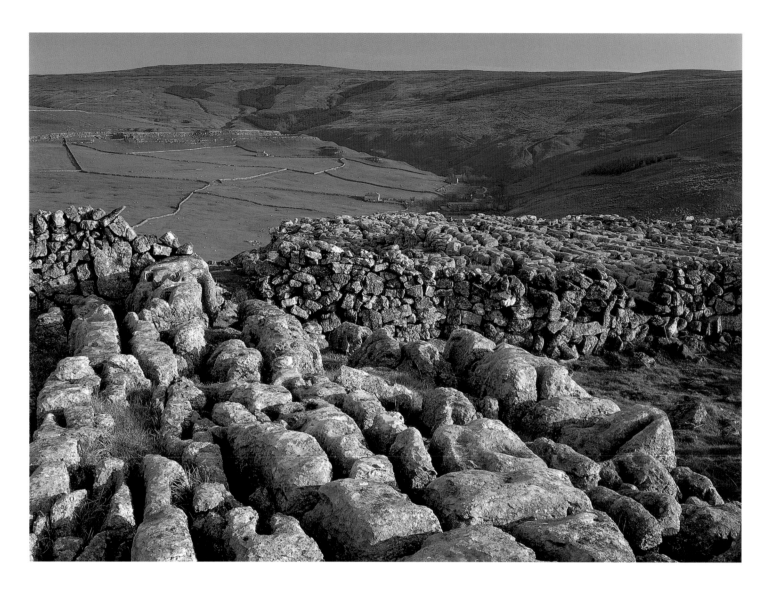

DARNBROOK FARM in the North Yorkshire dales is a limestone landscape, eroded by the action of rain water. *Above:* A detail of limestone pavement on Cowside, with Darnbrook Fell in the distance. The clints and grykes are now protected under a 'limestone pavement order' to stop them being removed to garden centres, where they have proved all too popular. [JC]

Right: COWSIDE BECK, once grazed by cattle but now almost entirely given over to sheep. [JC]

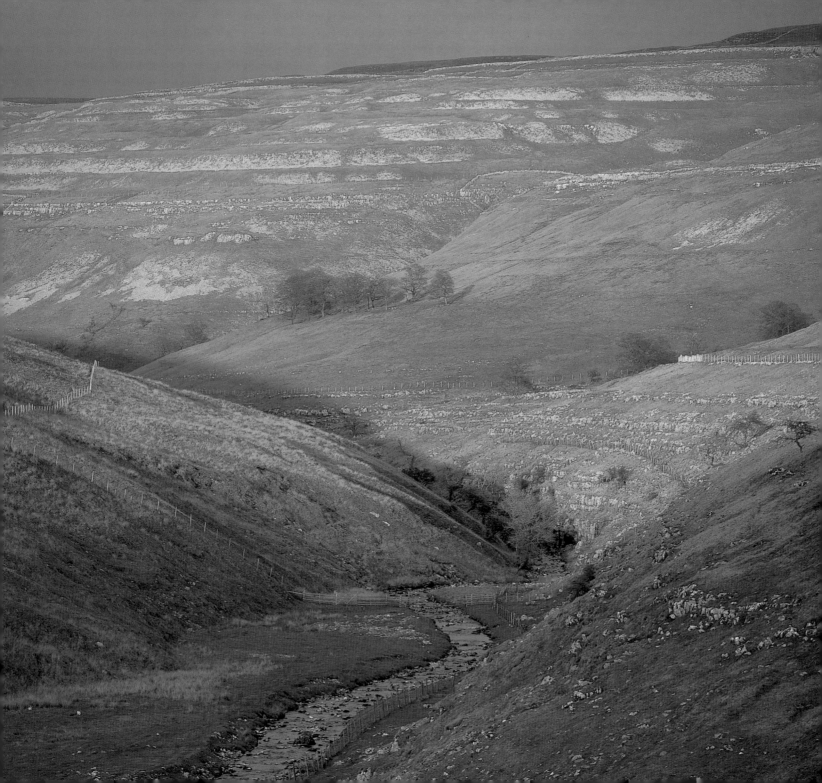

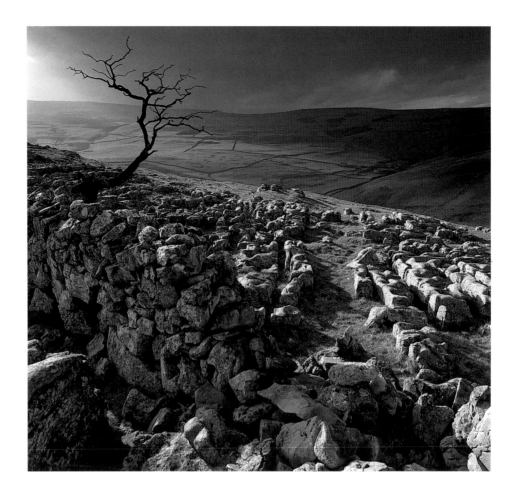

Above: Limestone pavement and dry-stone walling at DARNBROOK. These walls are probably two or three hundred years old, constructed with stones cleared from the fields, and interlocked with no mortar but much skill. The National Trust organises working holidays to repair them. [JC]

Right: Ice formations on HARDCASTLE CRAGS, created by Hebden Water as it drains the Heptonstall and Wadsworth Moors of West Yorkshire and tumbles down to join the River Calder at the picturesque woollen town of Hebden Bridge.

Red squirrels can still be found in the woods of oak, larch and pine planted by the Savile family, and given to the National Trust in 1950. For years the Crags have been a green lung for the mill workers of Halifax and Rochdale. [JC]

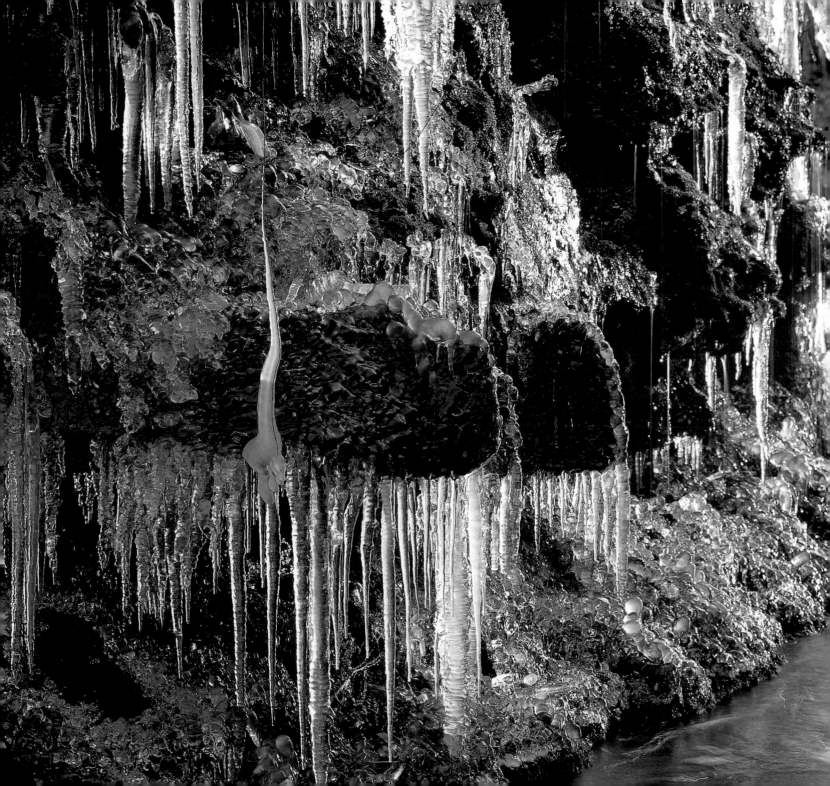

UPPER WHARFEDALE, near Burnsall in North Yorkshire, with a farm nestling into its surroundings. The local limestone has been used for its buildings and for the dry-stone walls that divide the fields: the true meaning of vernacular architecture.

Wharfedale has been farmed since prehistoric times, and the mosaic of fields has been traditionally used for a mixture of crops and sheep grazing. The National Trust owns nine upland farms, a former deer park, and stands of ancient oak woodland on the valley sides. The traditional way of farming has been allowed to continue, preserving unimproved pasture and wildflower meadows. [DN]

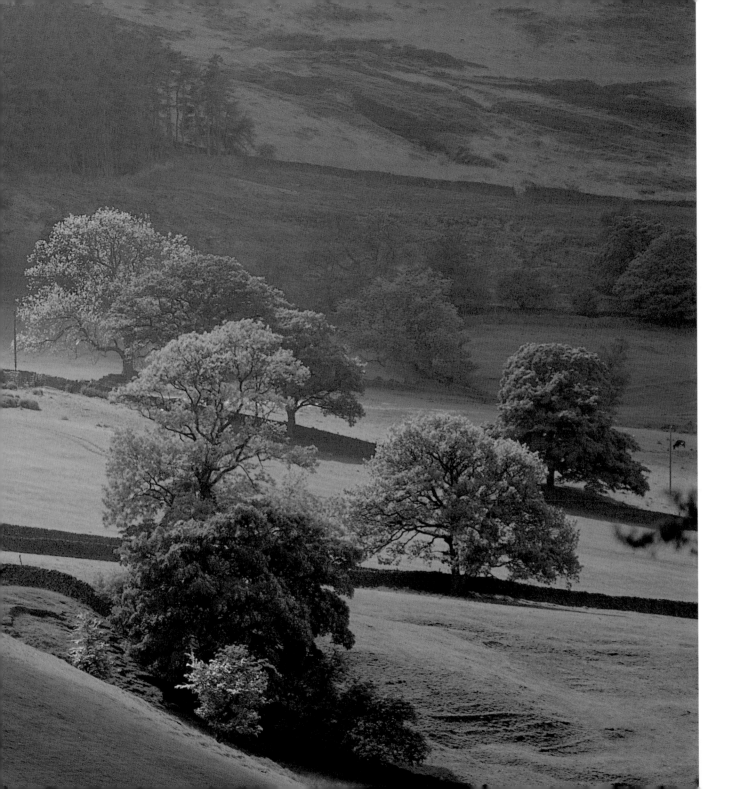

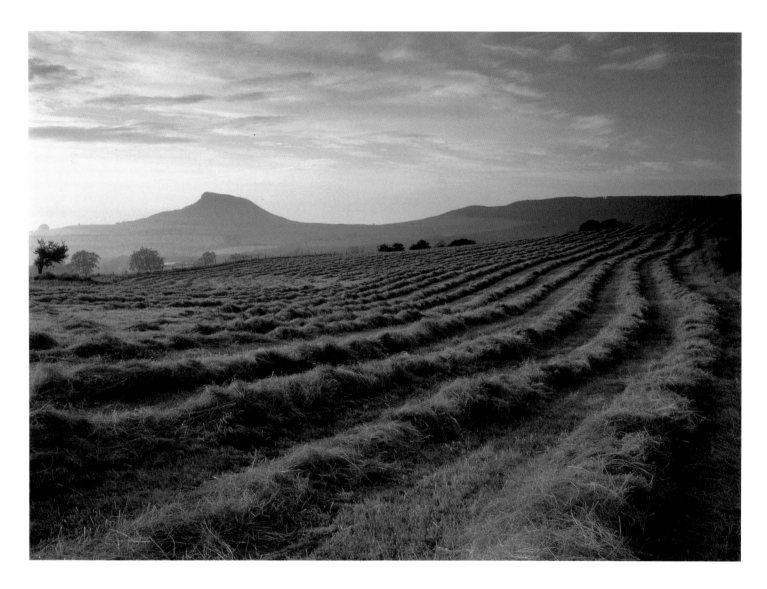

ROSEBERRY COMMON in autumn and icy midwinter.
Above: Harvested fields at Little Ayton, with the pyramidal outline of Roseberry Topping, rising 1,057 feet above sea level, providing a picturesquely named and familiar landmark for the heavily populated area of Teeside. [JC]

Right: Snowdrifts in the lee of dry-stone walls, with Roseberry Topping on the right and the Cleveland Hills beyond. [JC]

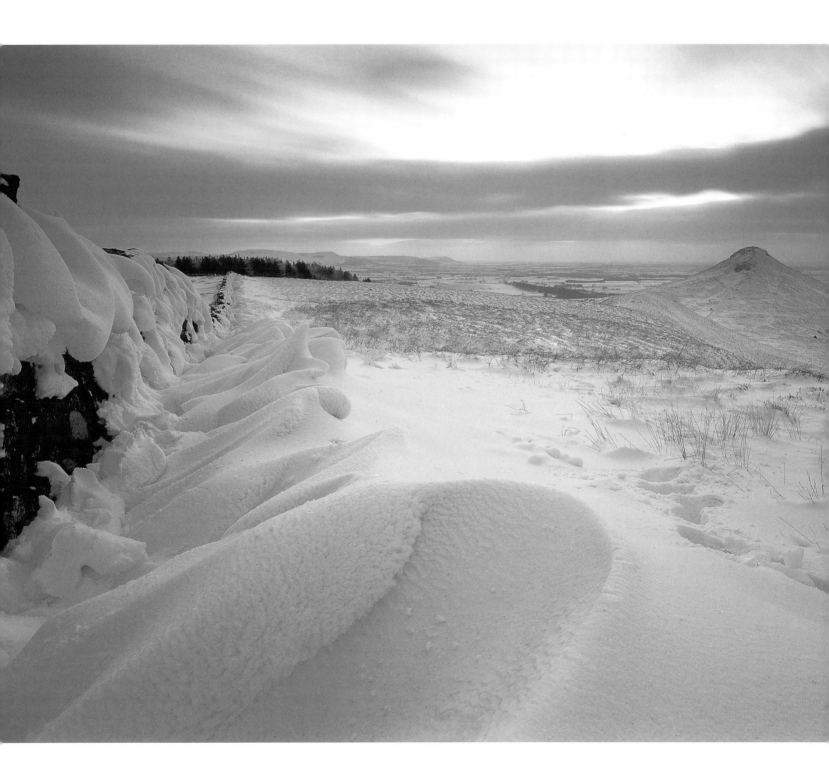

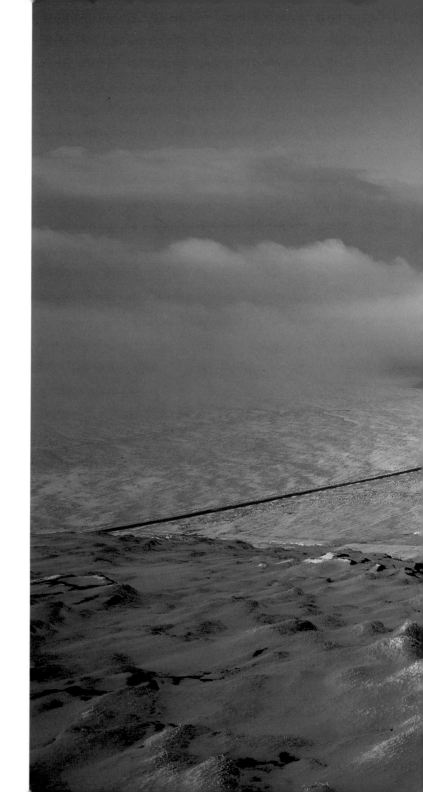

MARSDEN MOOR in West Yorkshire forms part of the Peak District and the scenery for BBC TV's *Last of the Summer Wine*. Here shown in bleak midwinter, in summer its bleakness is not greatly diminished, with a peat blanket providing habitat for mosses and moorland grasses, for curlew and golden plover. [JC]

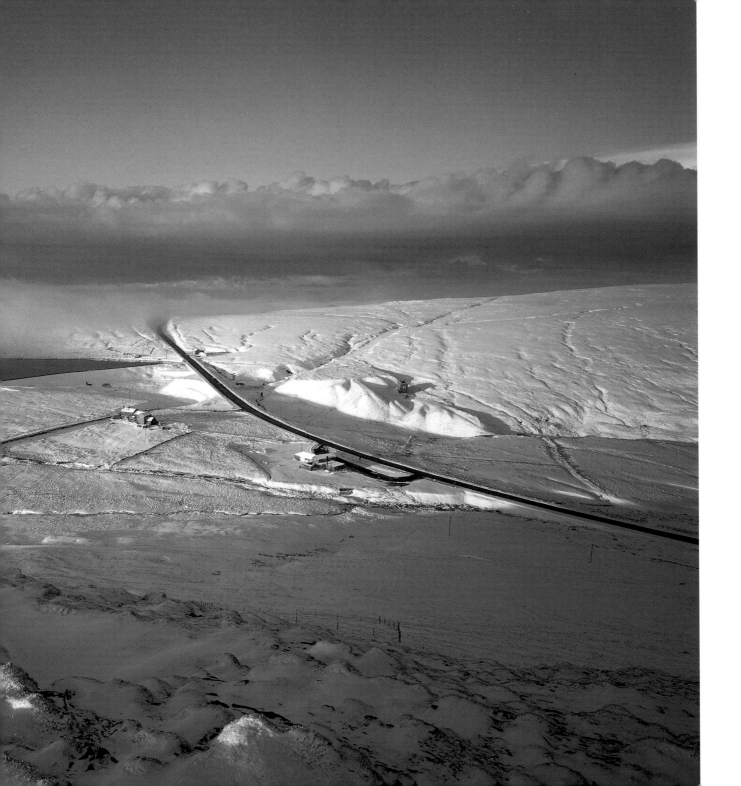

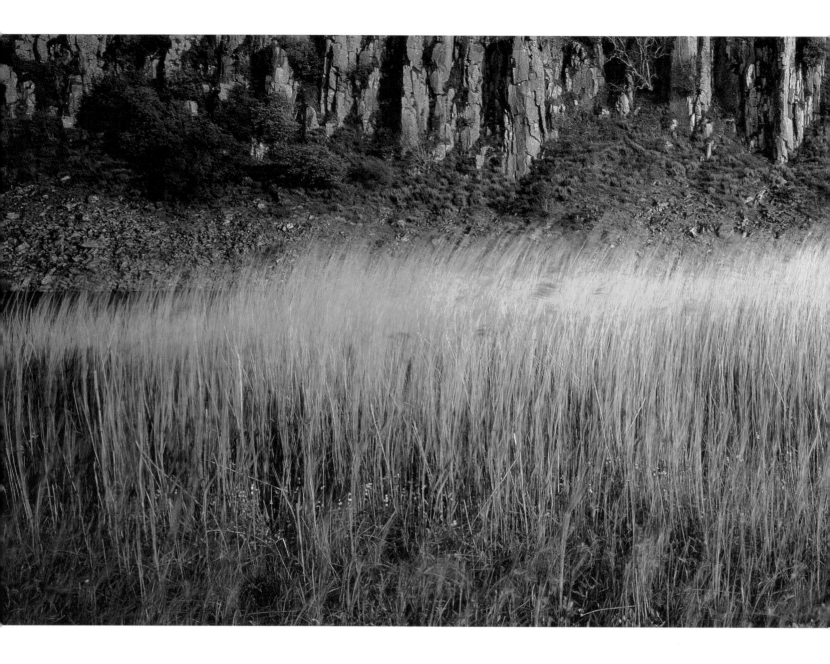

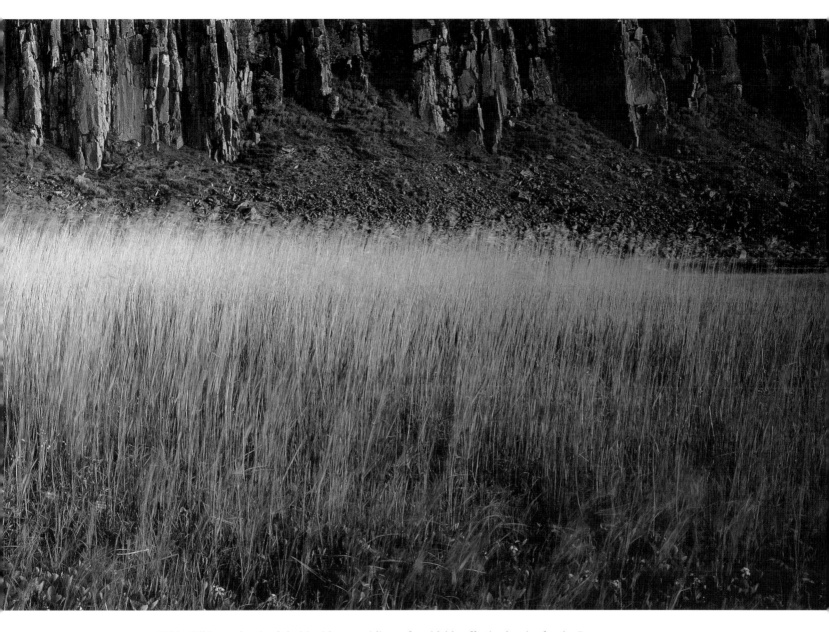

Whin Sill is a volcanic, doleritic ridge providing a formidably effective barrier for the Romans to construct HADRIAN'S WALL, and running through to the Farne Islands off the Northumbrian coast. This photograph shows Crag Lough, one of a series of little loughs below the Sill, with stands of common reed (*Phragmites australis*). [PW]

Right: SYCAMORE GAP on Hadrian's Wall. This tree took a starring role in Kevin Costner's film, *Robin Hood, Prince of Thieves.* [JC]

Far right: The Roman fort of Housesteads on HADRIAN'S WALL, looking out towards Sewingshields Crags. In the foreground is the South Granary: the stone piers supported wooden ventilated flooring for the storage of grain. [PW]

Following pages: When the Emperor Hadrian ordered the building of a wall from the Solway Firth to the mouth of the Tyne in AD 122, the Roman Empire was at its height, stretching from this northern outpost east to what is now Iraq, and south to the Sahara Desert. Whin Sill provided a craggy northern face to set against the Picts; the gentler southern slopes led toward the civilised world. This photograph shows part of the most dramatic section of HADRIAN'S WALL, winding its way across the landscape, with the blue of Crag Lough in the distance. [PW]

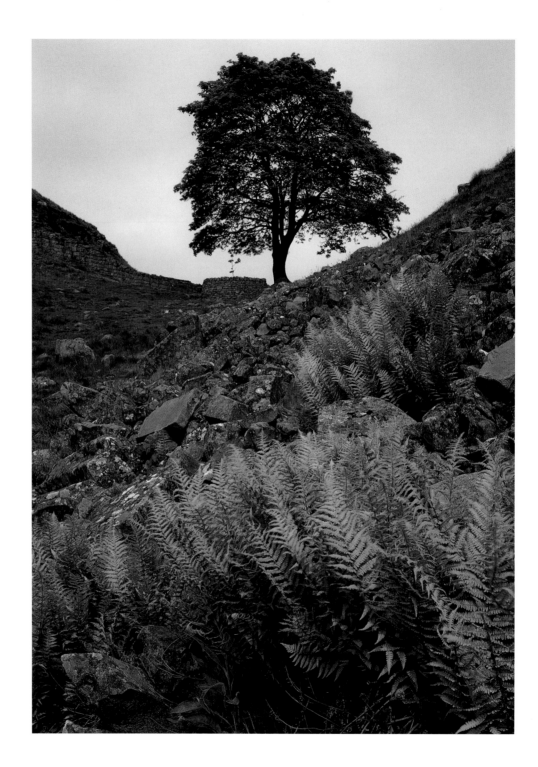

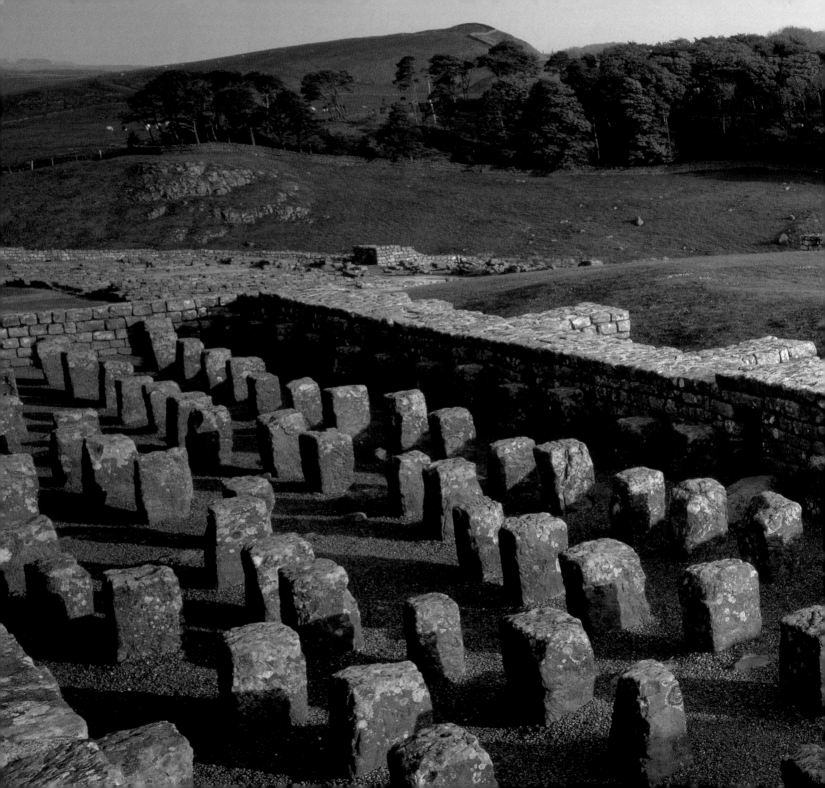

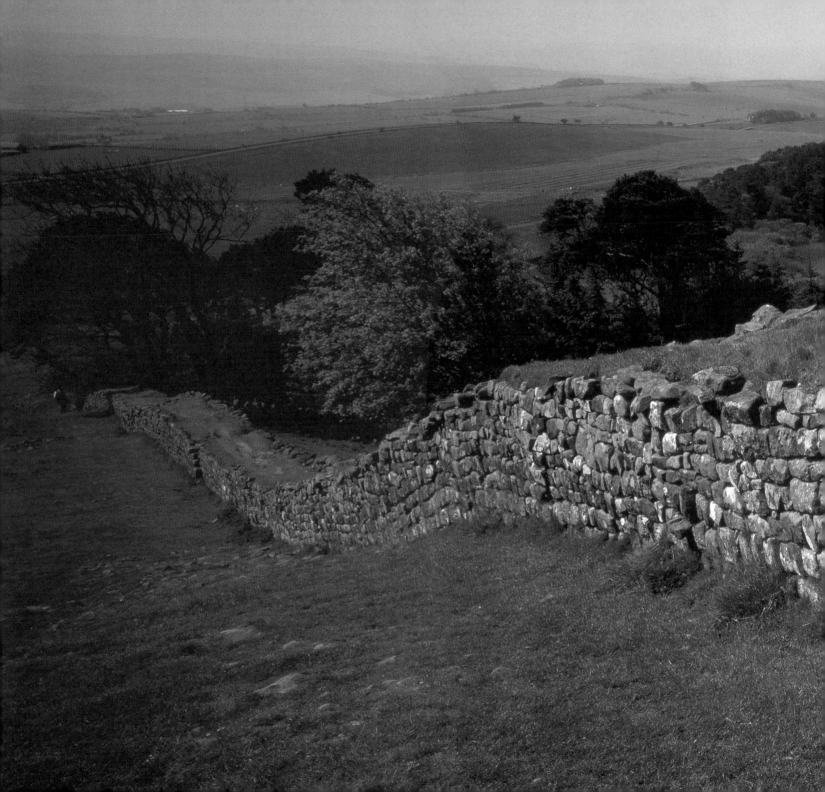

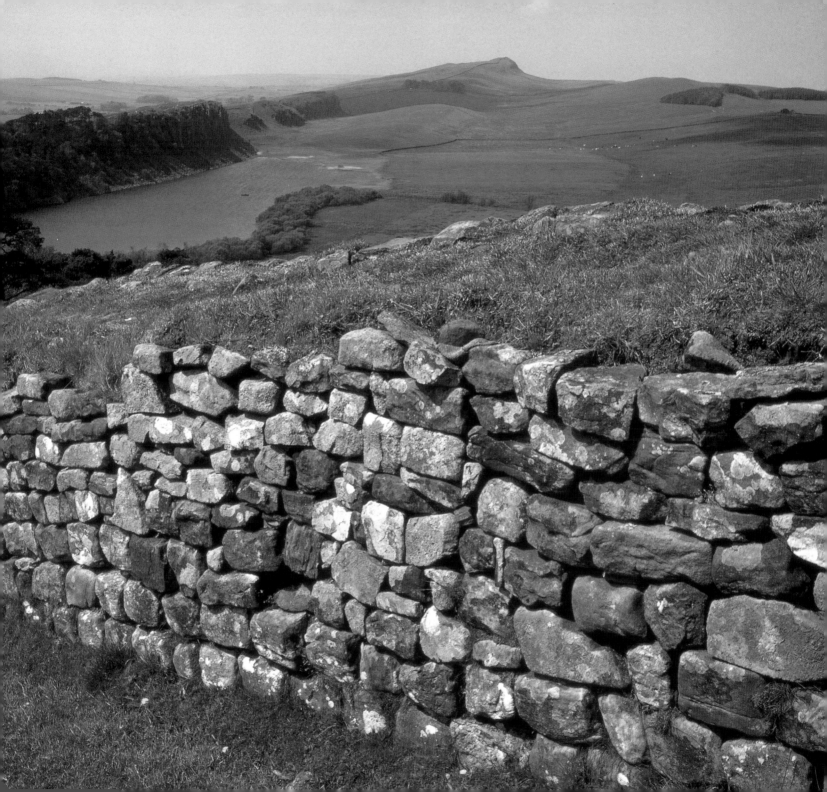

The wide expanse of Rhossili Beach, a favourite for surfers and hang-gliders. The more intense yellow section below the Down is a dune system known as the Warren, which covers a lost village, abandoned in the early fourteenth century, probably as a result of economic decline and the gradual encroachment of the sand. [JC]

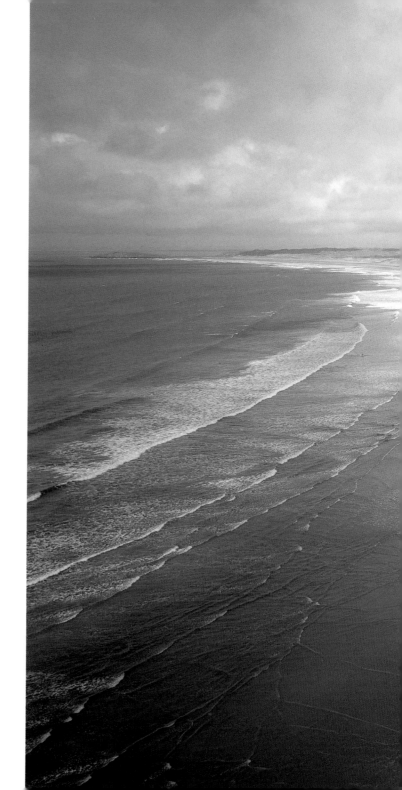

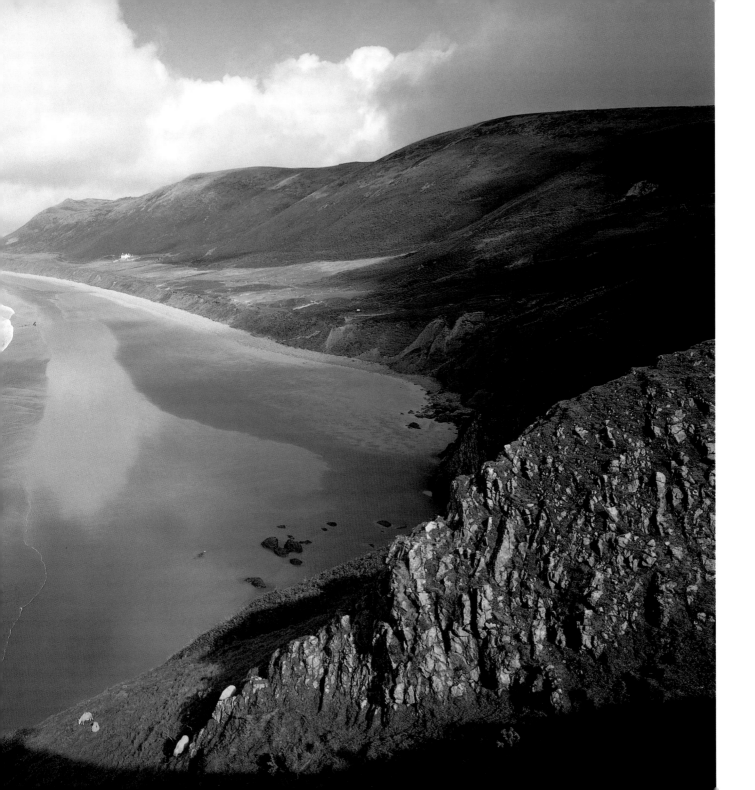

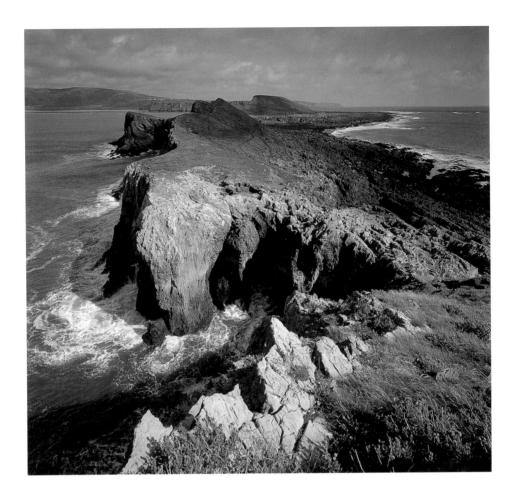

WORMS HEAD is a mile-long finger pointing west from Rhossili. At low tide it is possible for walkers to go from Inner Head to Middle Head, and then on, via the Devil's Bridge, a natural limestone arch, to the Outer Head. At high tide the sea swirls round each outcrop so that all that breaks the surface are the head and humped coils of the *wurm*, Old English for dragon or serpent.

Above: The view from the Outer Head, looking towards the mainland. For centuries sheep have winter grazed on the Inner and Middle Heads, which is said to account for their excellent flavour. [JC]

Right: From Rhossili and Worms Head, the coast turns east to Tears Point and the limestone outcrop of THURBA HEAD, a majestic headland 200 feet in height with an Iron Age fort on its western flank. [JC]

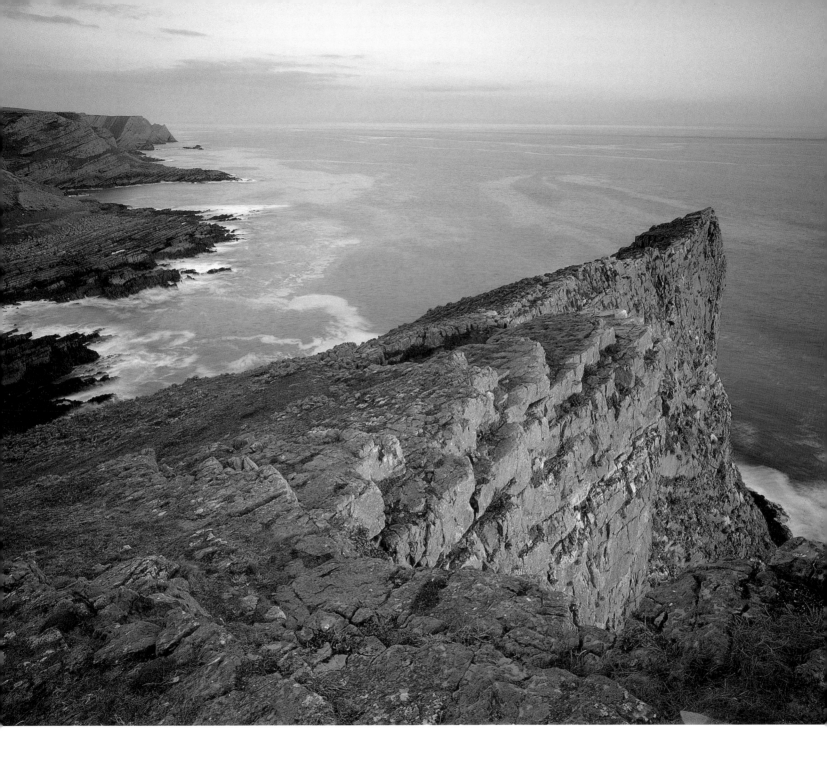

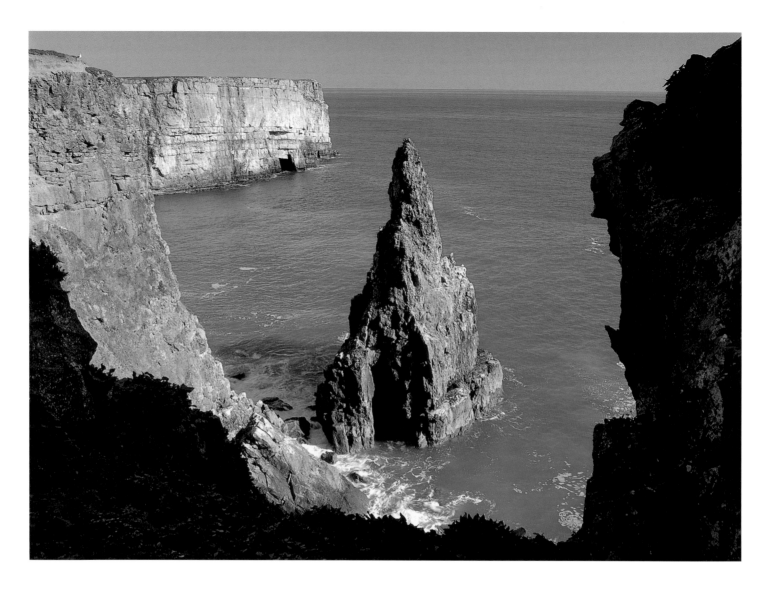

STACKPOLE in Pembrokeshire was a great coastal estate belonging to the Scottish Earls of Cawdor. The Cawdors dammed the valleys to create three lakes meeting above the sandy beach at Broad Haven, a man-made landscape of great beauty. But the sea-cliff landscape is equally beautiful, and natural, providing a habitat for the huge breeding population of sea birds – auks, kittiwakes, fulmars and gulls. In February 1996 the birds and marine environment on this coast were badly affected by the oil spill from the tanker, *Sea Empress*. Although National Trust staff and volunteers helped to clean the birds and the beaches, the long-term implications are still being closely monitored.

Above: Looking out from Stackpole south-east to Mowingword. [JC]

Right: The spectacular cliffs are used for rock climbing from the Outdoor Pursuits Centre based at Stackpole. [JC]

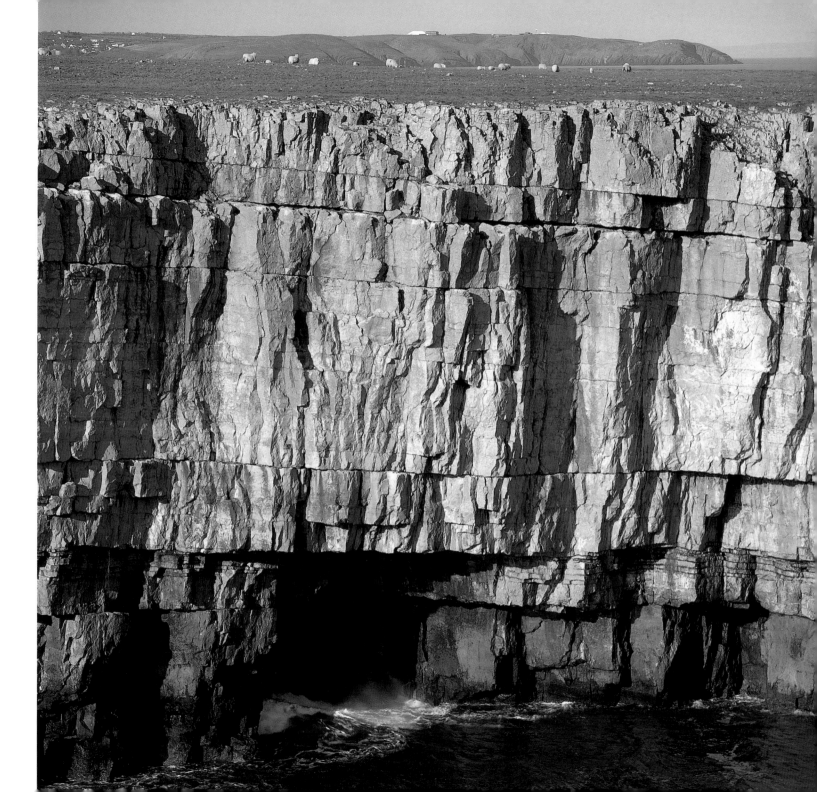

The headland of DINAS FAWR looking towards the islands of The Mare, Green Scar and Black Scar. This is an exposed site, with the wind and weather keeping the vegetation low. In the foreground the purple sheen on the gorse is a symbiotic plant, dodder. [JC]

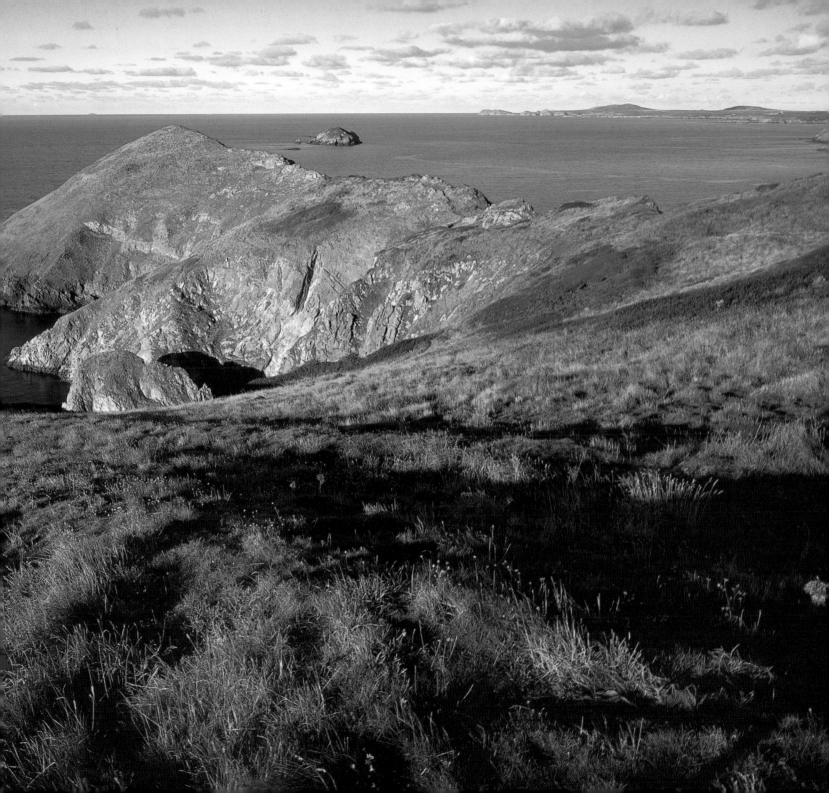

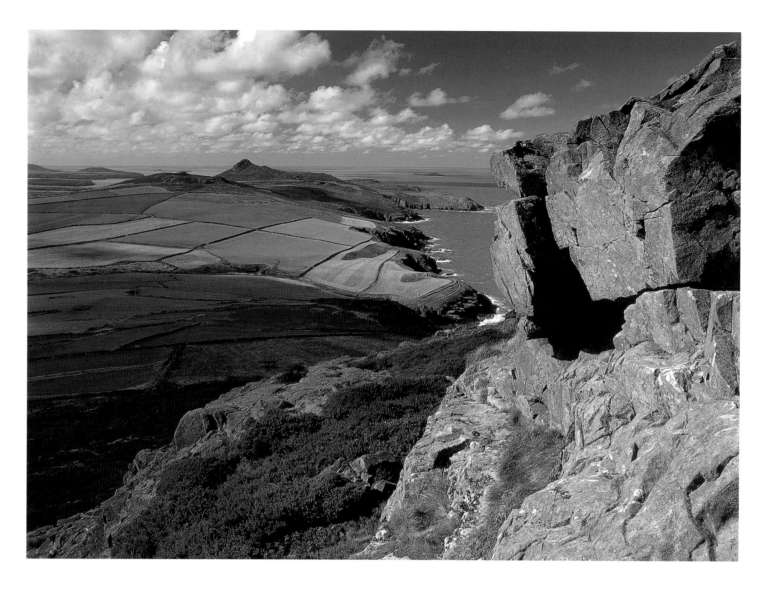

The National Trust began to acquire parts of the beautiful Pembrokeshire coast in 1939. At first scattered pieces of the jigsaw were bought, and then gradually linked up, providing a stretch of over fifteen miles of rugged cliffs, inaccessible coves and sandy bays. Walkers on the coastal path can observe large colonies of sea birds and, offshore, basking dolphins and porpoise.

Above: ST DAVID'S HEAD and the ancient field systems of Carn Llidi. [JC]

Right: WHITESANDS BAY, looking south-east to Porth-Clais. [JC]

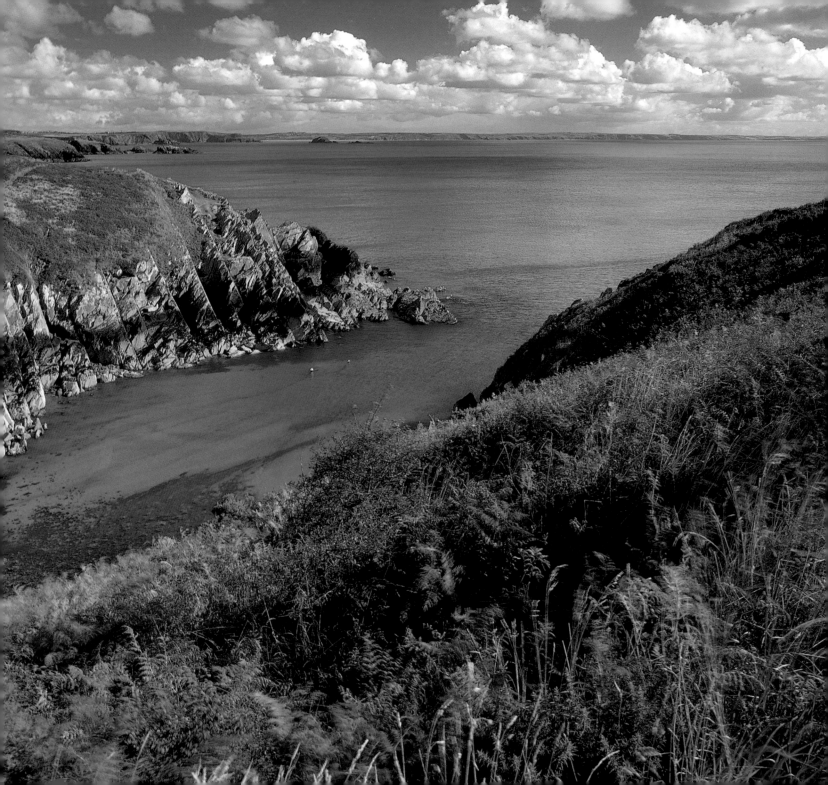

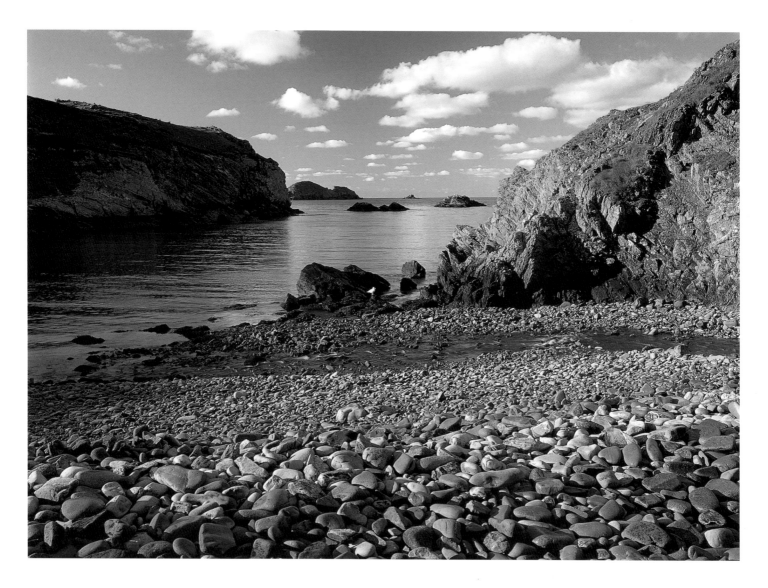

Above: UPPER SOLVA. The area around Solva is rich in archaeological remains. Some of the Neolithic flints found here show evidence of man's habitation for the last 4,000 years. Four of the ramparts of the Iron Age Fort of Castell Penpleidiau are still clearly visible. [JC]

Right: YNYS BARRI where the Trust owns two miles of the coastline between Abereiddy and Porthgain. This area is characterised by its beaches of grey sand, from fine particles of slate pounded by the sea. The harbour is known locally as Blue Lagoon because the clear waters are turned Mediterranean blue by the reflection from its slate walls. [DN]

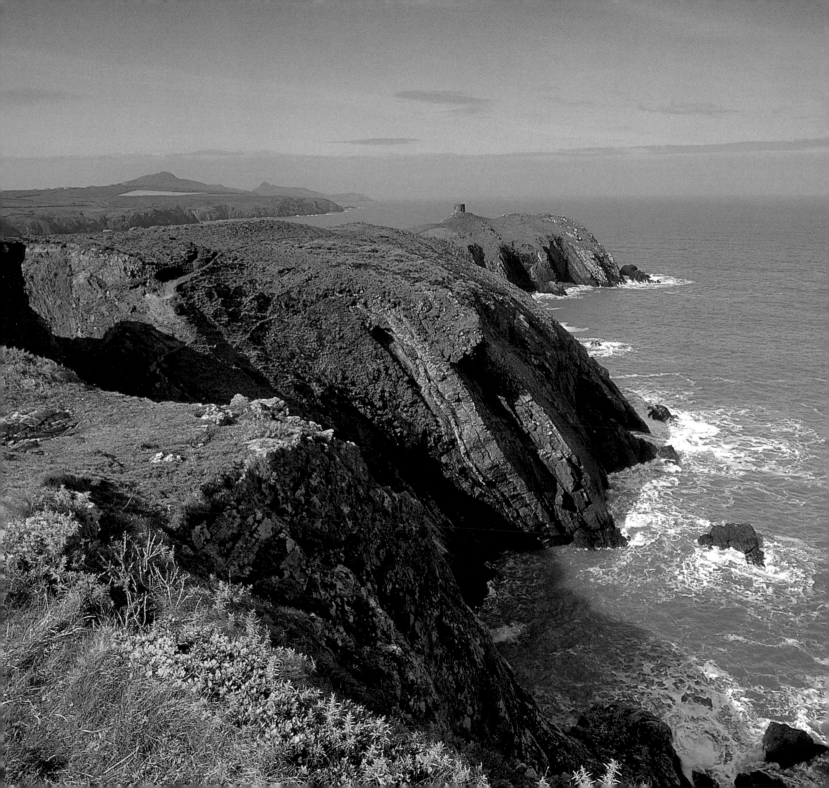

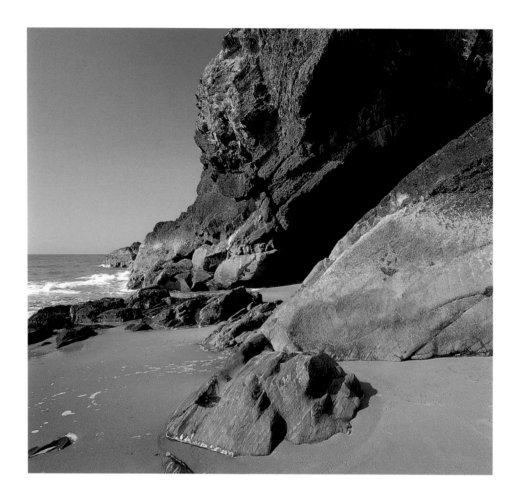

PENBRYN, on the Ceredigion coast.
The beaches here are particularly suited
to bathing and family holidays. [JC]

Behind the little bays are wooded valleys
with running streams – it is important
that the Trust looks inland whenever
possible, and protects the hinterland
as well as the coast itself. [JC]

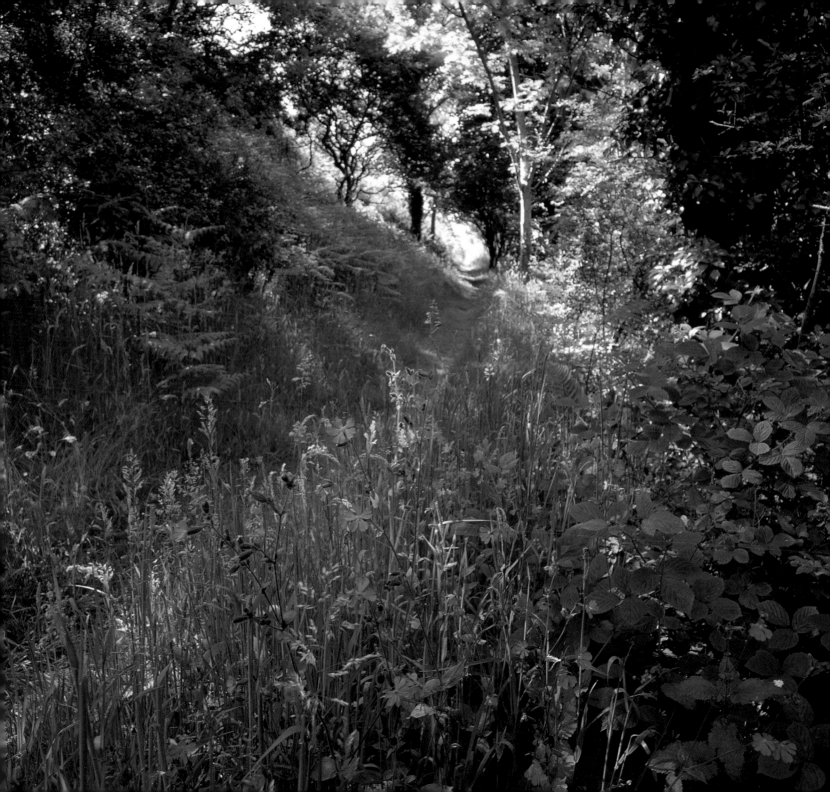

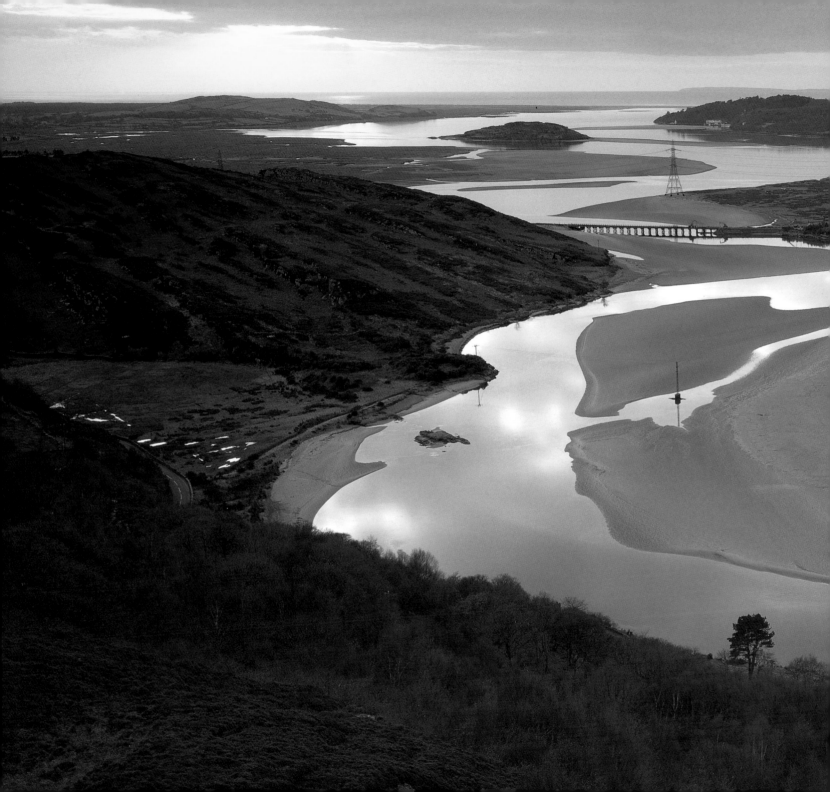

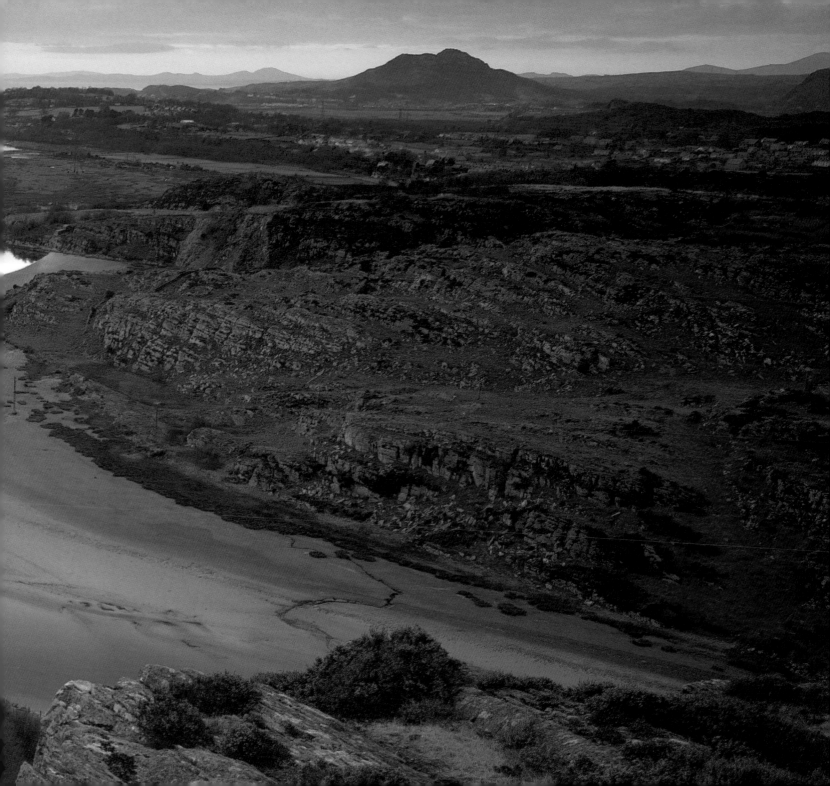

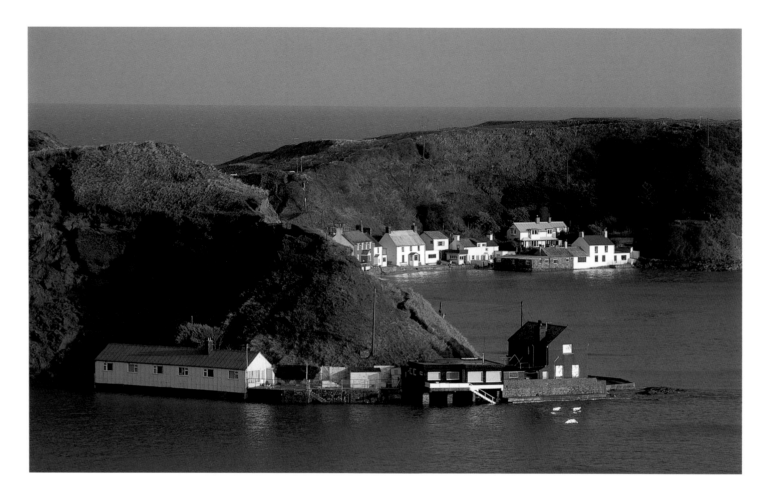

Previous pages: The wide estuary of the Dwyryd at HAFOD-Y-WERN combines extensive saltmarsh with outcrops of rock that are almost gorge-like, and a valley of grassland and oak woods. Formerly this was the site of the Cooke Explosive Works, established in 1865 to produce gunpowder for quarrying slate. Part of the Ffestiniog railway can be seen: this line transported Welsh slate to furnish roofs all over the world. [JC]

The National Trust is helping to ensure the protection of this spectacular estuary and is currently negotiating for the purchase of a large holding through an appeal to Enterprise Neptune donors.

Above: The tiny village of Porthdinllaen on the LLŷN PENINSULA can be reached only along the shore. While the National Trust may own considerable areas of coast, the sea-bed belongs to the Crown: the boundary is at high tide level. At Porthdinllaen the Trust, as harbourmaster, has leased the seabed.

PORTHDINLLAEN'S days as a commercial fishing village are over, but in earlier times it was contender for bigger stakes – the packet steamer trade to Ireland. Holyhead carried off the prize by one vote in Parliament, though it is still darkly maintained that the geological samples that clinched the decision really came from Porthdinllaen. [JC]

Right: BRAICH-Y-PWLL, on the western tip of the Llŷn, with Bardsey Island in the far distance. The north and south coasts of the Llŷn Peninsula are totally different in character: rocky and rugged on the north, long stretches of sand on the south. The peninsula itself has always been farmed, with small fields divided by stone walls known as *claddau*. John Leland, visiting this area in the 1530s, wrote that 'Al Llene is as it were a pointe into the se', and remarked on the doubling up of fishing and agriculture, with the farmers growing corn by the shore and on the upland. [JC]

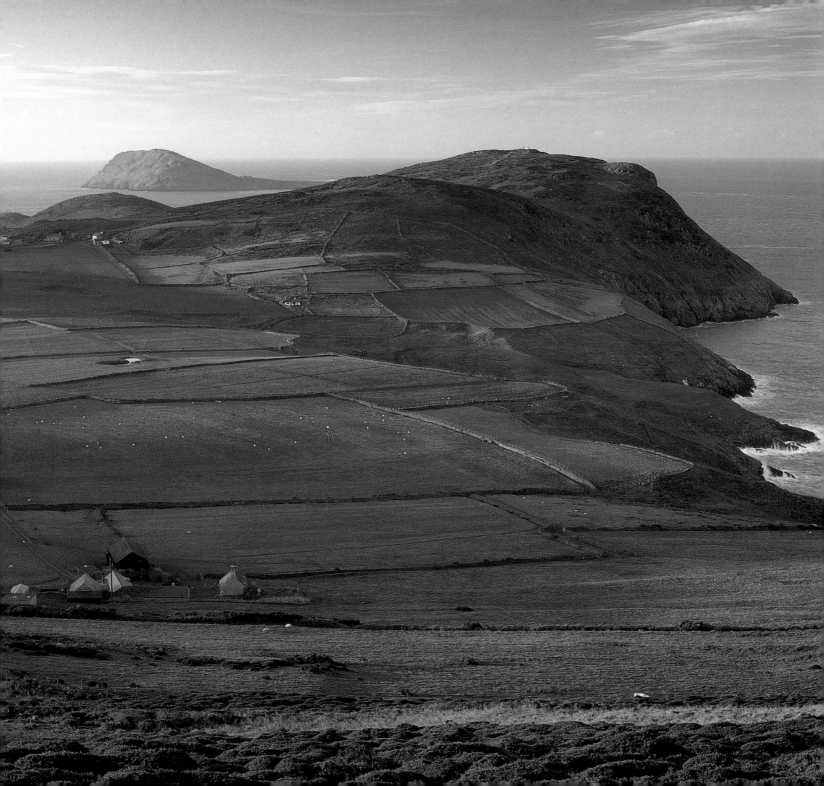

PORTHOR, known as Whistling Sands, from the screeching sound made by the dry sand when trodden on. The small sandy bay is backed by low cliffs rich in wild flowers, particularly orchids. [JC]

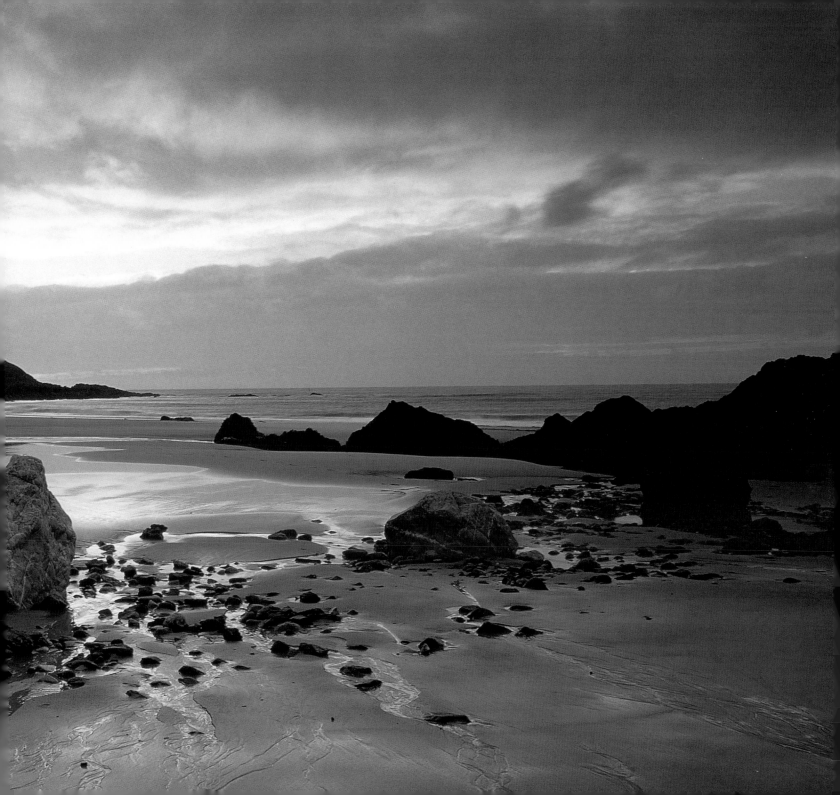

MURLOUGH, on the coast of County Down, was Northern Ireland's first national nature reserve. In the foreground are the sand dunes, which the Trust has planted with marram grass to make them stable. In the distance can be seen the dramatic outline of the famous Mountains of Mourne which, according to the traditional song, 'sweep down to the sea'. [PW]

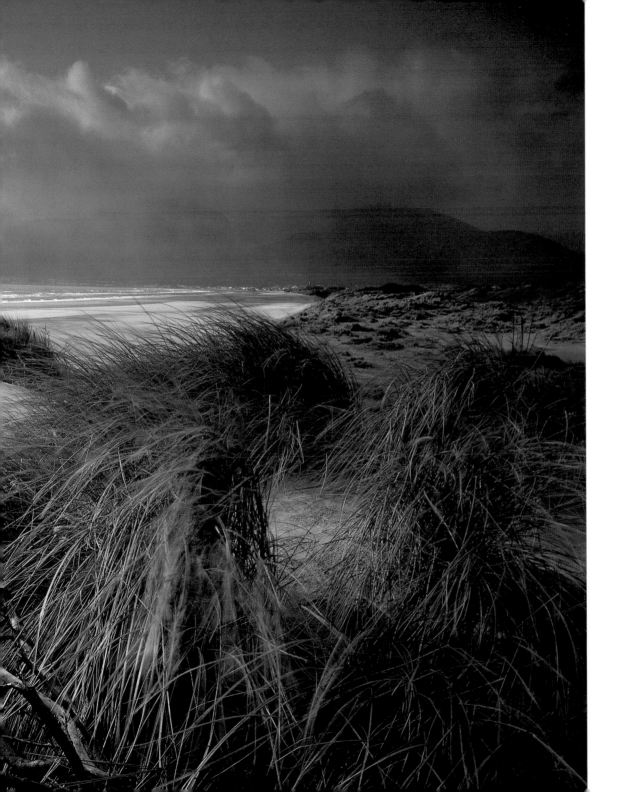

Right: Murlough is part of a large sand dune system which built up across the head of Dundrum Bay at the end of the last Ice Age. Evidence of man's settlement has been found from Neolithic times onwards. Seven hundred years ago the Normans introduced warrens of rabbits for their meat and fur, and thus determined the nature of the vegetation: intensive grazing has produced a short turf rich in wild flowers, such as the pyramidal orchid and dune burnet rose, with a few trees and shrubs. [JC]

Far right: The fishing village of Strangford on the western shore of the Narrows on the lough. STRANGFORD LOUGH, over twenty miles in length, is one of the largest sea inlets in the British Isles. In places it is five miles wide, but the Narrows form a bottleneck of less than half a mile where the lough joins the sea, creating treacherous currents. Herring, mackerel, whiting and skate are all fished here, while clams and oysters are farmed on the lough. [JC]

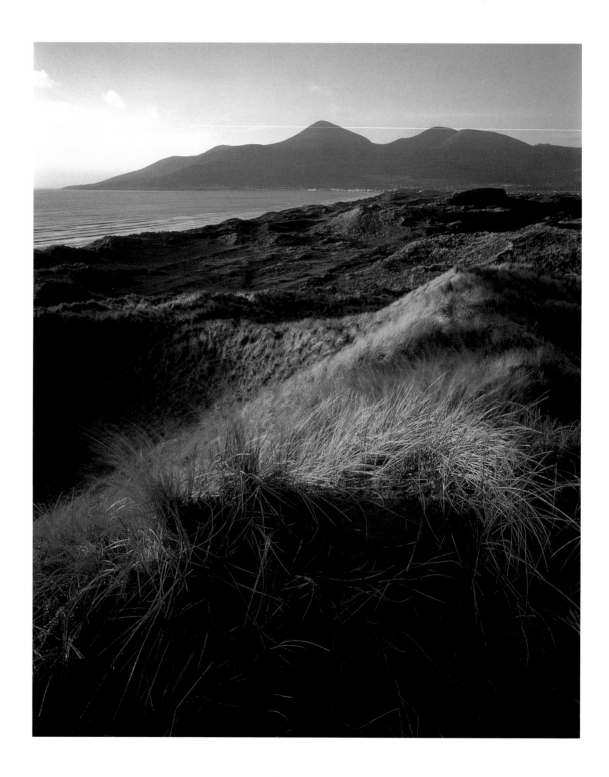

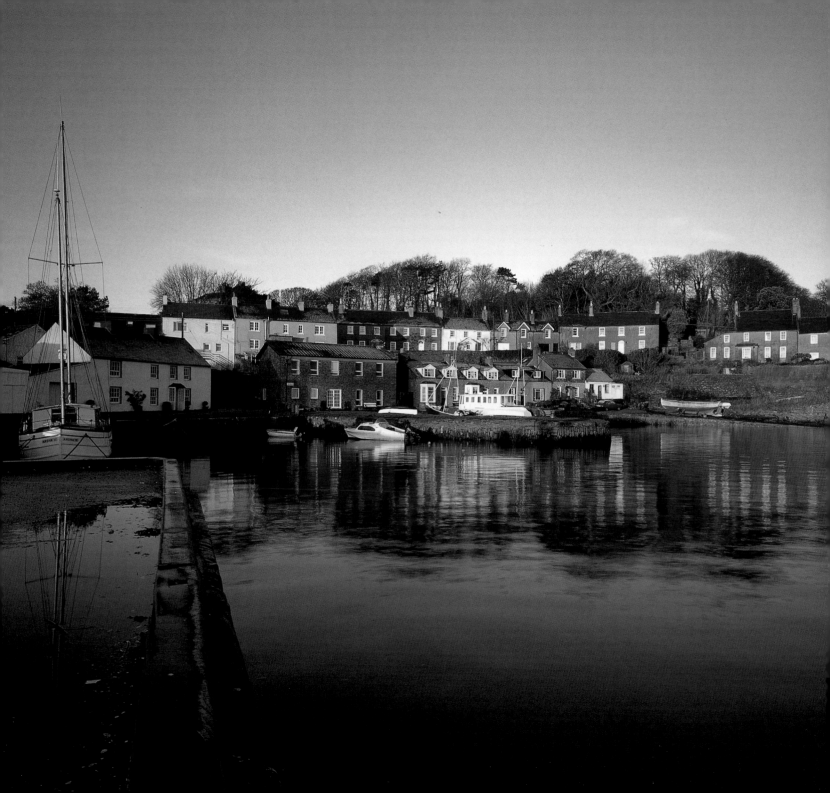

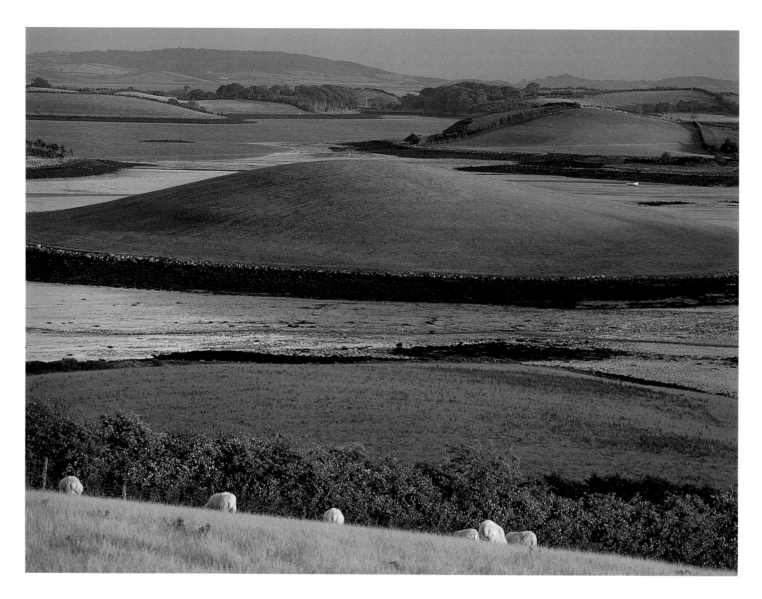

The low flat landscape of STRANGFORD LOUGH in late afternoon, and (*right*) at dawn. The drumlins, like semi-submerged flying saucers, are deposits dumped by the retreating ice sheets at the end of the last Ice Age. There are over a hundred of these islands and, together with the shoreline, they provide habitats for a huge and varied number of plant and animal species. Because of this wealth, the lough is a marine nature reserve, with the various organisations that own the foreshore working together on a management committee to ensure there are areas of sanctuary. [JC]

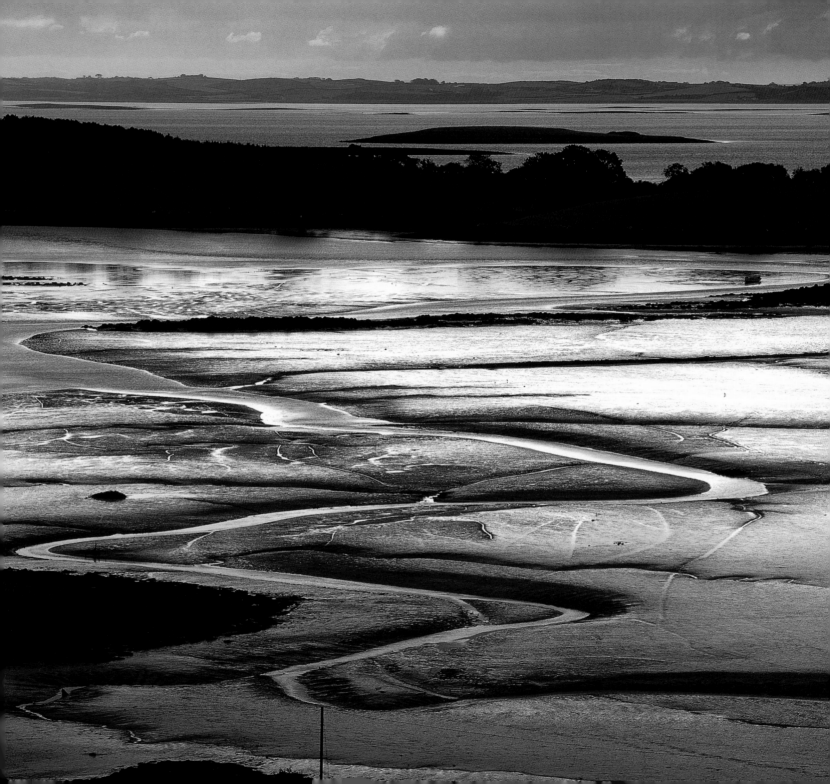

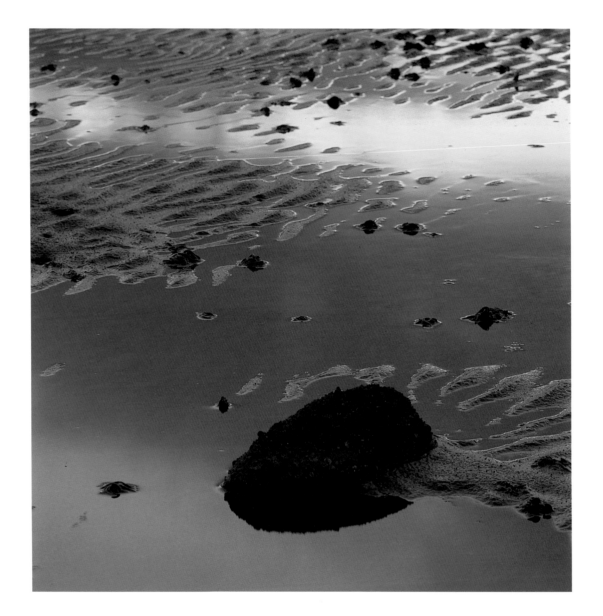

Right: BALLYMORAN BAY at sunrise with the mudflats exposed. This intertidal zone has been leased by the National Trust from the Crown Estate.
Left: The sun reflected in a tidal pool on the foreshore. [JC]

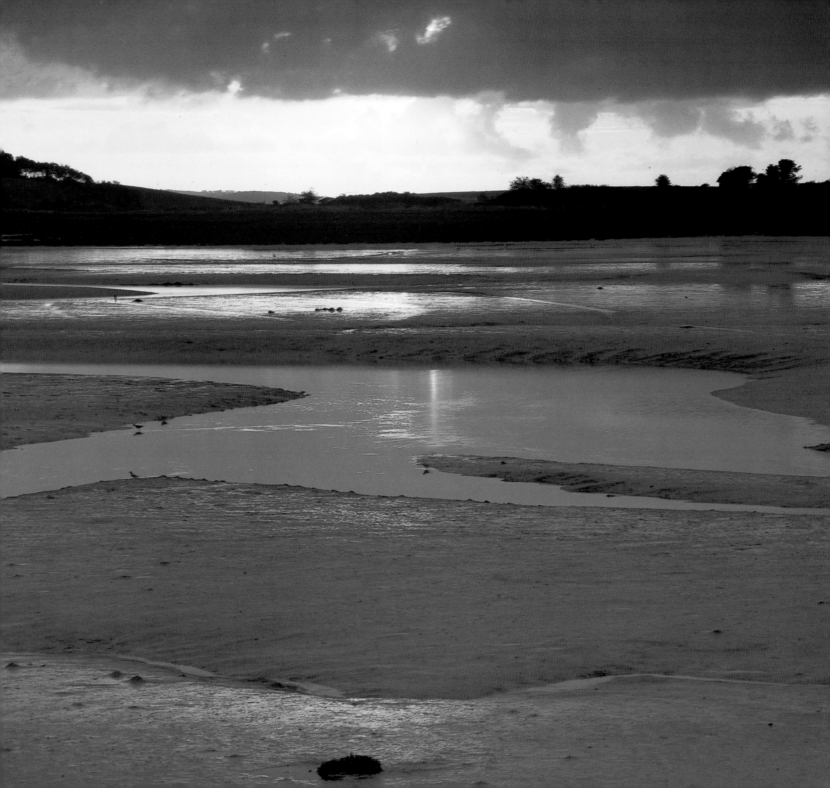

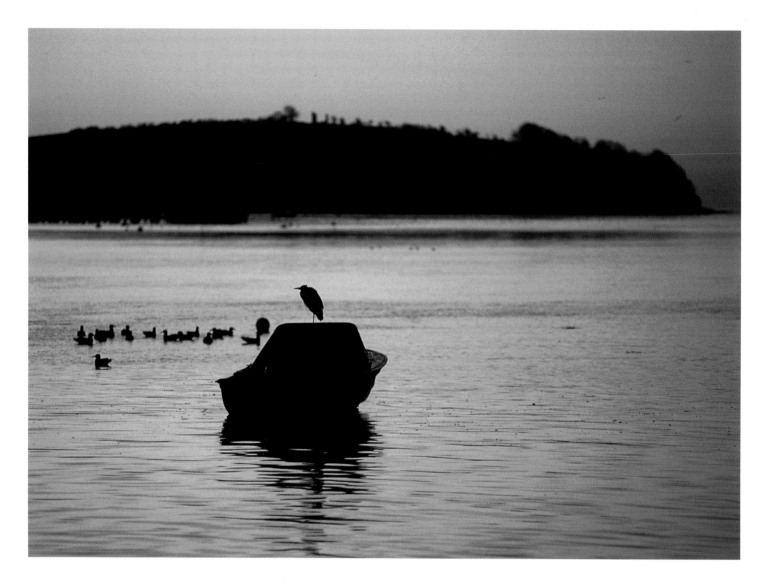

The marine nature reserve at Strangford provides habitats for over 2,000 recorded species of birds. Large numbers of duck and goose, including widgeon, shelduck and pale-bellied Brent Goose over-winter here. The muddy and sandy shores provide feeding grounds for large flocks of waders, such as oyster catcher, lapwing, golden plover, curlew, redshank, dunlin and knot. [JC]

Alongside all the wildlife, the lough is used for recreation – water sports, shooting, walking and riding – and for shellfish culture, commercial fishing and field studies. [JC]

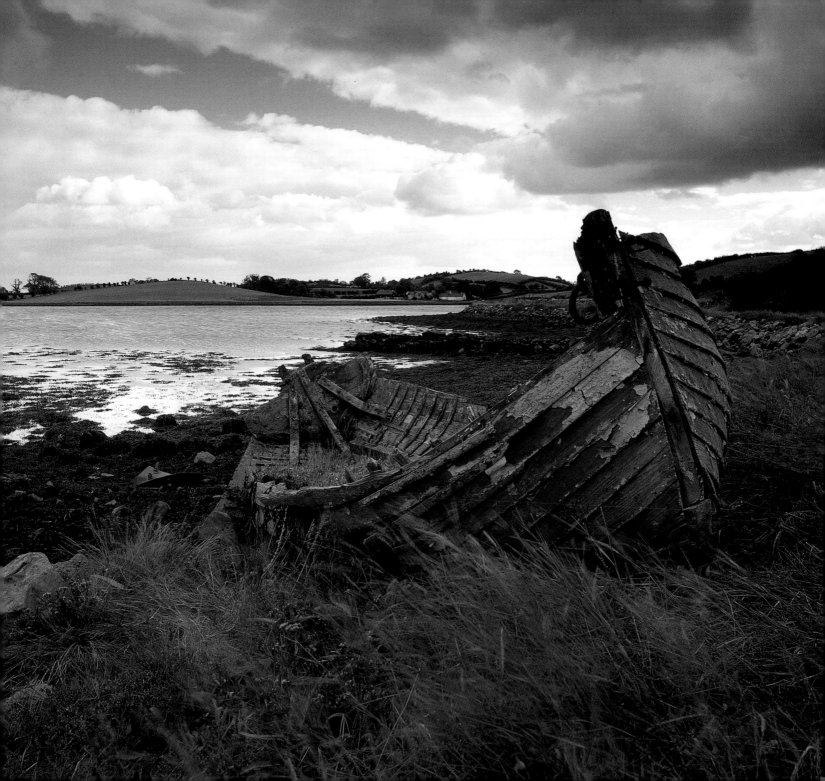

WHITE PARK BAY on the North Antrim coast. This was the first piece of coast in Northern Ireland to be bought by the National Trust in 1938, with support from the Pilgrim Trust, a charity particularly interested in saving unspoilt coastline, and the Youth Hostels Association.

 One of White Park's great attractions is the wide, sandy beach, backed by botanically rich sand dunes. By tradition local farmers have extracted sand for use on their fields, but in recent years this has developed into a major enterprise, depleting the sand and speeding up erosion and starving of the dunes. The Trust has sought to solve this particular problem by providing sand for removal at nearby Cushendun. [PW]

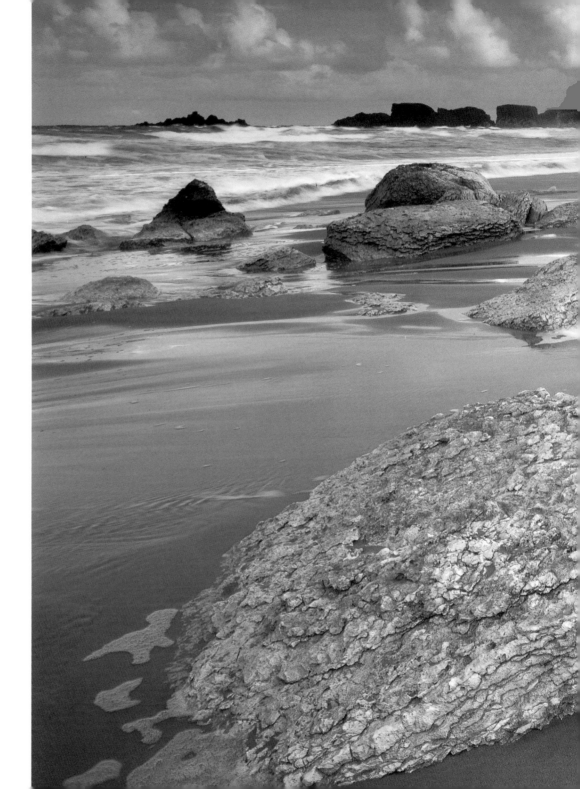

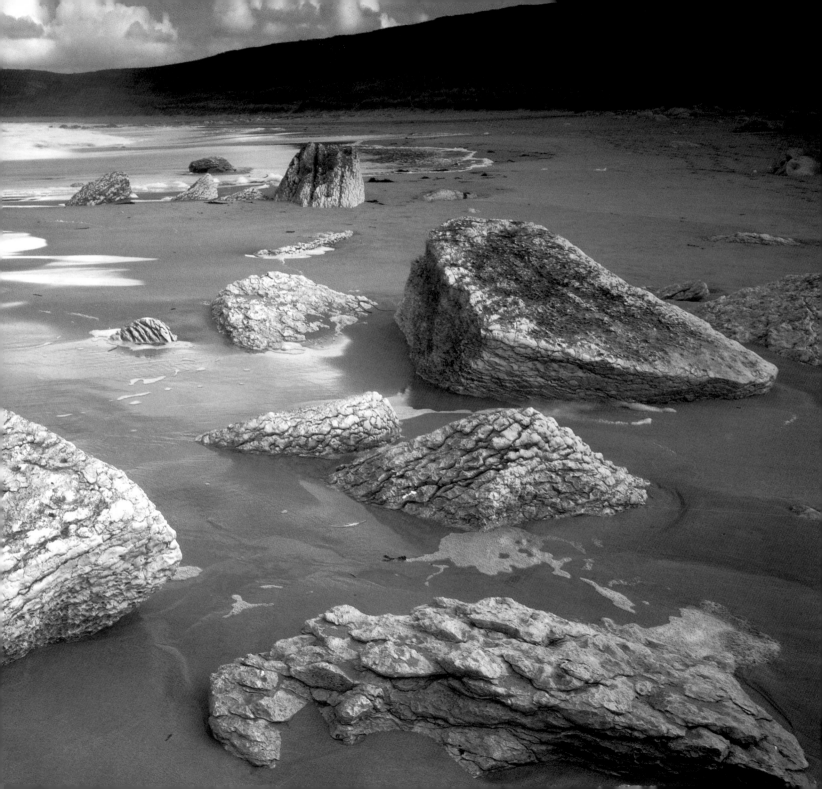

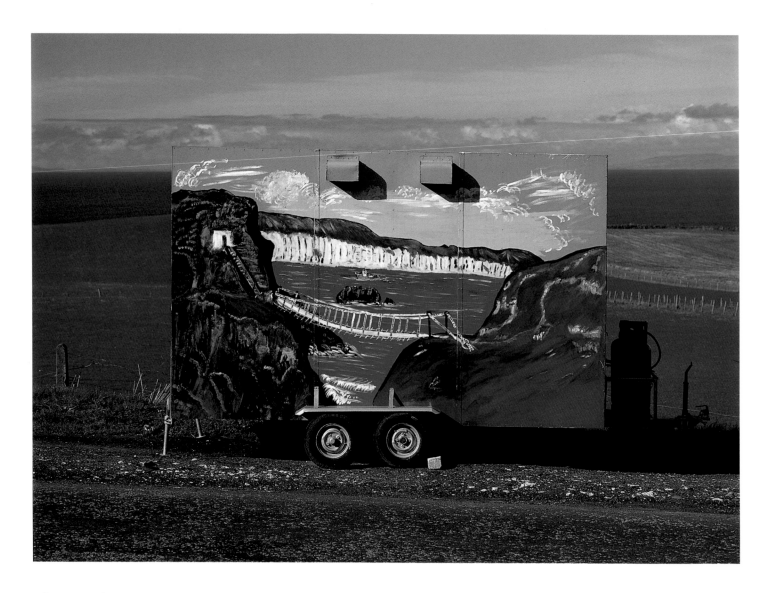

Above: One of the National Trust's interpretation vans, displaying an artist's impression of the extraordinary swing bridge which temporarily joins the island of CARRICK-A-REDE to the mainland. [JC]

Carrick-a-Rede is Gaelic for 'rock in the road', the route taken by salmon each year. At the beginning of the fishing season in April the local fishermen sling the rope bridge across the deep chasm (*right*), and use this tricky access until the season's end in September. [JC]

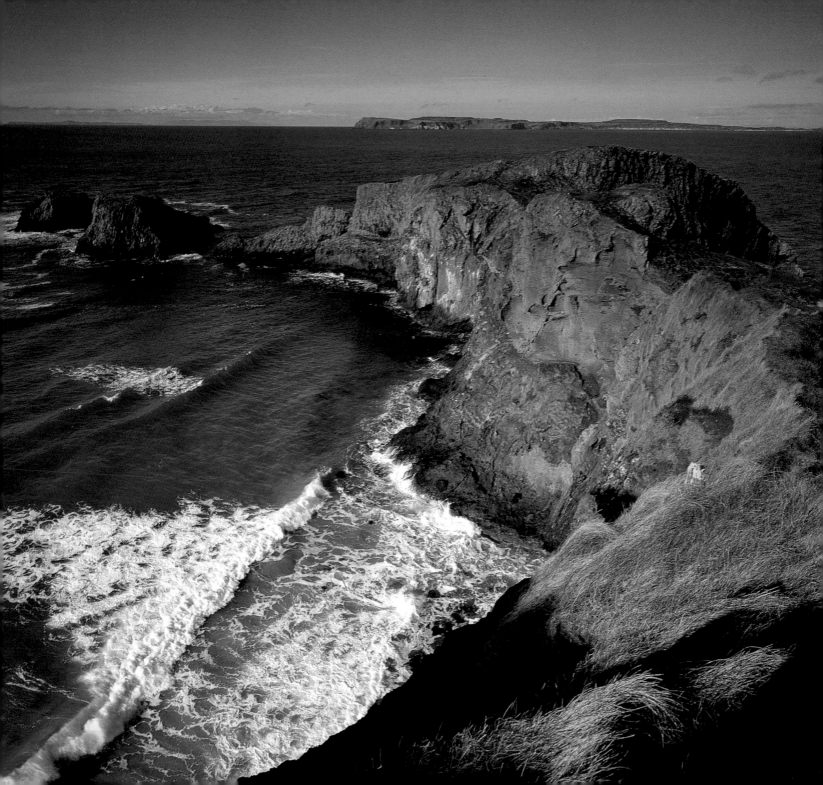

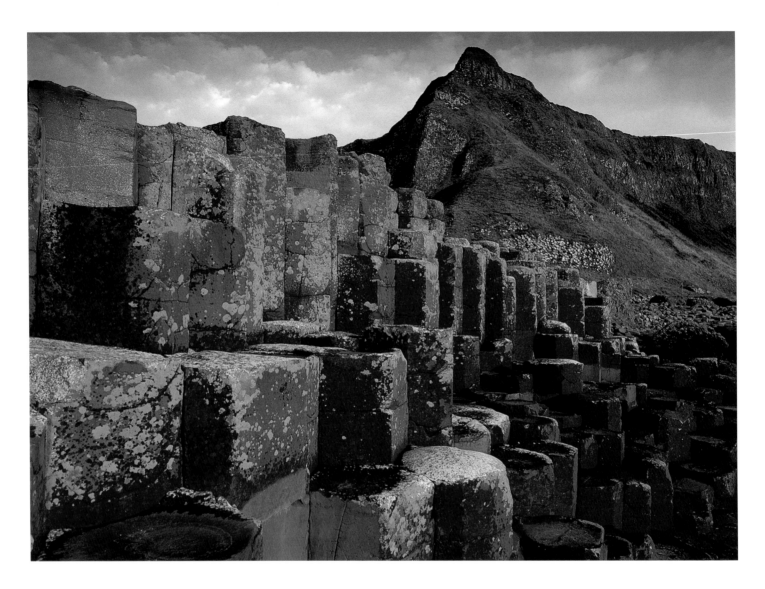

The GIANT'S CAUSEWAY on the Antrim Coast, a World Heritage Site that attracts over half a million visitors a year. They are following a long tradition, for visitors have been travelling over the centuries to see the huge basalt polygonal pillars that look like giant organ pipes. This extraordinary geological formation was caused by volcanic activity millions of years ago, though legend has it that the causeway was created by the giant Finn McCool to get to Scotland to fight another giant. An echoing fragment of causeway is to be seen at Fingal's Cave on the Scottish island of Staffa. [JC]

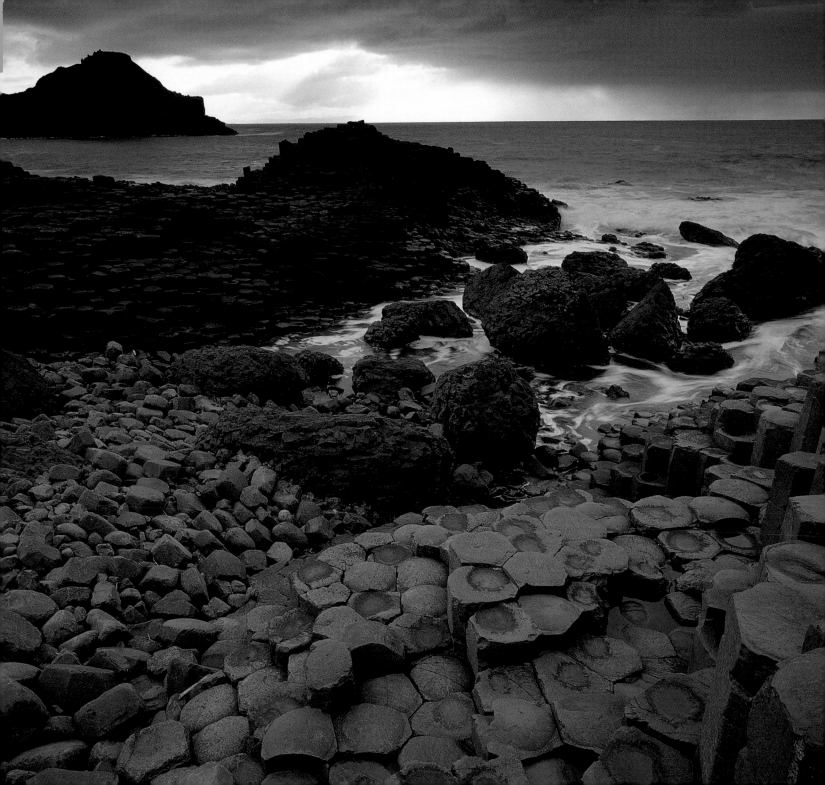

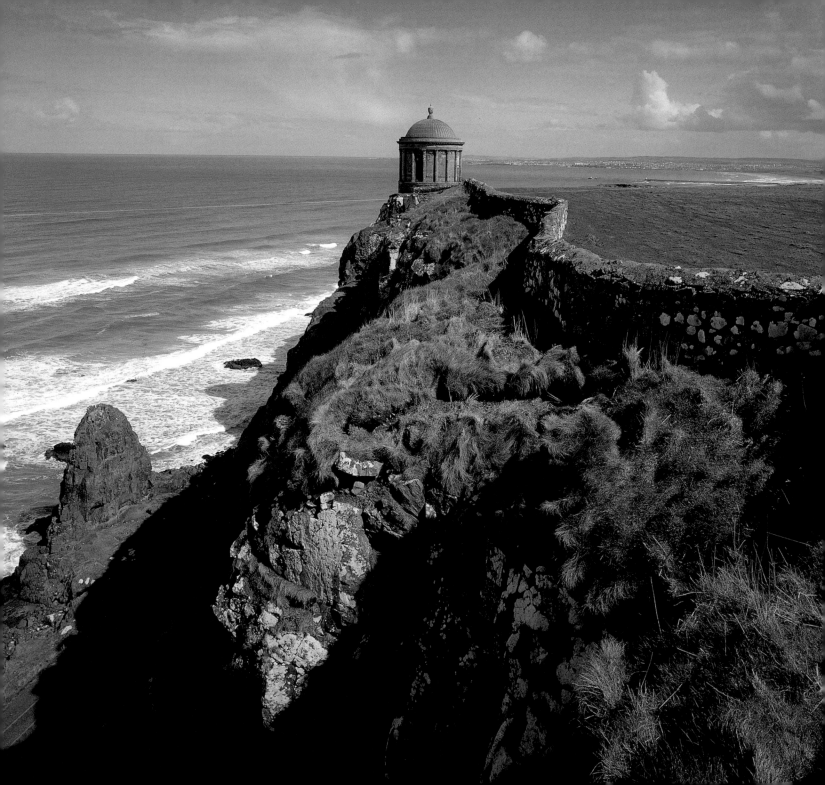

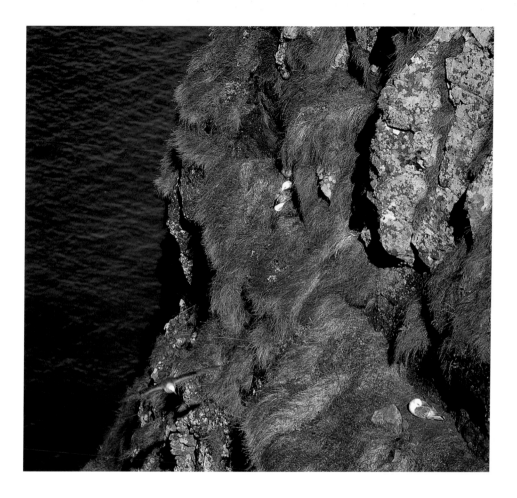

Left: The Mussenden Temple at DOWNHILL in County Londonderry. This was built as a commemoration of love by Frederick Hervey, 4th Earl of Bristol and Bishop of Derry, and thus known as the Earl-Bishop. He was also known as 'the edifying bishop' as he loved building, especially rotundas. The rotunda at Downhill was built for his cousin, Frideswide Mussenden, but sadly turned out to be her memorial as she died suddenly in 1785. The Earl-Bishop's vast palace at Downhill is now a ruin, but the Mussenden Temple still perches precariously on the cliffs. [JC]

Above: Fulmars nesting at Dunseverick. In 1921 only one pair of fulmars bred on the north coast of Ireland, but the bird has so flourished that it is now one of the commonest nesting birds on the Antrim cliffs. [JC]

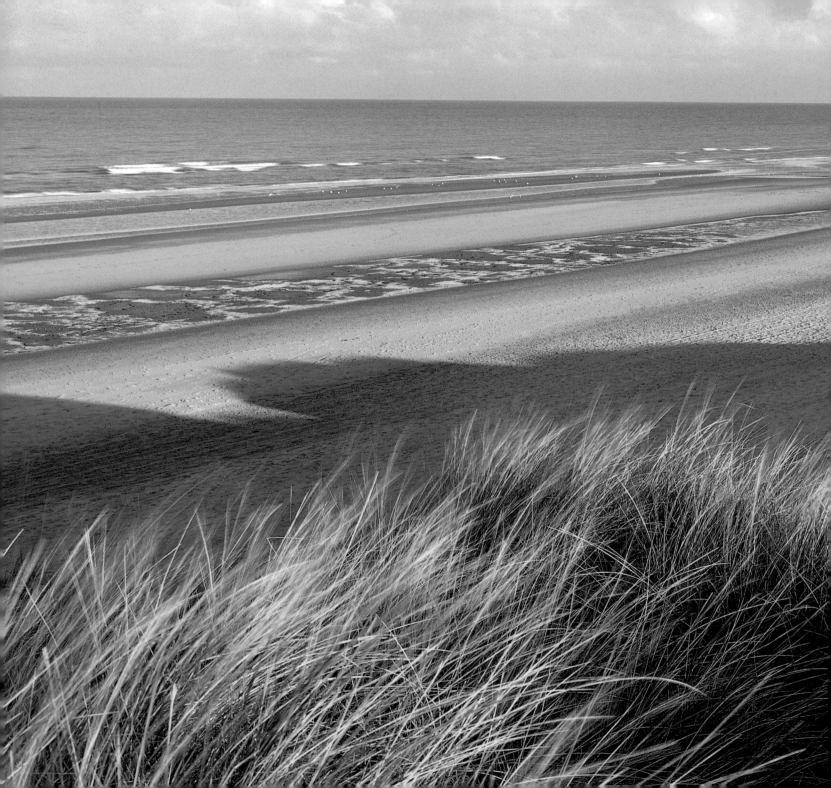

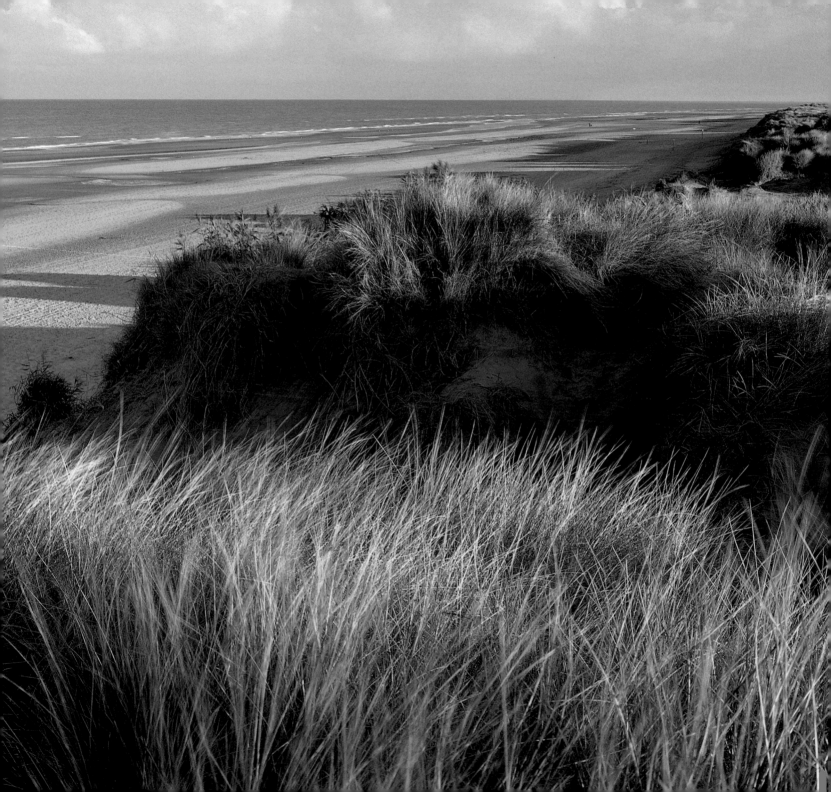

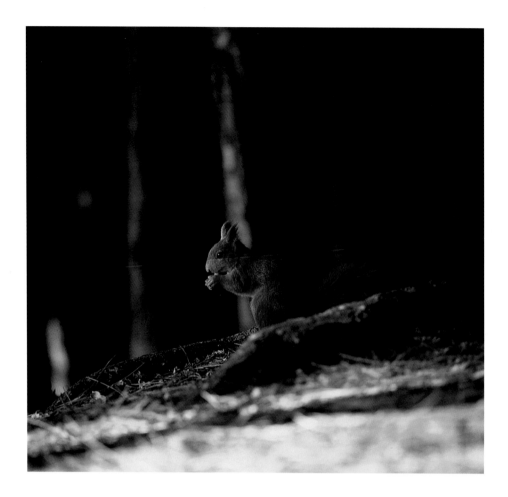

Previous pages: FORMBY POINT, on the Sefton coast in Merseyside, is a remarkable survivor – unspoilt coast close to the urban sprawl of Liverpool. Five hundred acres (200 ha) of sand dunes, created as the Crosby Channel silted up and the sea receded, are now home to a range of unusual plants, due to the sweepings from grain cargoes discharged at Liverpool. The National Trust is working with the local council, and financial aid from the European Community, to stabilise this fragile coastline by planting marram grass on the dunes. [JC]

Right: Behind the sand dunes at Formby are several former dumps for nicotine, brought here from tobacco processing factories on Merseyside. Pine forests, planted at the beginning of this century, again to stabilise the site, are now one of the last strongholds of the red squirrel in Britain (*above*). Their more aggressive grey cousins have been sighted only four miles away, although the National Trust has implemented various initiatives to try to keep the red squirrel safe. [JC]

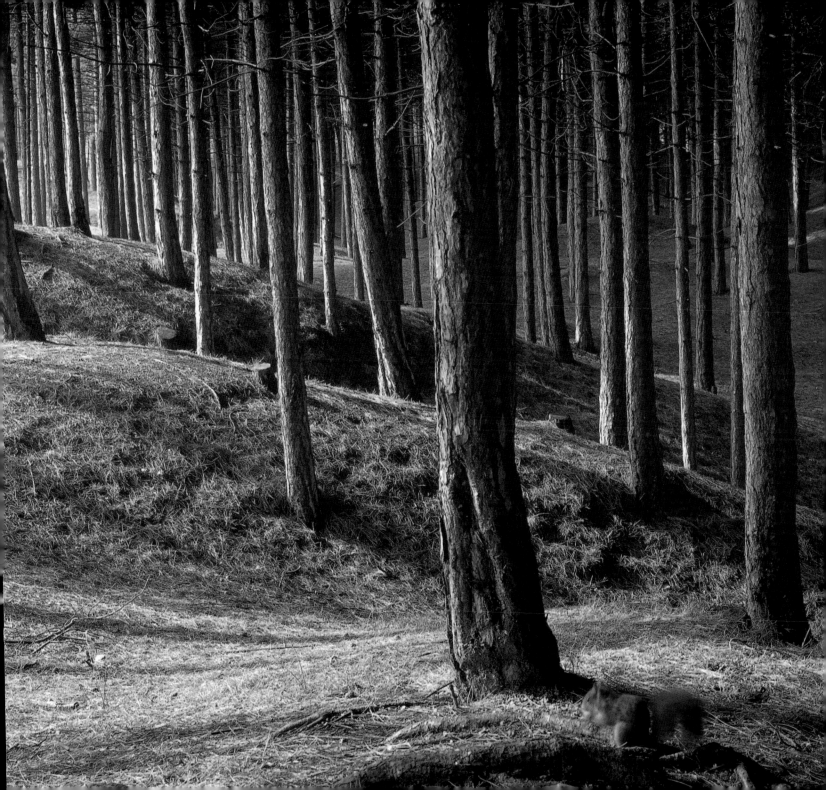

LINDISFARNE CASTLE rises up on a basalt crag, accessible only at low tide by the causeway to Holy Island. The castle was built in Tudor times to protect the Northumbrian coast from possible French attack, but its present form dates from the beginning of this century, when Edward Hudson, founder of *Country Life*, decided to make it his summer retreat. The architect Edwin Lutyens turned the primitive fort into an attractive home, though even he could not give it all the comforts. Lytton Strachey, staying on Lindisfarne in 1918, wrote to a friend, 'All timid Lutyens – very dark, with nowhere to sit, and nothing but stone under, over and round you, which produces a distressing effect – especially when hurrying downstairs for dinner – to slip would be instant death.' [JC]

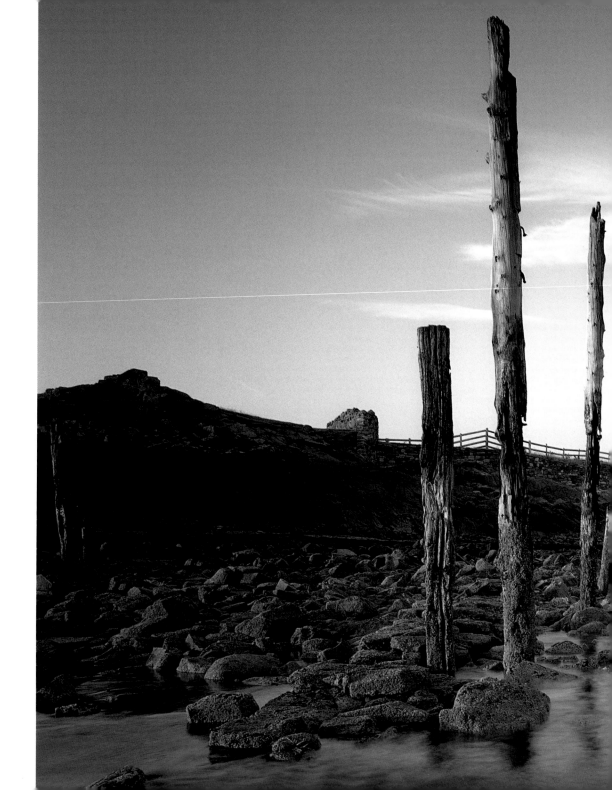

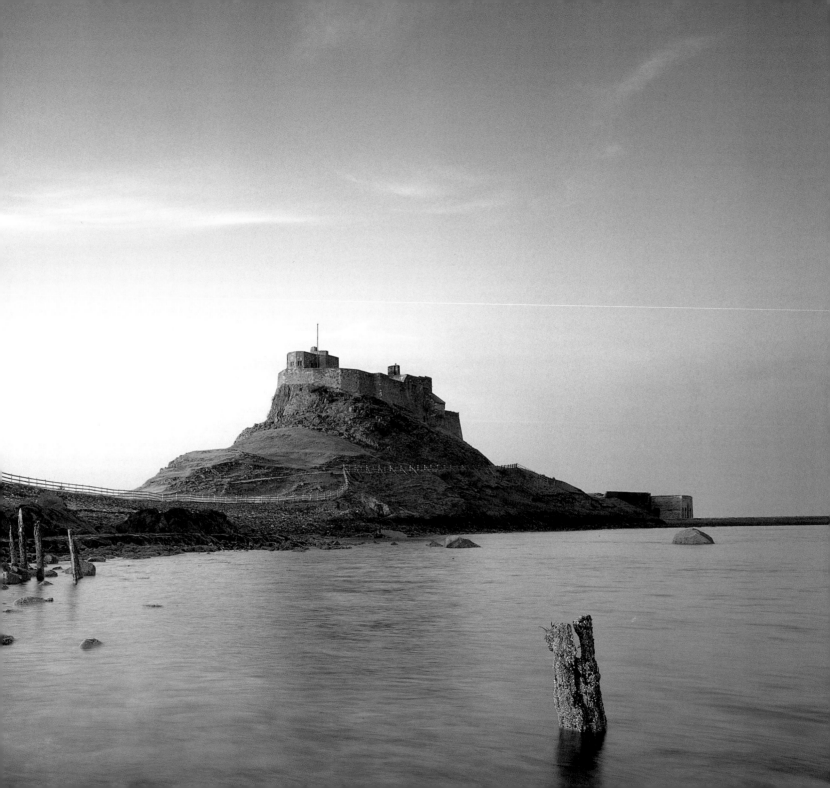

Above: A rock pool in the marine nature reserve at NEWTON HAVEN, Northumberland. The water here is particularly clear with heart urchins and a rich gathering of molluscs and crustaceans. [JC]

Right: Fishing boats at SEAHOUSES. This photograph was taken in 1989, when there were twice as many boats as today. The traditional east coast cobles fishing for salmon, sea trout, cod, lobster and crab are sadly dwindling in numbers. Some boats are licensed by the National Trust to take visitors out to the bird sanctuaries on the Farne Islands. [JC]

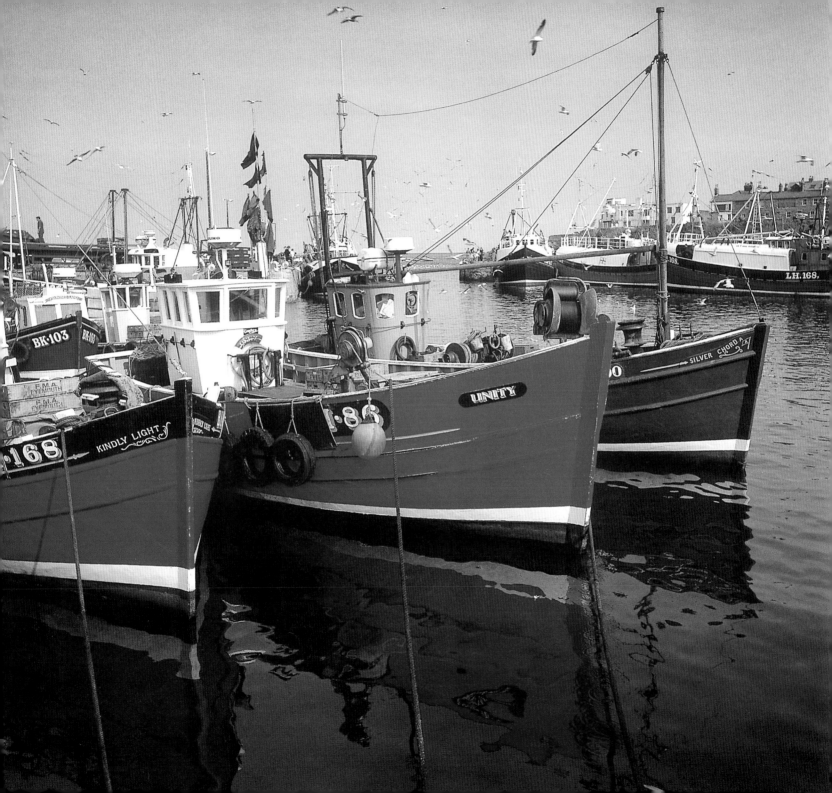

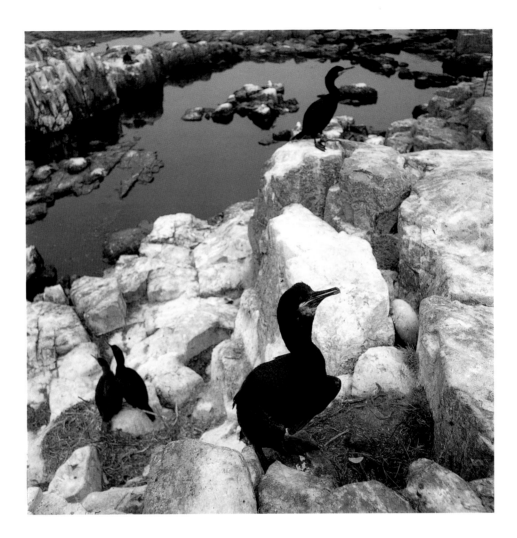

The FARNE ISLANDS came to the National Trust through the initiative of Lord Grey of Falloden, the man who, as Foreign Secretary at the beginning of the First World War, described the lights going out all over Europe. His rousing appeal raised the necessary money and the Farnes became Trust property in 1925.

But the twenty-six islands have been a sanctuary for seabirds such as kittiwake, puffins, guillemots, and terns for centuries. St Cuthbert, who lived as a hermit on Inner Farne in the seventh century, laid down rules for the protection of eider ducks when nesting. They are now known to Northumbrians as Cuddy ducks in his memory.

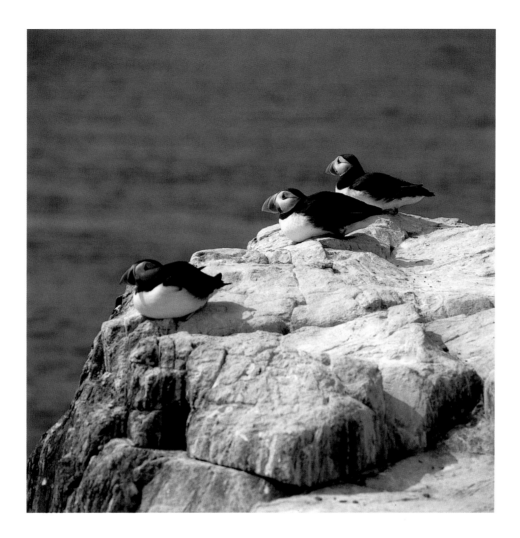

The Farnes are one of Europe's most important nature reserves. The Trust seeks to ensure the birds and the Atlantic grey seals flourish while visitors are shown as much as possible. Visitors land only on Inner Farne and Staple Island, but can see the teeming bird life on other islands from their boat. *Left:* Young shag at the end of their first season. [JC]

Right: Puffins. [JC]

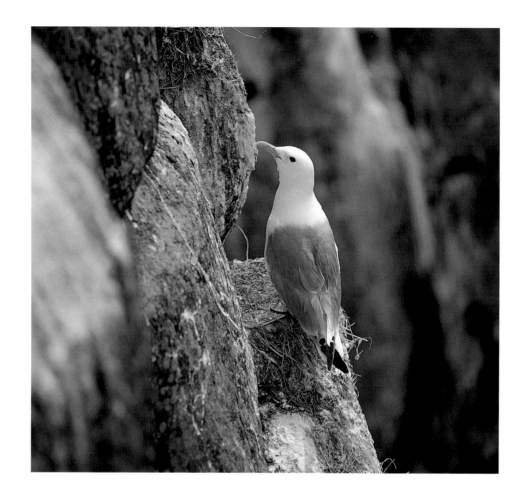

Southwards from the Farnes stands the spectacular castle of DUNSTANBURGH, built on the basalt ridge of Whin Sill, that further west carries Hadrian's Wall. In the middle ages Dunstanburgh was the stronghold of the Earls and Dukes of Lancaster until it was reduced to a ruin in the Wars of the Roses. No roads lead to it, so visitors arrive along the shore from Craster or Embleton. [JC]

The castle is now home to seabirds like the kittiwake (*above*). [JC]

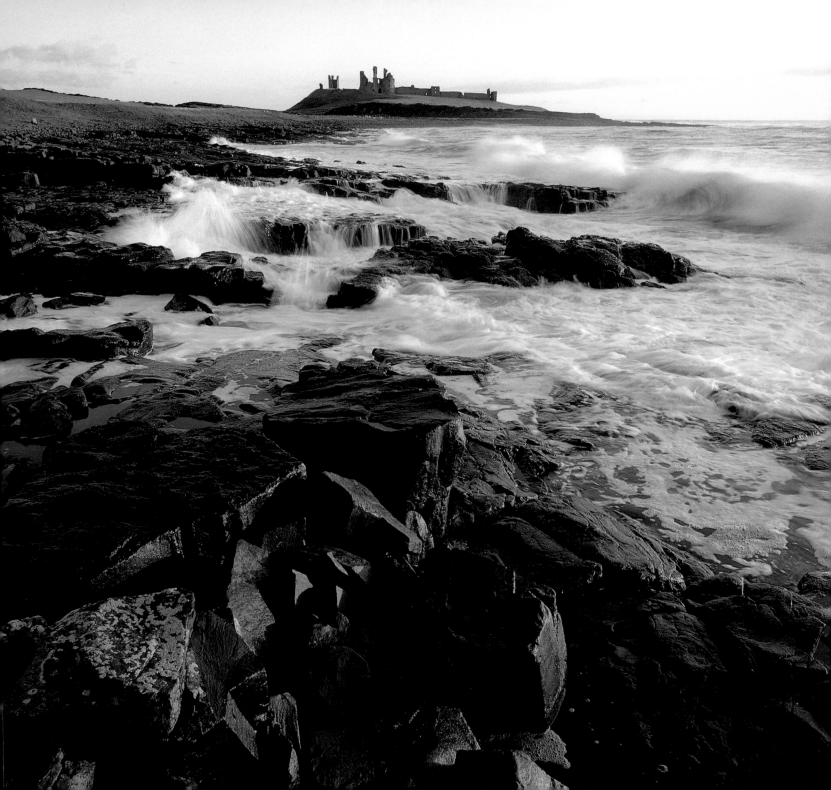

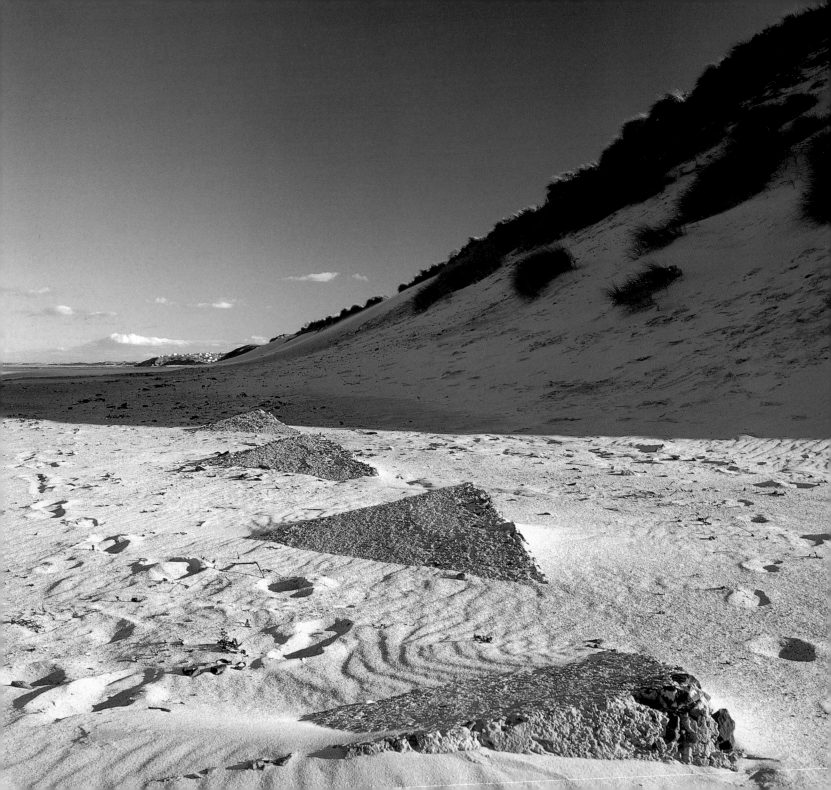

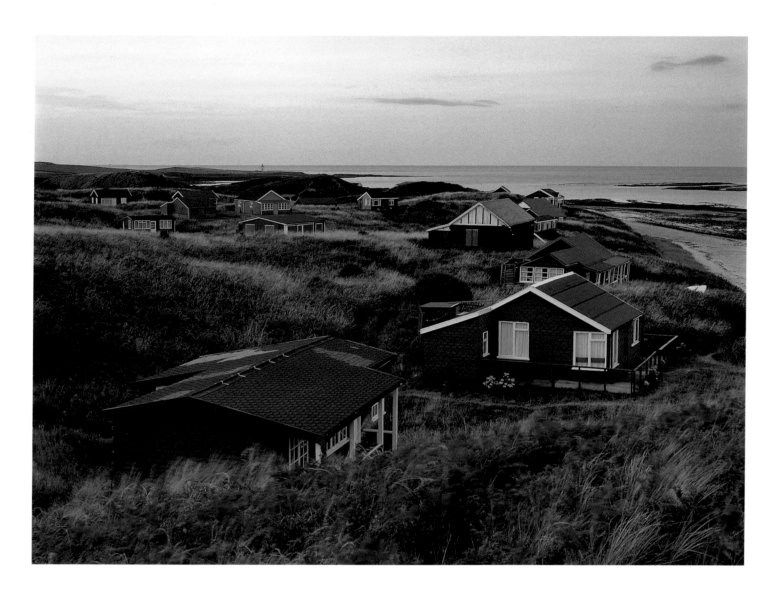

The Northumbrian coast offers both rocky headlands and sandy beaches. *Left:* BOULMER BEACH still has the anti-tank blocks, put up in the Second World War rather than to prevent the gin smuggling, which apparently was a thriving trade here. [JC]

Above: At EMBLETON there is a sweep of sand backed by dunes which are not only home to wooden holiday chalets but also wild flowers like bloody cranesbill, burnet rose and purple milk vetch. [JC]

HORDEN on the Durham
coast marks a watershed for
Enterprise Neptune. Before
Neptune was launched in
1965, the National Trust
had conducted a survey of
the 3,000 miles of coastline
of England, Wales and
Northern Ireland. Some
coast was already protected
by the Trust and other
organisations: of the
rest one third was judged
to be developed beyond
conservation; one third of
little interest; and one third
to be of outstanding
natural beauty. Enterprise
Neptune was aimed at
securing as much of this
last category as possible.

However, in 1988, when
the appeal bought its 500th
mile, it was Horden, where
coal-mining had taken place
under the sea and the slag
thrown on the beach. This
property would not have
appeared on the original
list of outstanding sites of
beauty, but now the Trust
recognised that the area
between the cliffs and the
highwater mark contained
a whole series of important
habitats. This photograph
shows Horden at the time
of acquisition, with its
black beach. Today it
has been restored to its
condition a century and
a half ago with its former
eco-systems flourishing.
[JC]

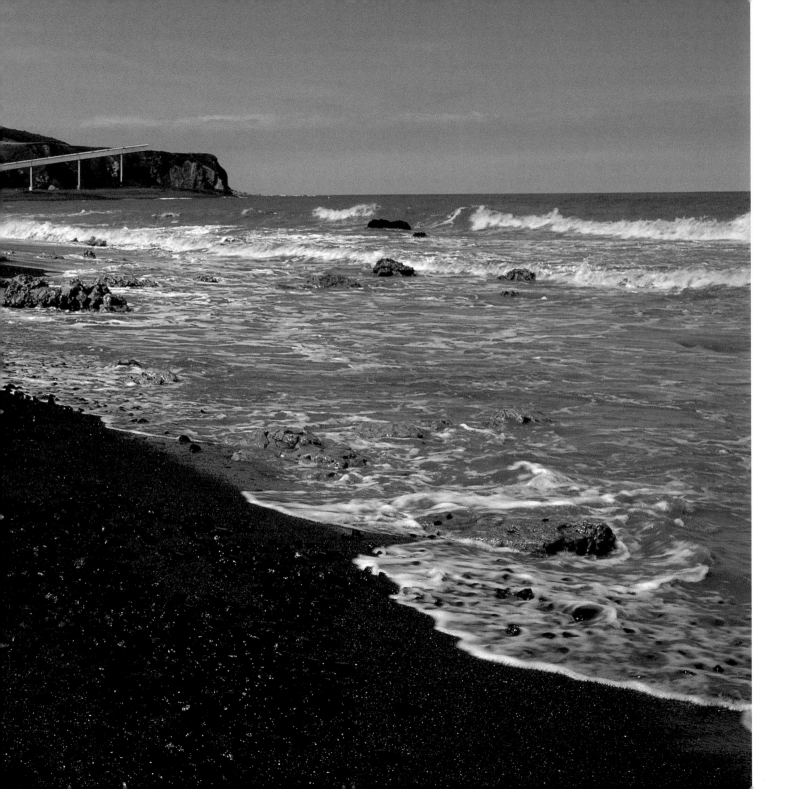

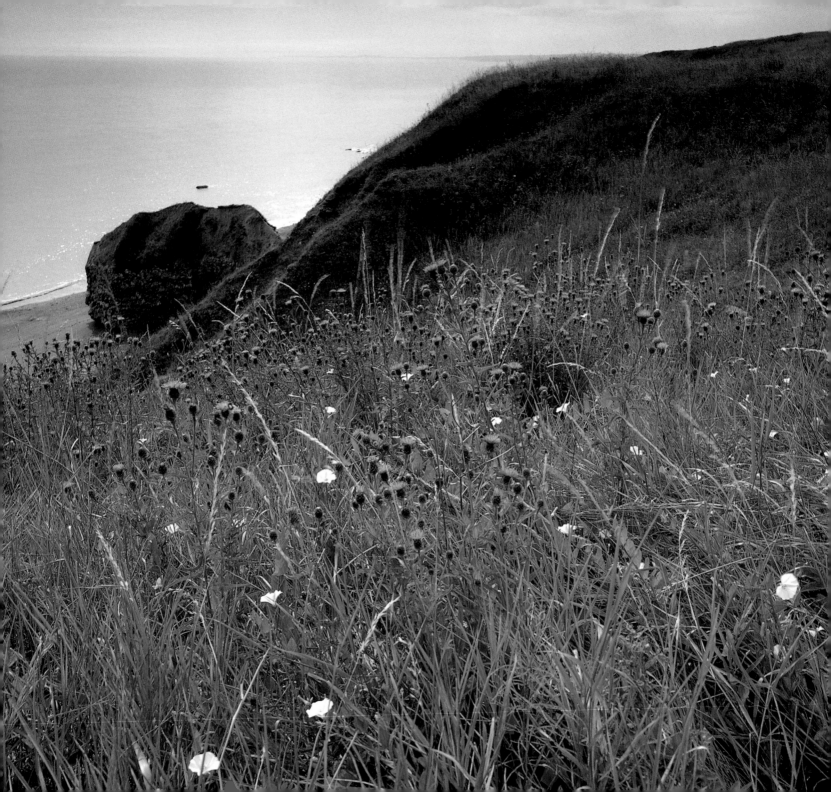

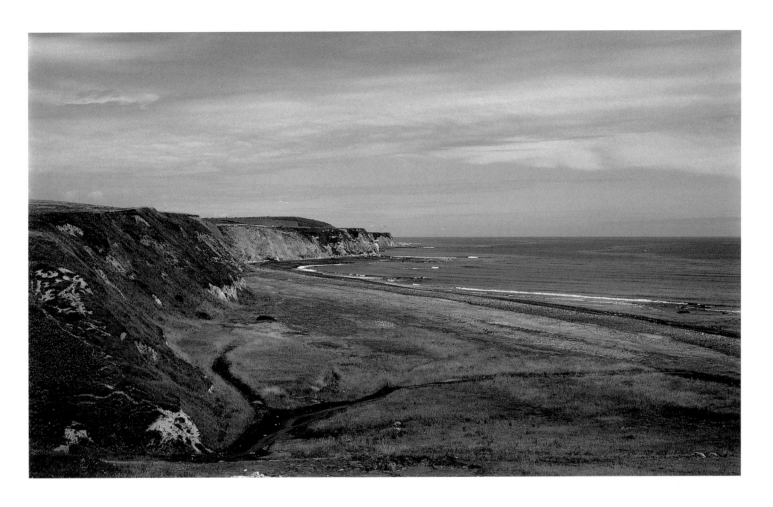

Above: The view along Horden Beach north to Beacon Hill. [JC]

Left: Wildflowers growing in meadowland at Beacon Point. [JC]

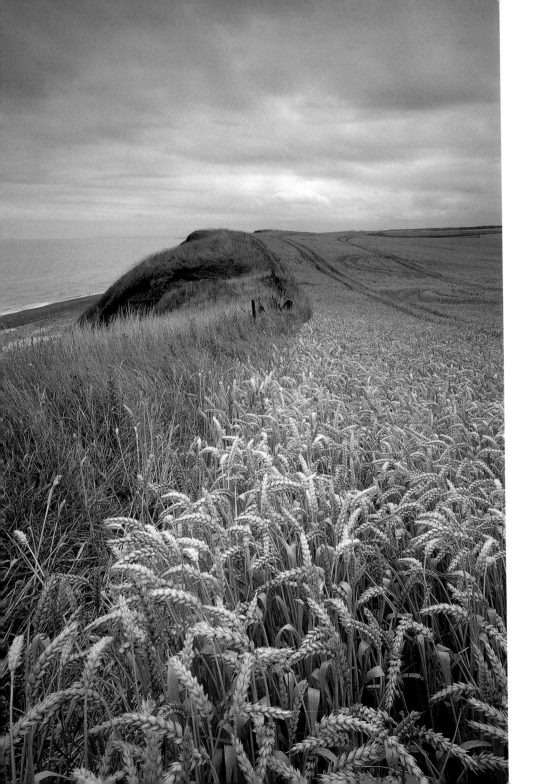

Left: When the National Trust bought Horden from British Coal for £1, the fields on BEACON HILL, above the beach, were cultivated with wheat. [JC]

Under a Countryside Stewardship Grant Scheme, the Trust has taken away the crops to improve the wildlife on this habitat of magnesium limestone, and to provide public access via a coastal path.

Right: Rock pools on Horden Beach. Following a long mining tradition, visitors still gather coal dust, using it to feed their vegetables, especially their prize leeks, on the cliff-top allotments. [JC]

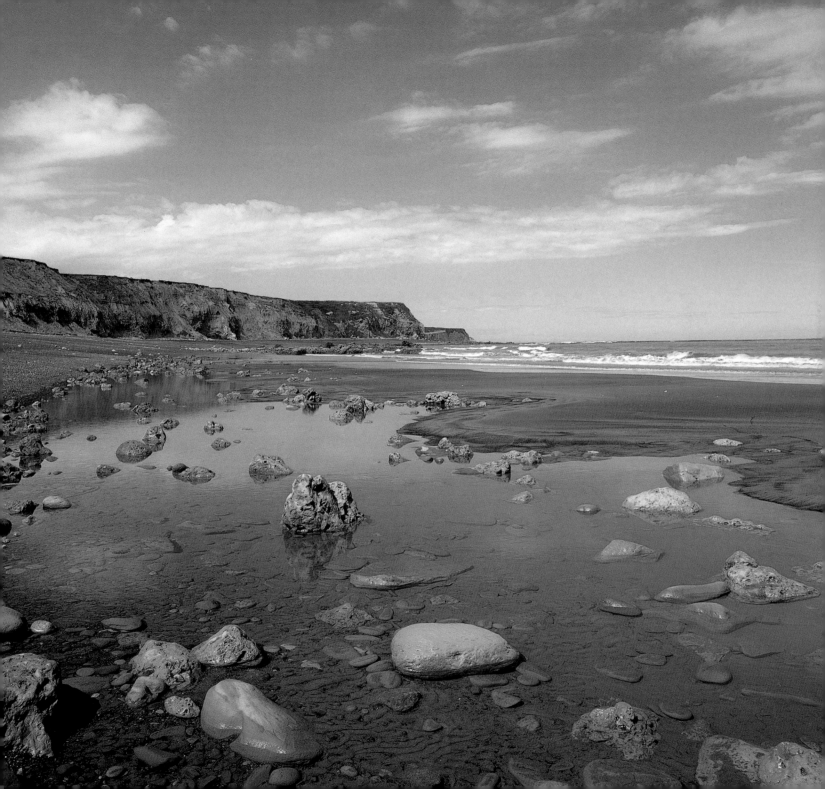

Right: ROBIN HOOD'S BAY in North Yorkshire, looking north from the cliffs of Ravenscar. The striped effect in the bay is produced by wave action, cutting platforms in the complex geological layers of shale, limestone and sandstone. [JC]

Ravenscar is 'the town that never was'. In the early years of this century a company tried unsuccessfully to create a holiday resort to rival Scarborough. Sewers and roads were laid down, but people were put off by the high winds and exposed cliff-top.

Above: Behind the headland, the National Trust owns a patchwork of farmland, former alum and silica quarries, and brickworks for the town's development, now abandoned. This photograph shows the old brick ovens at Peak Alum Works. Here alum was extracted for use as a fixative in the dyeing of wool. In the nineteenth century the shale was dug out of the cliffs by hand, laid in piles and roasted slowly over a brushwood fire. The residue, brick red, was washed with water and an alkaline solution, usually stale urine supplied by the local population. [JC]

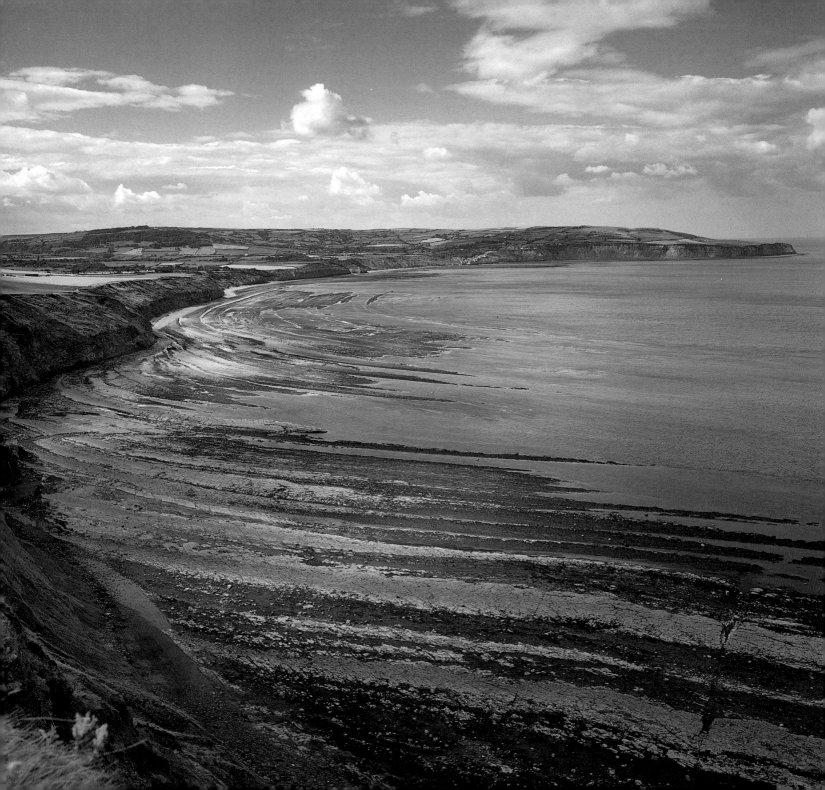

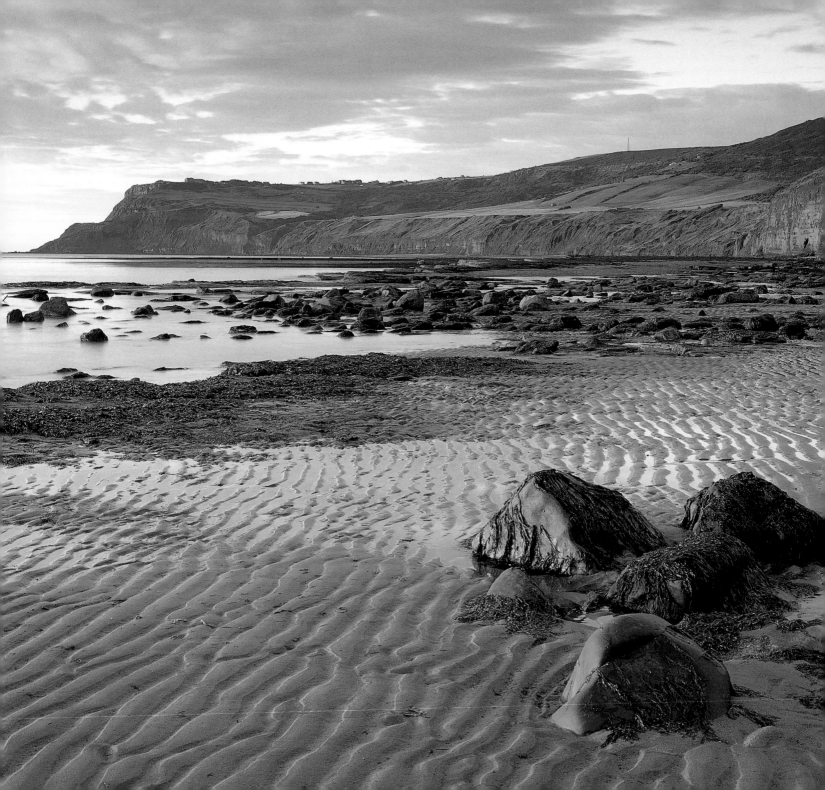

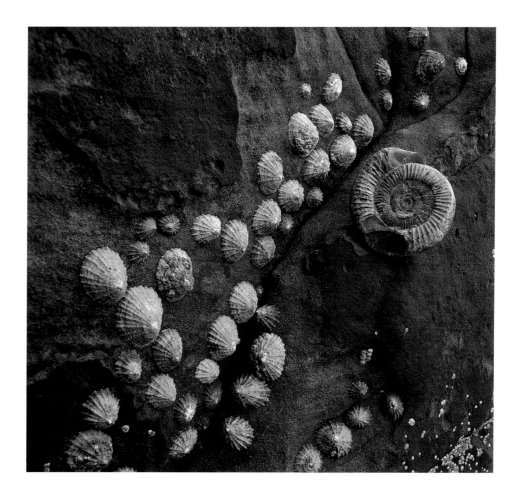

The rock pools below the cliffs at RAVENSCAR (*left*) are of great geological interest, for the coast here is famous for its ammonites and belemnites, primitive members of the family of marine molluscs. Because of their likeness to curled horns, ammonites are named after Ammon, the ram-headed god of the Ancient Egyptians. Local Yorkshire tradition has it, however, that St Hilda of Whitby, finding this area infested with snakes, cut their heads off, and drove them over the cliffs. Their bodies then curled up and turned into stone (*right*). [JC]

Following pages: Ladybirds perching on the reeds in the early morning at BRANCASTER in Norfolk. This is classic East Anglian landscape: the horizons here are low and broad, the shoreline constantly changing through the action of wind and waves on shingle and sand. [PW]

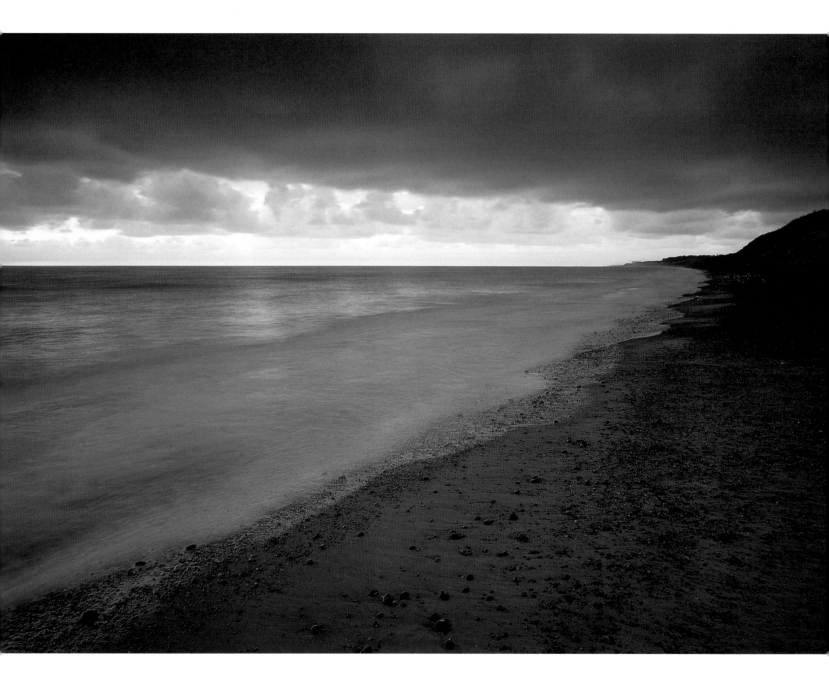

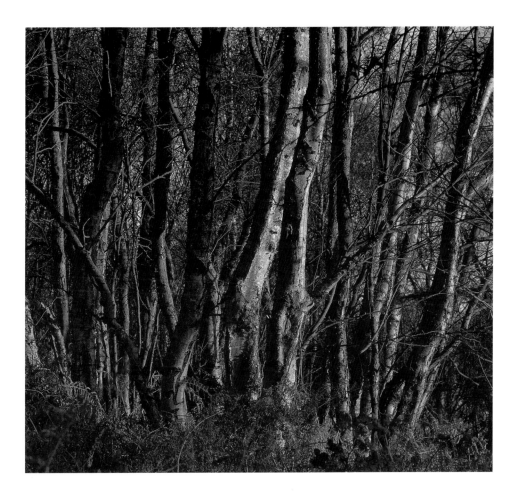

In Anglo-Saxon times Dunwich in Suffolk was the capital of East Anglia; in medieval times it was one of the great ports of the east coast. Today, scarcely anything is left: the low cliffs have crumbled and the great entrepôt has been washed into the sea.

South of Dunwich is the heath now looked after by the National Trust. It consists of about a mile of shore and cliff, together with over 200 acres (80 ha) of heathland, which the Trust's warden maintains by grazing to prevent it reverting to scrub and woodland. It is an important bird reserve and a sanctuary for rare healthland species such as nightjar.

Left: The foreshore at DUNWICH HEATH, looking south to the nuclear power station at Sizewell. [JC]

Above: Silver birch trees, which have to be kept in check to maintain the heathland habitat. [JC]

Far right: DUNWICH HEATH in Suffolk, showing Docwra's Ditch, which is named after Jack Docwra, the warden who dug it in the late 1970s and 80s. The ditch acts as both firebreak and a reservoir as the dry sandy heathland, with its heather, bracken and silver birch, is very much at risk. Dunwich Heath lies next to the Royal Society for the Protection of Birds' major nature reserve at Minsmere, and is therefore rich in birdlife, including the avocet, symbol of the RSPB. [JC]

Right: NORTHEY ISLAND, off the Essex coast. Here the Trust is taking part in an experiment with the Environment Agency and English Nature to allow the sea to breach the old defences and return the habitat to saltmarsh. This will not only encourage saltmarsh birds to overwinter, but also provide a buffer to protect other areas vulnerable to flooding. This photograph was taken twenty months after removal of the sea wall, and shows how quickly saltmarsh plants are establishing themselves. [JC]

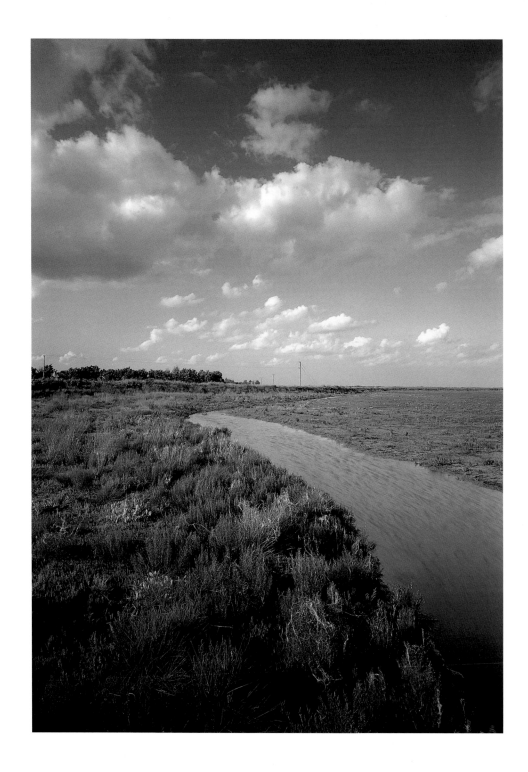

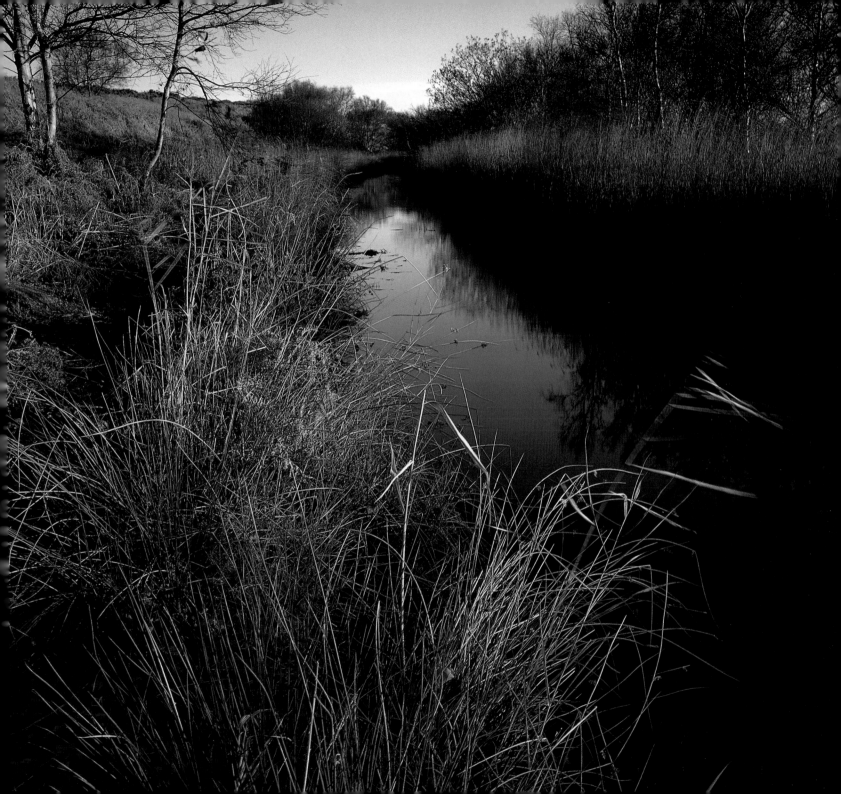

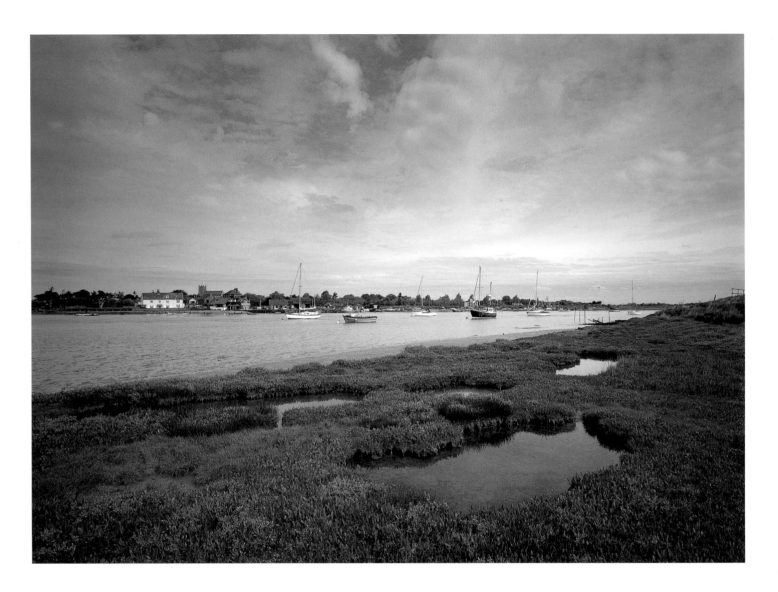

ORFORD NESS is a narrow shingle spit about ten miles in length, running parallel with the Suffolk coast. *Left:* The saltmarshes and narrow straits that separate the Ness from the main coast, with the fishing village of Orford. [JC]

For centuries Orford has provided shelter from the North Sea. In the twelfth century Henry II built his square keep to protect the harbour. Five hundred years later a lighthouse was erected on the Ness, following a stormy night when thirty-seven ships were lost in the treacherous waters off the spit: this was replaced in 1792 by the lighthouse that is still maintained by Trinity House (*right*). [JC]

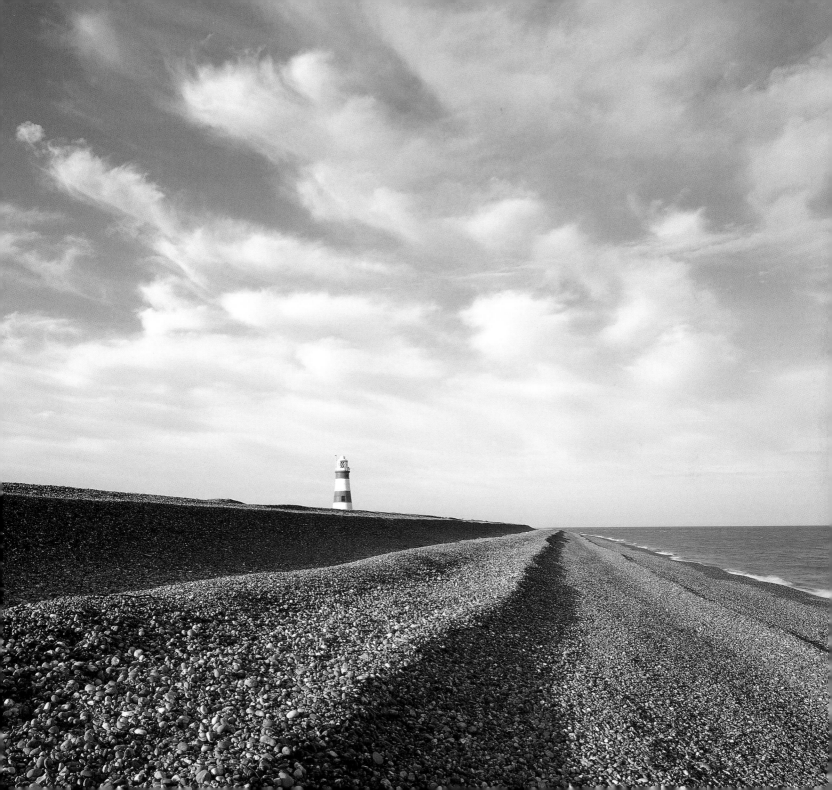

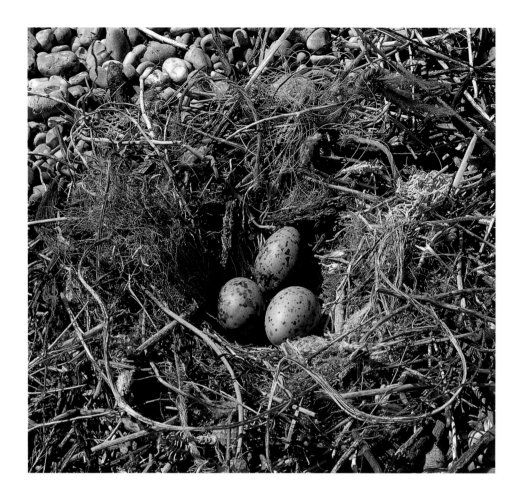

Right: The shingle surface preserves a complex pattern of ridges and swales (valleys) deposited over many centuries and recording stages in the evolution of the land form. This shingle provides a habitat for plants and seabirds, especially for the common gull: Orford has the largest breeding colony in Europe. [JC]

Above: The gulls make use of any material they can find for their nests on the shingle. [JC]

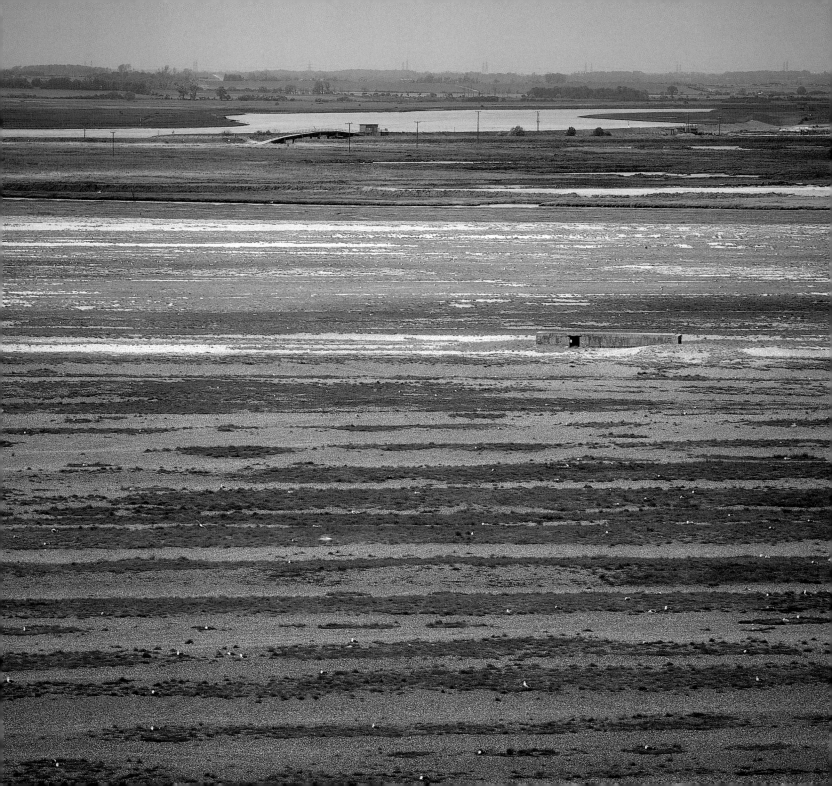

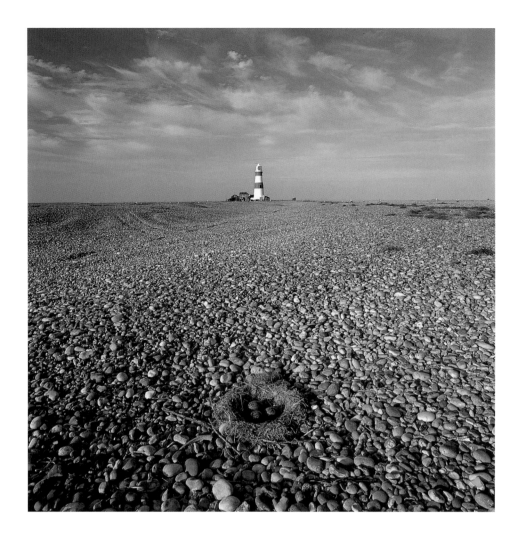

The Ness at Orford is the largest cuspate spit in Europe, its estuarial mudflats and the ridges on the shingle created by the wind and waves providing a home for marsh birds like the avocet and the marsh harrier, and seabirds – it supports a huge colony of breeding common gulls – and for wild flowers. With the help of European funding, the National Trust has brought back grazing and raised water levels to reintroduce reed beds and thus enhance the nature conservation value of the area.

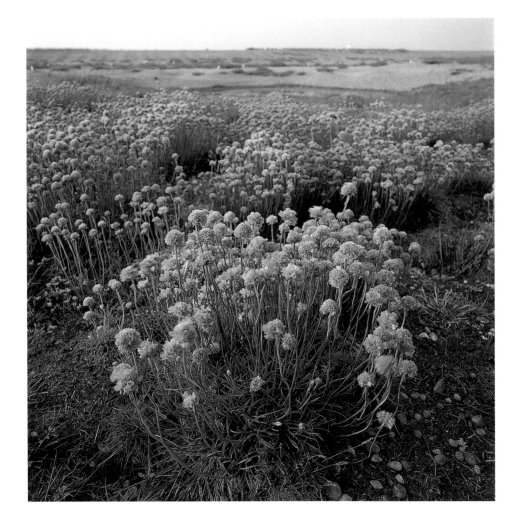

Left: Gulls·nest directly on the shingle. [JC]

Above: Sea thrift is one of the many plants that flourish
in the harsh environment of Orford Ness. [JC]

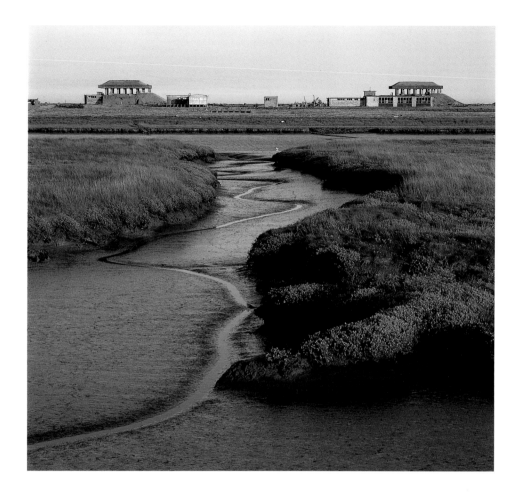

In this century the flat terrain and isolated position of Orford Ness has been exploited for military purposes. In the First World War it was used by the Royal Flying Corps; in the 1930s trials in radar were carried out here; and in the Second World War, Barnes Wallis experimented with new types of bomb. Finally, during the Cold War huge aerials were erected on the Cobra Mist site (*right*) for a sophisticated defence system gathering information from all over the world – within months of its installation it was already superseded. [JC]

On another part of the Ness oriental-style pagodas were built (*above*) for the testing of nuclear warhead detonators. In the event of an accident, the pagodas would collapse in on themselves. [JC]

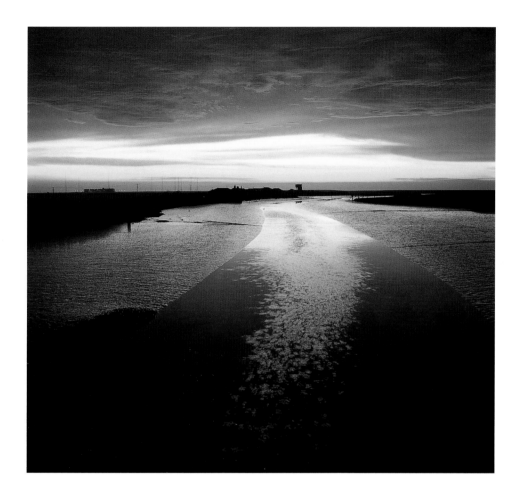

In the 1970s the Ness was declared surplus to Ministry of Defence requirements, and twenty years later, in 1993, a five-mile stretch was bought by the National Trust through Enterprise Neptune with the support of various organisations. Many of the buildings connected with the sinister affairs of war remain, adding powerfully to the mournful beauty of this site.

Right: Once more the Ness can be an area of wilderness for the avocet and the marsh harrier, rather than the bouncing bomb and other sinister projects. Already this photograph is out of date, with only the black tower left. [JC]

Far right: The estuarial mudflats at Orford, now home to thousands of waders. [JC]

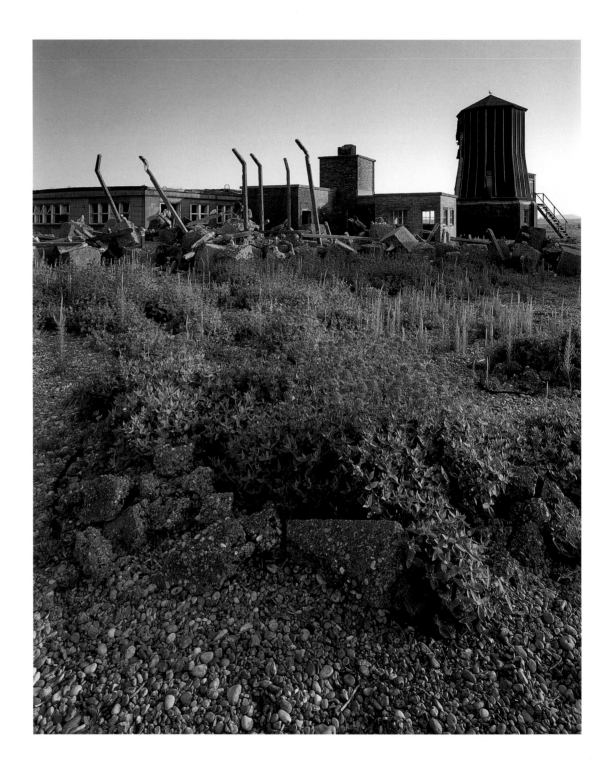

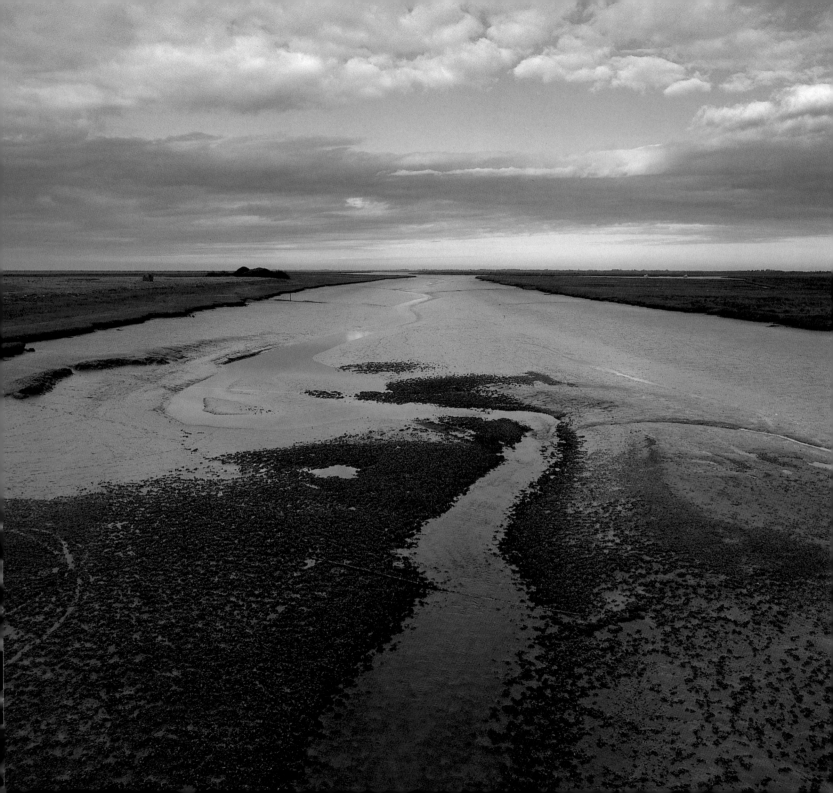

Sunset over the Ness, looking towards the little town of ORFORD. It was this bleak, uncompromising landscape that inspired the poetry of George Crabbe, and through him Benjamin Britten's opera, *Peter Grimes*. [JC]

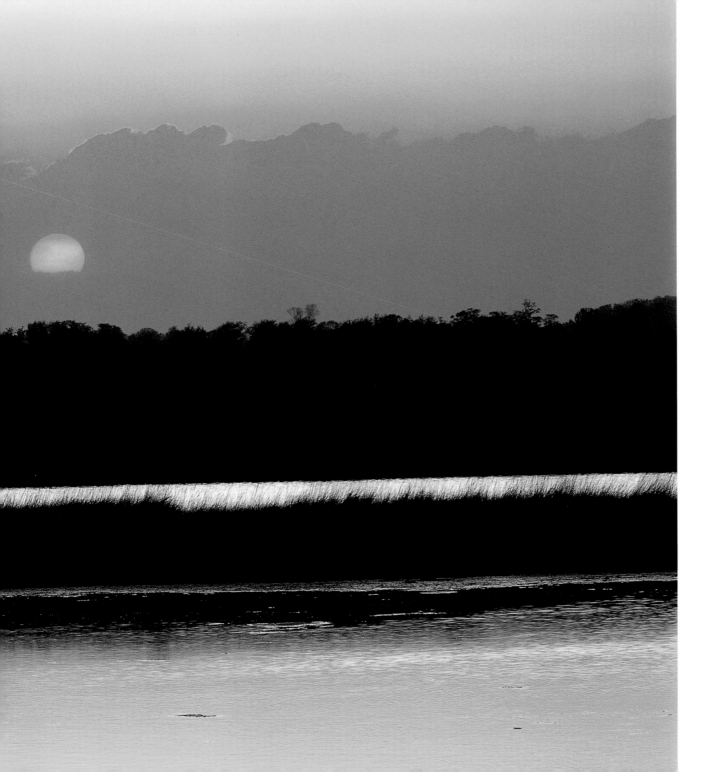

Despite its proximity to densely populated areas the BLACKWATER ESTUARY in Essex retains its isolated feel, each farm having its sea wall, saltings and mudflats. At the head of the estuary lies NORTHEY ISLAND, connected to the mainland by a causeway (*far right*). [JC]

In the ninth and tenth centuries, Northey and other islands along this coast were used as hideaways by the Vikings on their forays into Anglo-Saxon England: the bloody Battle of Maldon was fought in 991 between Saxons and Vikings on the site now occupied by South House Farm at the mainland end of the causeway.

Today the National Trust, in association with the Environment Agency and English Nature, is experimenting in allowing the sea to breach the old sea walls, returning the habitat to saltmarsh. This will not only encouarage saltmarsh birds to over-winter, but also provide a buffer to protect other areas vulnerable to flooding. *Right:* Remains of the revetment that originally protected the seaward edge of the saltmarsh. [JC]

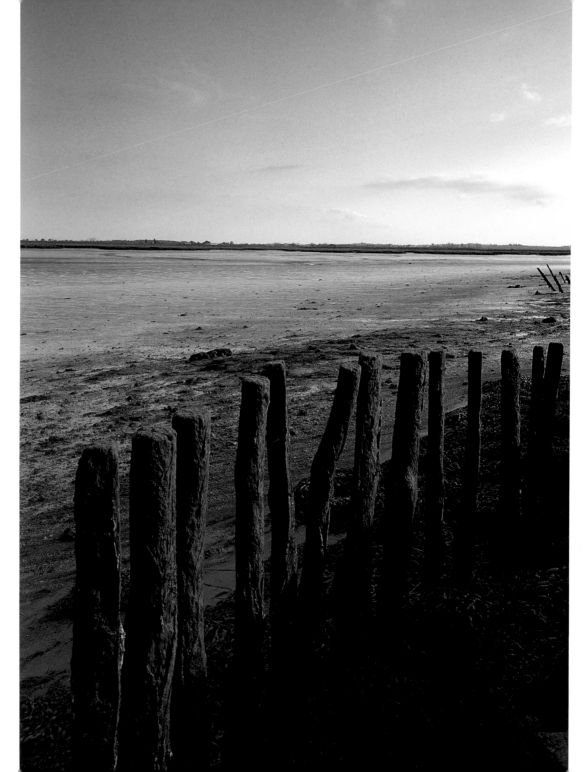

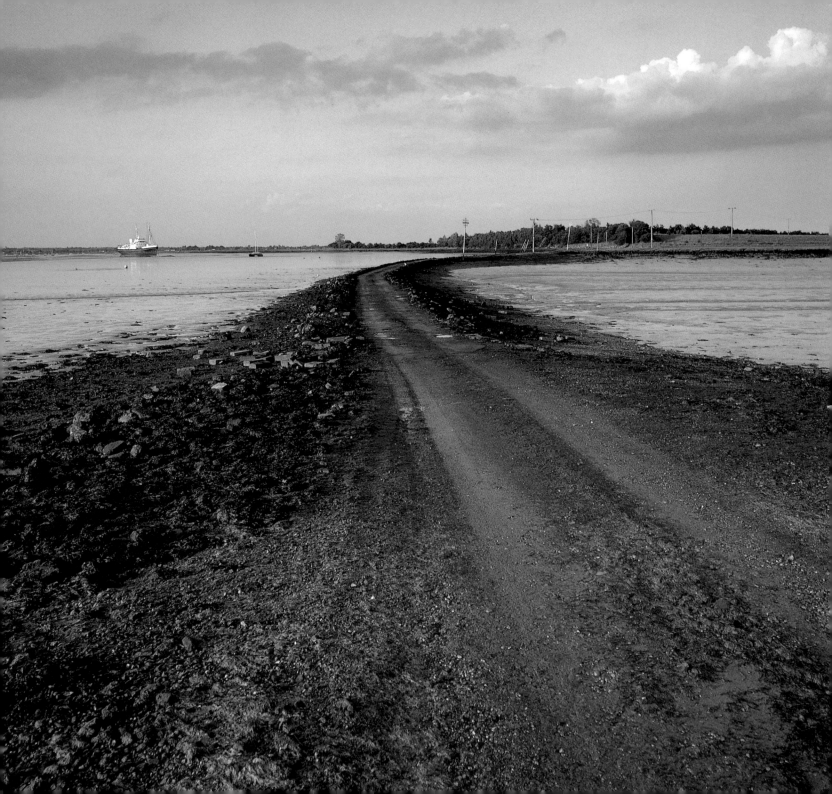

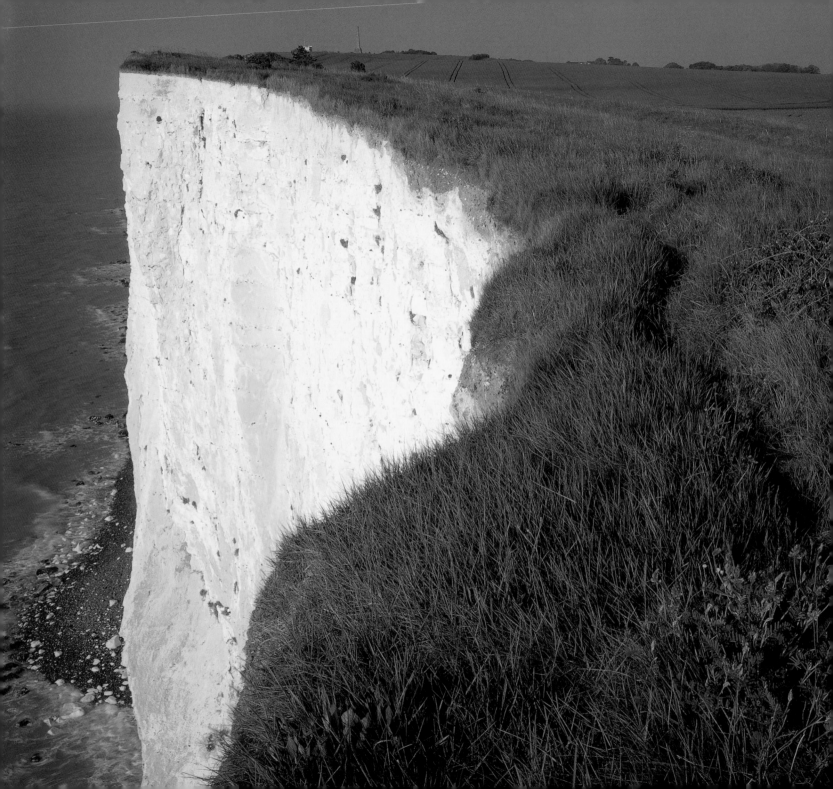

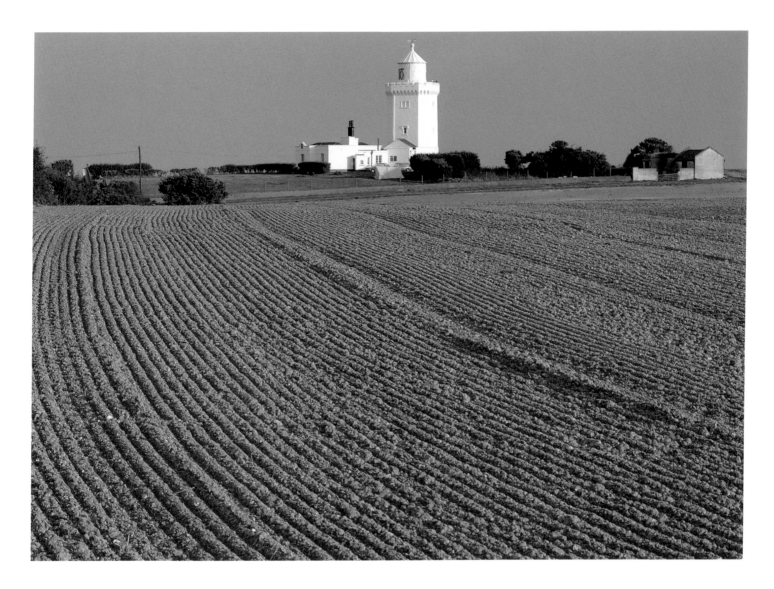

The famous WHITE CLIFFS OF DOVER, and of the Kent coast are the result of the North Downs meeting the English Channel. The seas on this stretch of the coast are notoriously treacherous, especially the shifting shoals of the Goodwin Sands. This was recognised by the Romans, who built the first lighthouse in Britain at Dover. On the edge of the downland near St Margaret's stands another pioneering lighthouse, the SOUTH FORELAND (*above*), built in 1843, originally lit by an oil lamp, but later converted to electricity, the first in the country to be so powered. From South Foreland, Marconi made the first contact by radio with the East Goodwin lightship on Christmas Eve 1898. [JC]

Left: Sunrise reflected on the cliffs, with South Foreland just peeping over the horizon. [PW]

The chalk of LANGDON CLIFF, just east of Dover, gleaming white in the sunlight, was formed over 100 million years ago from the shells of microscopic shrimps, which settled at the bottom of the ocean. After the last Ice Age this part of south-east England became grassland, while the rest of the British Isles was covered in forest; this has resulted in a number of plant species which have remained local to the area. [PW]

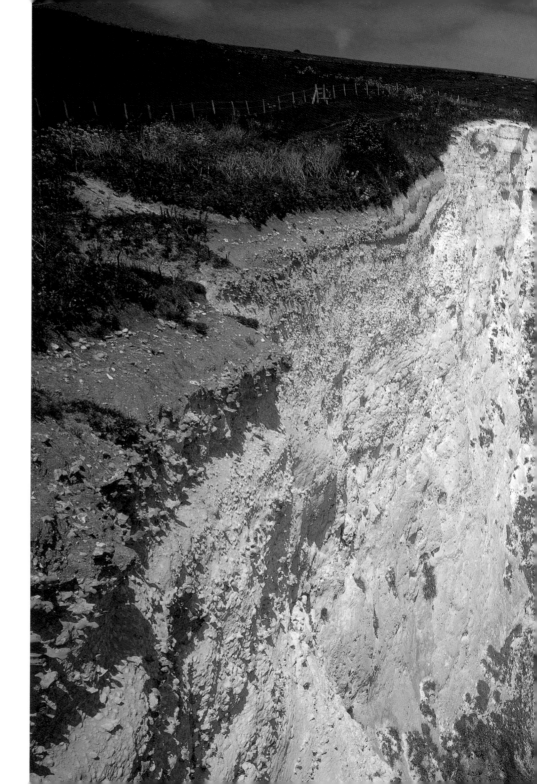

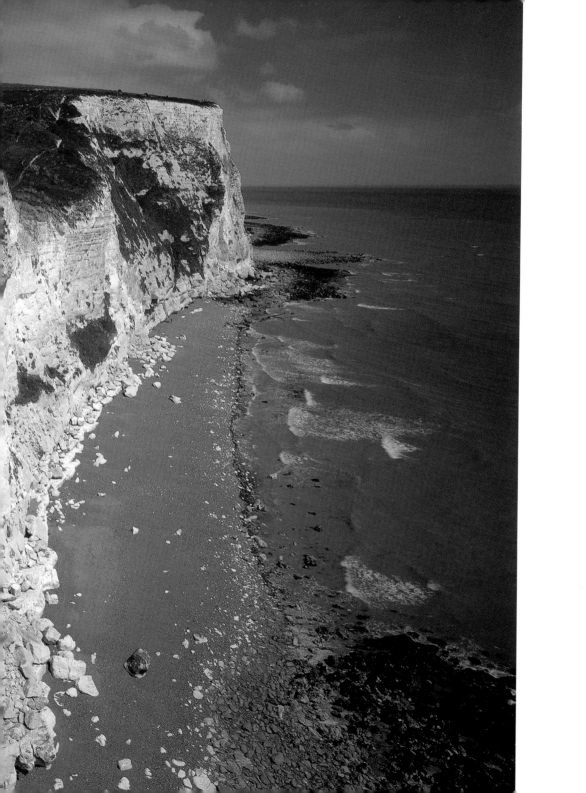

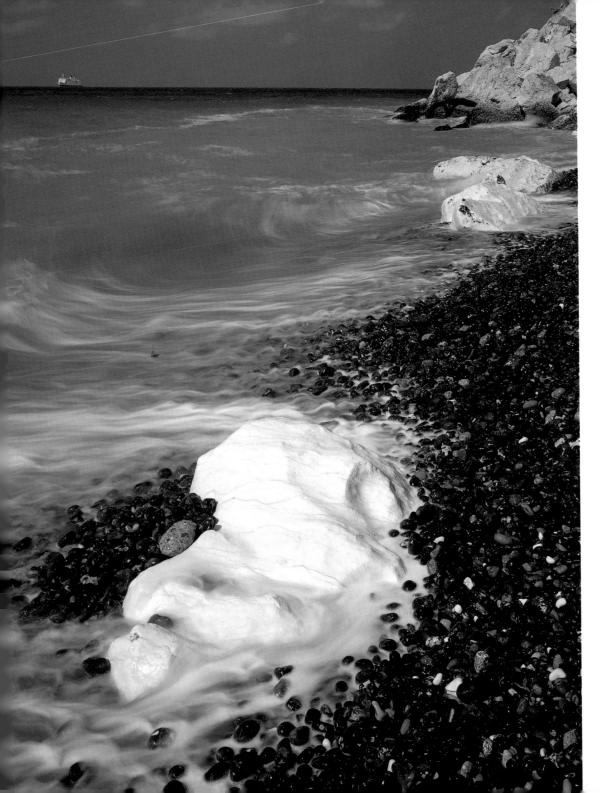

Right: Down on the beach at ST MARGARET'S BAY, where the boulders cluster like huge sculptures at the foot of the chalk cliffs. [PW]

Left: This is the nearest point to France on the British main-land and is the traditional starting or finishing point for cross-Channel swimmers. [PW]

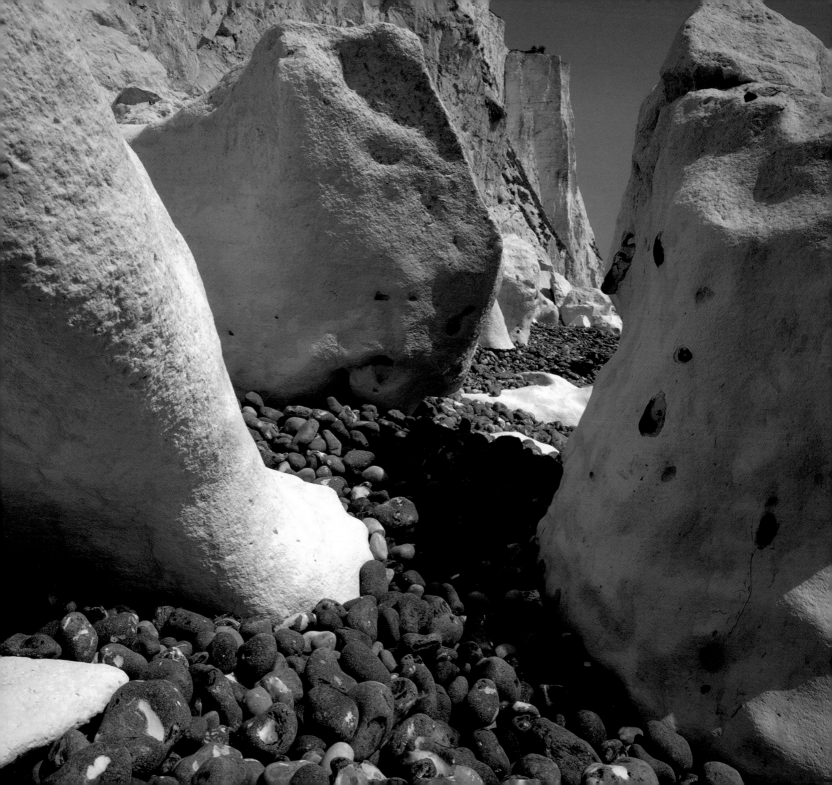

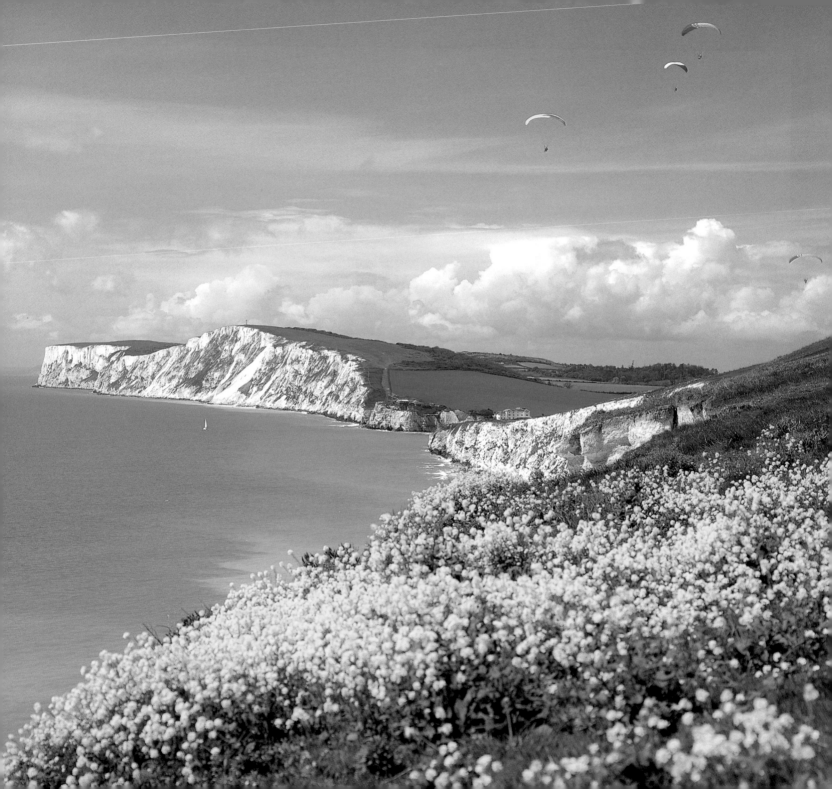

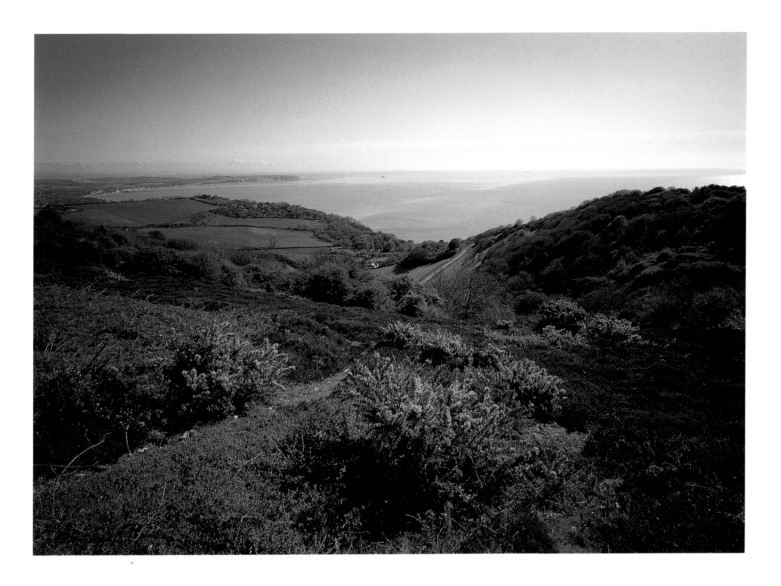

The National Trust looks after eighteen miles of coast on the Isle of Wight. *Above:* BONCHURCH DOWN in South Wight is a coastal heath on chalkland, a habitat very vulnerable to scrub development. The Trust maintains the heathland by grazing with semi-wild New Forest ponies, and with feral goats. [JC]

Left: Paragliders hovering over TENNYSON DOWN on West Wight. The Down was given to the National Trust in 1927 by his son in memory of the Victorian poet, Alfred Lord Tennyson, who walked there daily when living at Farringford. Beyond lies West High Down, providing the final link of the western tip of the island to the Needles. [JC]

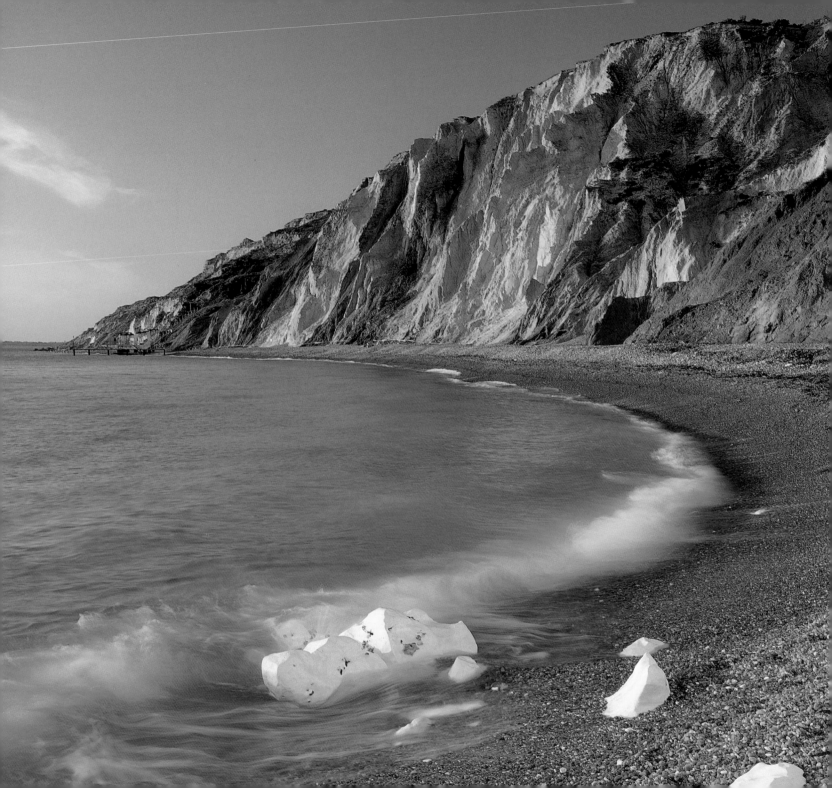

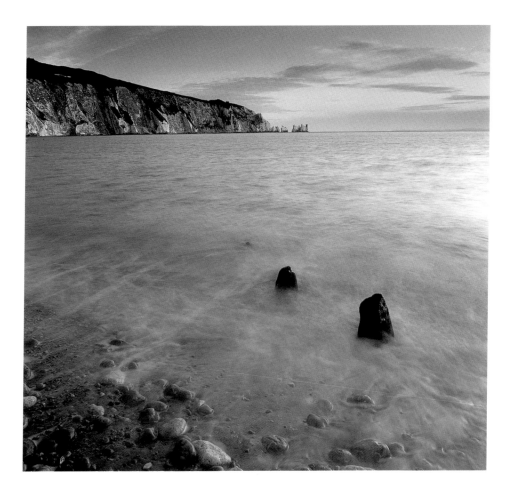

ALUM BAY on the Isle of Wight, where the famous coloured sands, running from deep reds to greens and blues, are created by the minerals that have seeped into the chalk.

Left: Looking towards Hatherwood Point.

Right: View of the NEEDLES, three dramatic pinnacles created by erosion of the chalk cliffs. A lighthouse stands on the most seaward, while built into the cliff is the nineteenth-century Old Battery, part of Lord Palmerston's system of defence of the Solent. [JC]

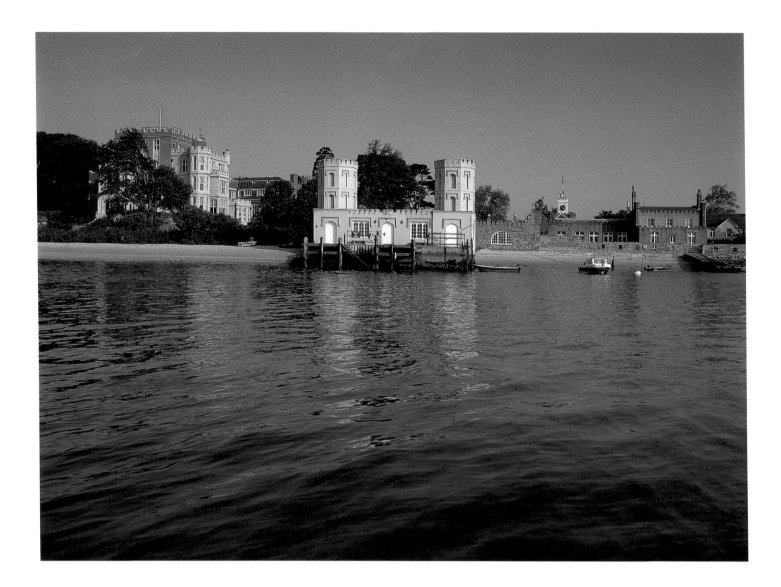

BROWNSEA ISLAND represents an oasis of quiet and a sanctuary for wildlife in the midst of Poole's highly commercialised harbour. This character was reinforced by Brownsea's last private owner, Mrs Bonham Christie, who lived here in seclusion from 1927 until her death in 1961, when the island was transferred to the National Trust. *Right:* The lagoon at Brownsea. [JC]

Above: Visitors to the island arrive at the quay, with its coastguard cottages and landing stage in Gothick style. To the left is Brownsea Castle, originally constructed by Henry VIII in the 1540s as part of his revamping of the defences along the south coast, but rebuilt at the end of the last century and now run by the John Lewis Partnership as a holiday home for staff. [JC]

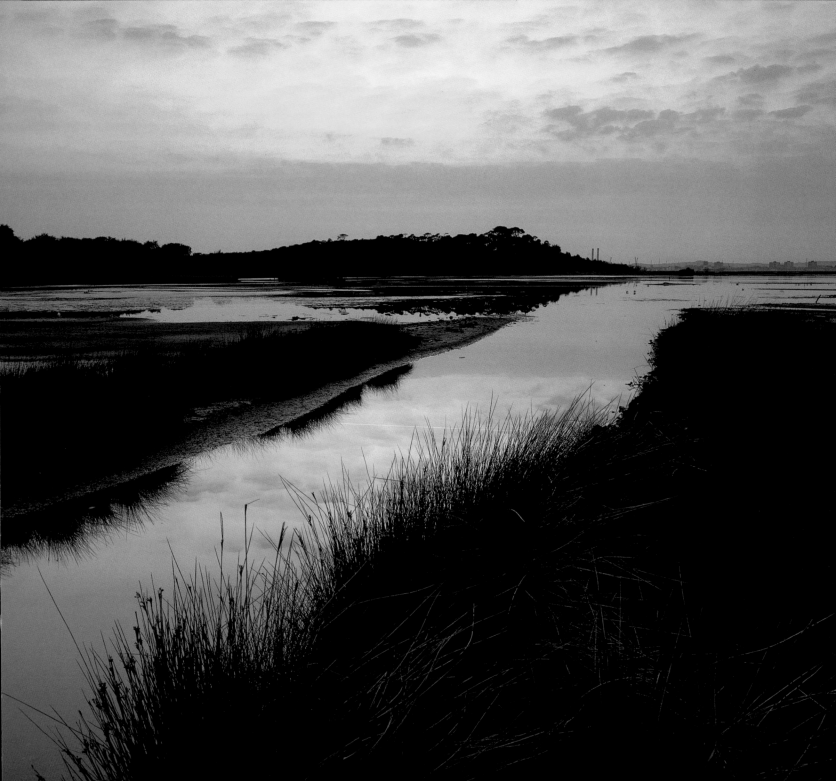

Right: BROWNSEA ISLAND lies in Europe's largest natural harbour, at Poole in Dorset. The peacock is sitting on a memorial commemorating the first camp set up here in 1907 by General Baden-Powell, from which sprang the Boy Scouts' Association. [JC]

There has been a settled community on Brownsea Island since prehistoric times, but perhaps the island's busiest period came in the nineteenth century when a pottery works was built on the north-west end, along with a worker's village named Maryland after the proprietor's wife. This village was largely abandoned when the island was bought by Mrs Bonham Christie in 1927. Opposed to blood sports and to the exploitation of animals by man in any form, she turned Brownsea into a wildlife sanctuary, now enjoyed by thousands of visitors. *Far right:* Trees and ferns growing over the remains of Maryland. [JC]

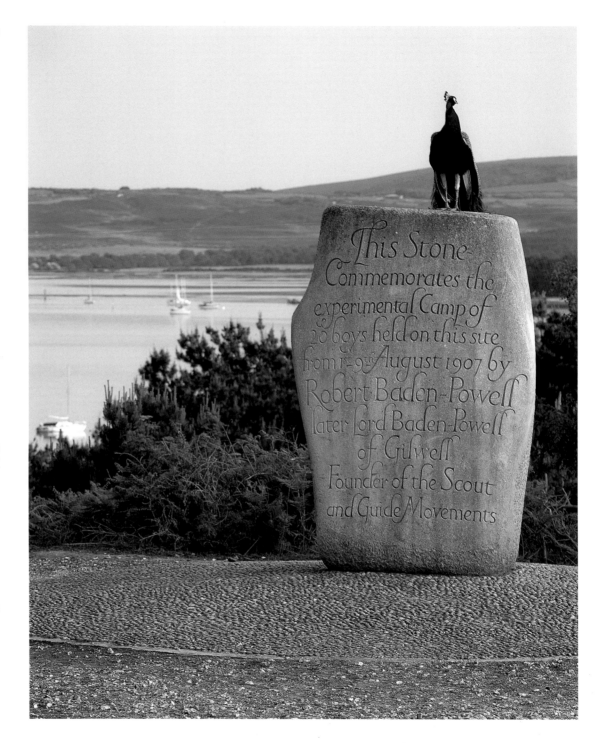

This Stone Commemorates the experimental Camp of 20 boys held on this site from 1 – 9th August 1907 by Robert Baden-Powell later Lord Baden-Powell of Gilwell Founder of the Scout and Guide Movements

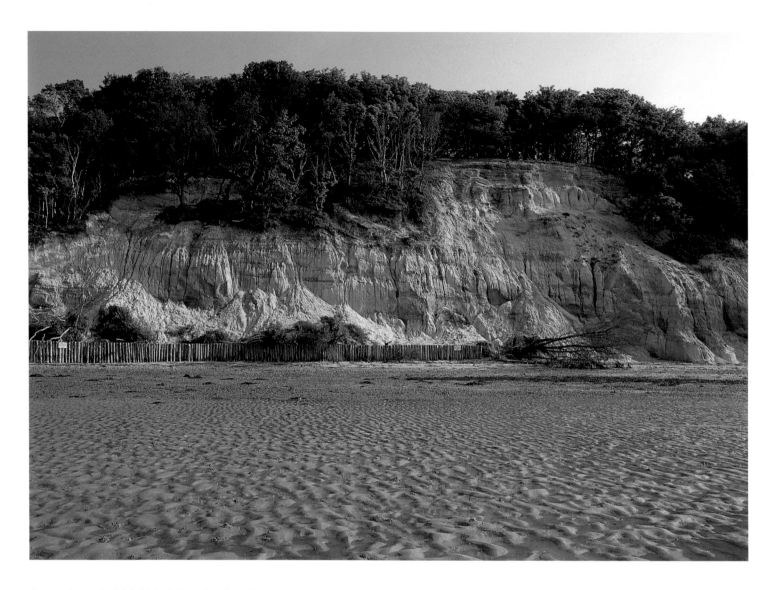

Approximately 120,000 visitors land each year on Brownsea, making their way into the island's interior to enjoy its wildlife. Brownsea is one of the few places where the red squirrel survives, and because it is an island, is easier to defend than the colony at Formby. It is also a breeding site for terns, visiting waders and wildfowl.

Above: Beach and cliffs on the south east corner of Brownsea. Dredging to enable large ships to enter Poole Harbour has resulted in erosion of the cliffs. The National Trust has sunk huge quantities of stone to break the force of the waves, but the current problem is to know what to do next. [JC]

Right: The northern half of the island is let to the Dorset Wildlife Trust and managed as a nature reserve. [JC]

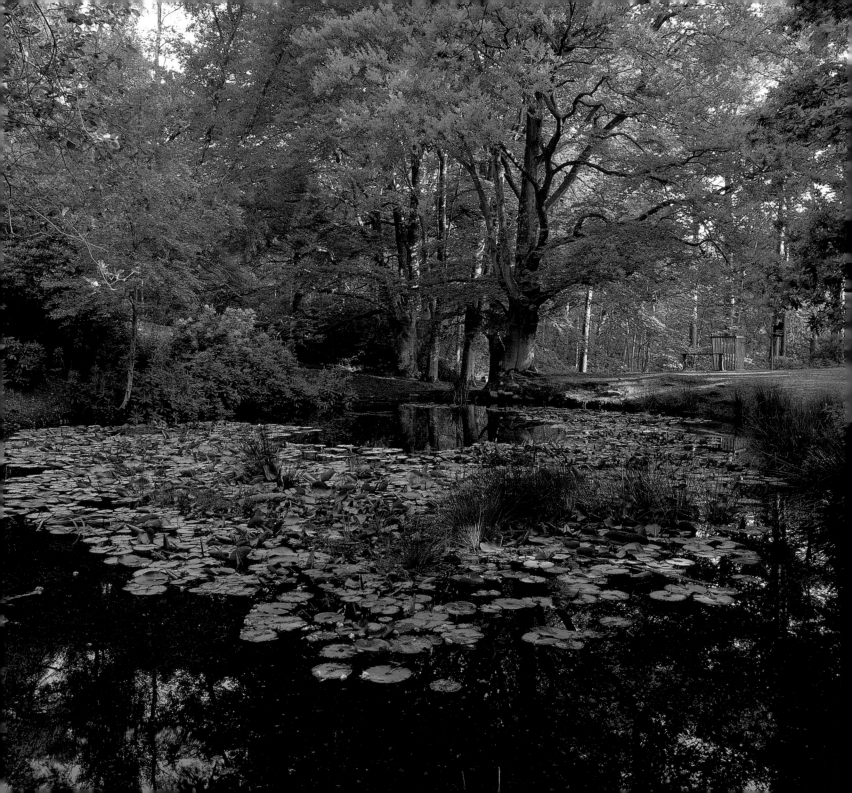

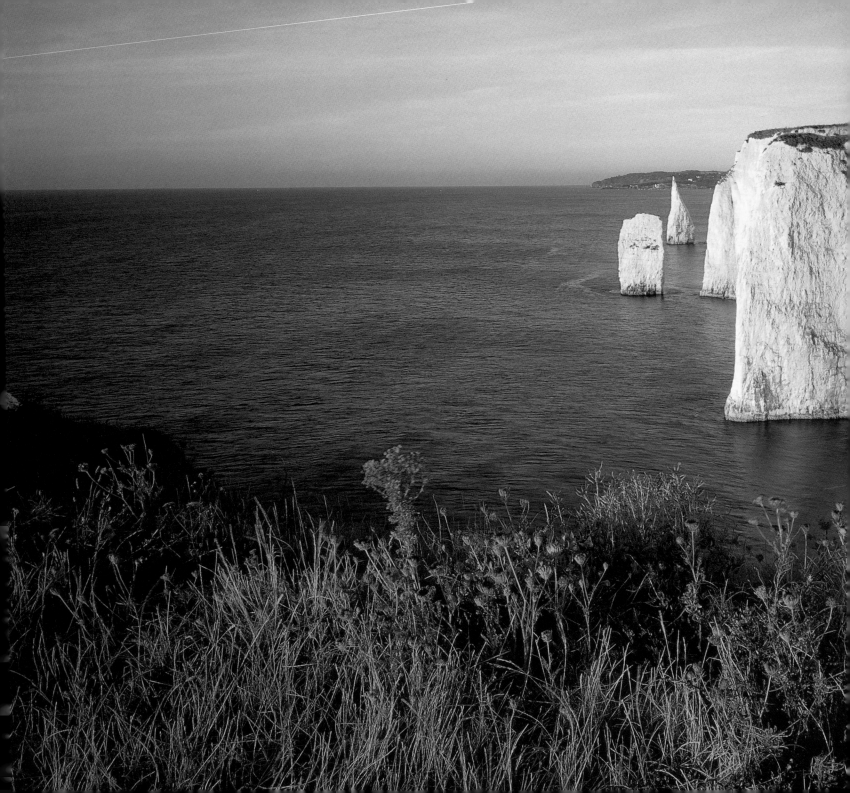

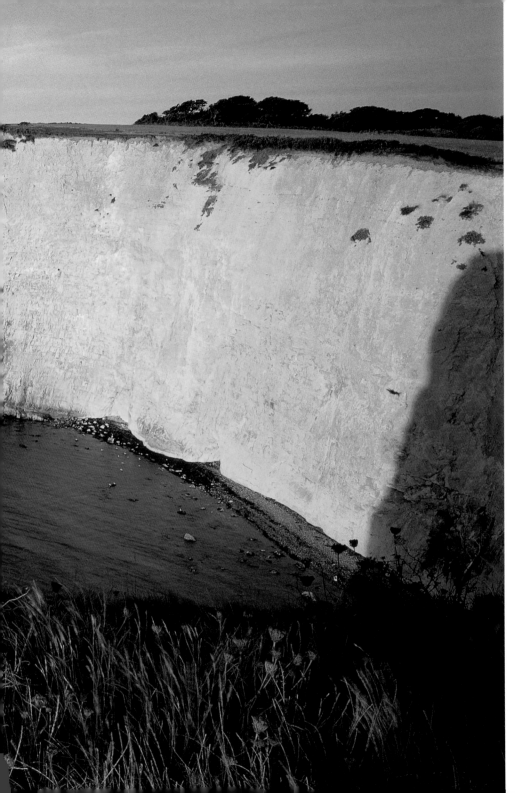

The chalk rocks of the Needles are linked westwards with the crumbling chalk stacks of Old Harry Rock and Old Harry's Wife on the eastern shore of the ISLAND OF PURBECK in Dorset. Purbeck is, in fact, not an island at all, but a rectangular peninsula ten miles long by seven miles wide. It includes Poole Harbour, and on the western side St Aldhelm's Head and Lulworth Cove. [JC]

Right: The last rays of the sun on St Aldhelm's Head near Seacombe on the Isle of Purbeck. This is a highly worked landscape, for the Purbeck limestone has the character of high-quality marble, and has been quarried for centuries to be shipped out for cathedrals and palaces. The Seacombe quarries, abandoned in the 1930s, form man-made caves in the sea cliffs, now the residence of bats. [JC]

Far right: Eastington Farm on Purbeck. Sheep grazing the turf encourage chalk downland flowers such as orchids and vetches. A little below Eastington Farm is a man-made rabbit warren, in appearance not unlike an ancient long barrow. As at Murlough, rabbit farming provided a valuable source of protein in medieval times. [JC]

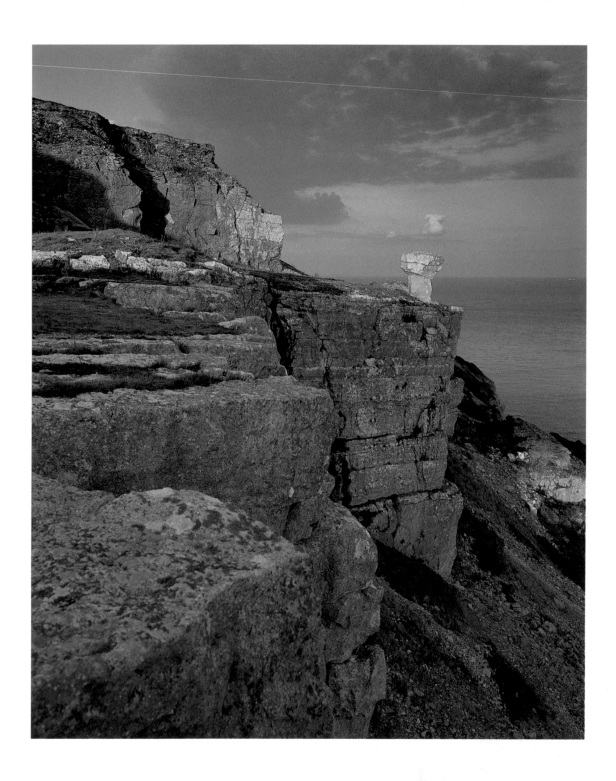

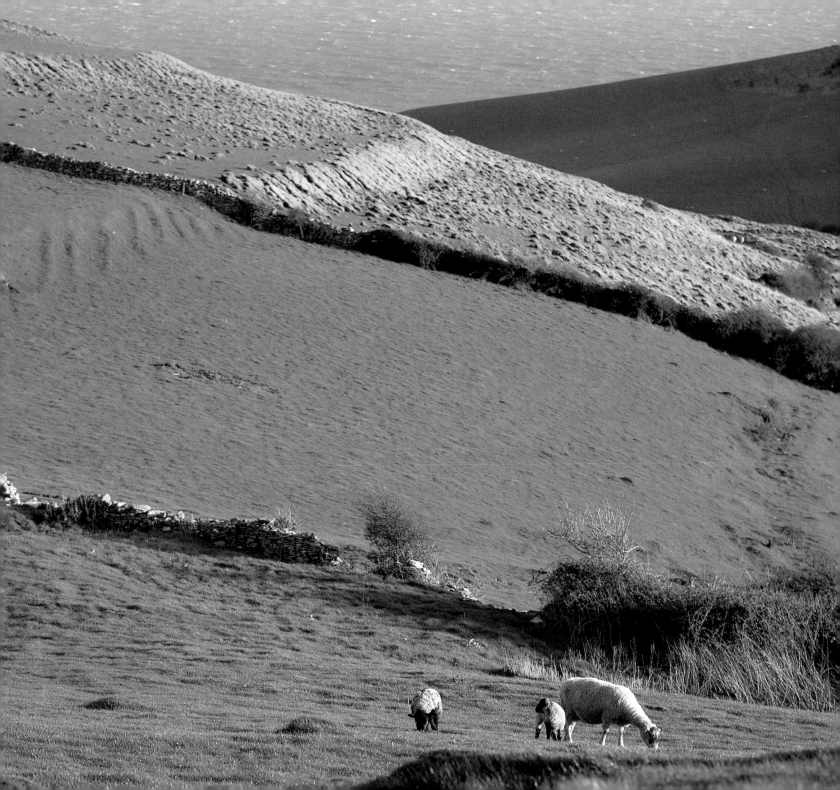

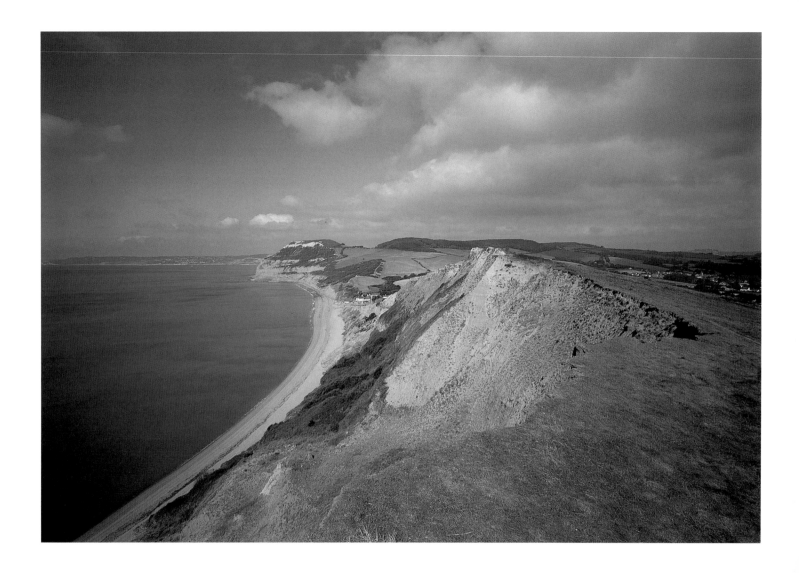

GOLDEN CAP on the Dorset coast gets its name from the band of green sandstone that glistens as the sun strikes the cliffs, with a view eastwards along the beach to St Gabriel's Mouth with Portland Bill in the background (*right*). Above the sandstone lies a thin layer of cherty soil, and below a bed of blue lias clay, which is often treacherous and on the move, as is demonstrated by the landslip that runs right through the seaside resort of Lyme Regis. This complex geology from the Jurassic period results in an area rich in fossil remains. [JC]

The National Trust has gradually been accumulating its Golden Cap estate and now owns 2,000 acres (800 ha) in one continuous spread. Most of the holding is accommodation land; land without buildings let to nearby farms. *Above:* Farmland on the clifftops looking west towards Seatown and Lyme Bay. This land is steep and hilly, with thin soil, so it is mostly used for grazing sheep and cattle. [JC]

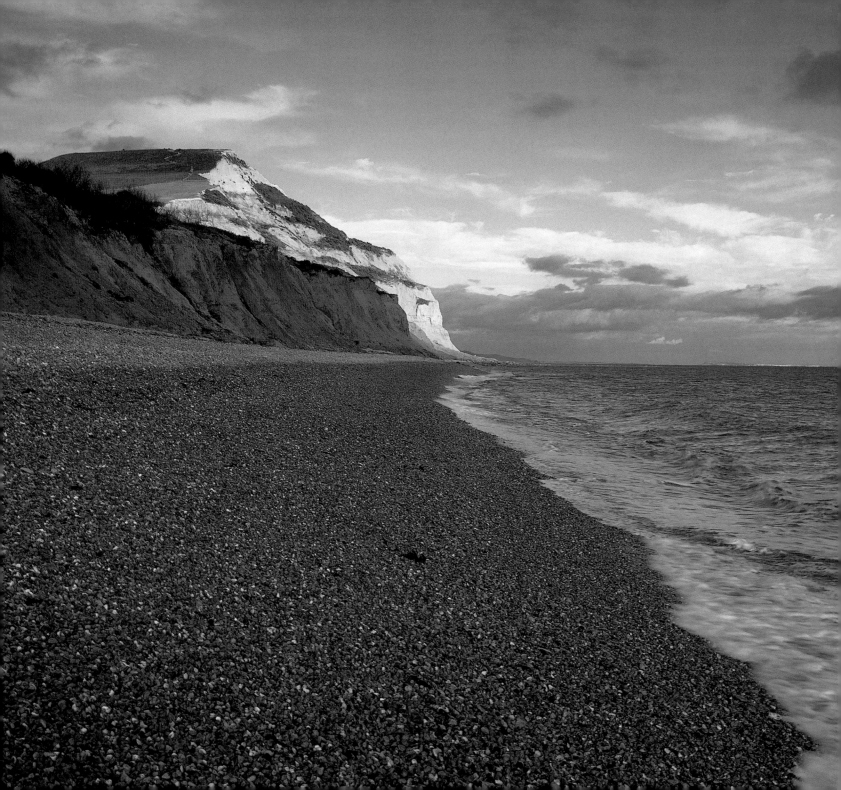

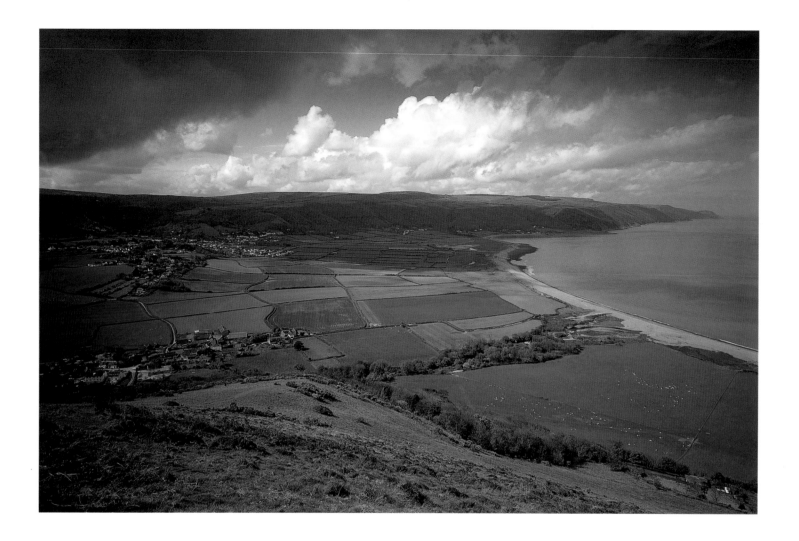

The view from Bossington Hill on the HOLNICOTE ESTATE, looking down towards Bossington Beach in Porlock Bay on the north Somerset coast (*above*). [JC] Since this photograph was taken in April 1993 the landscape has changed as the National Trust has undertaken managed retreat of the bay. As the shingle holding back the sea (*right*) is breached, so the farmland behind Bossington Beach reverts to a saltmarsh habitat. [JC]

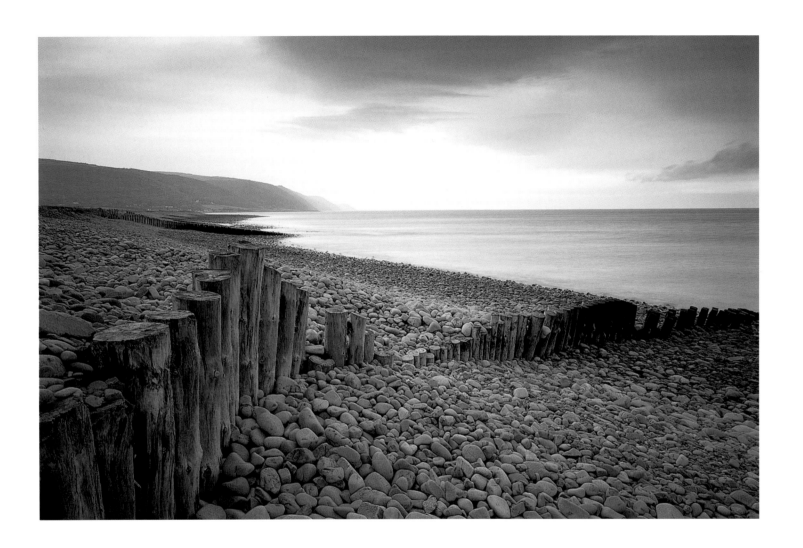

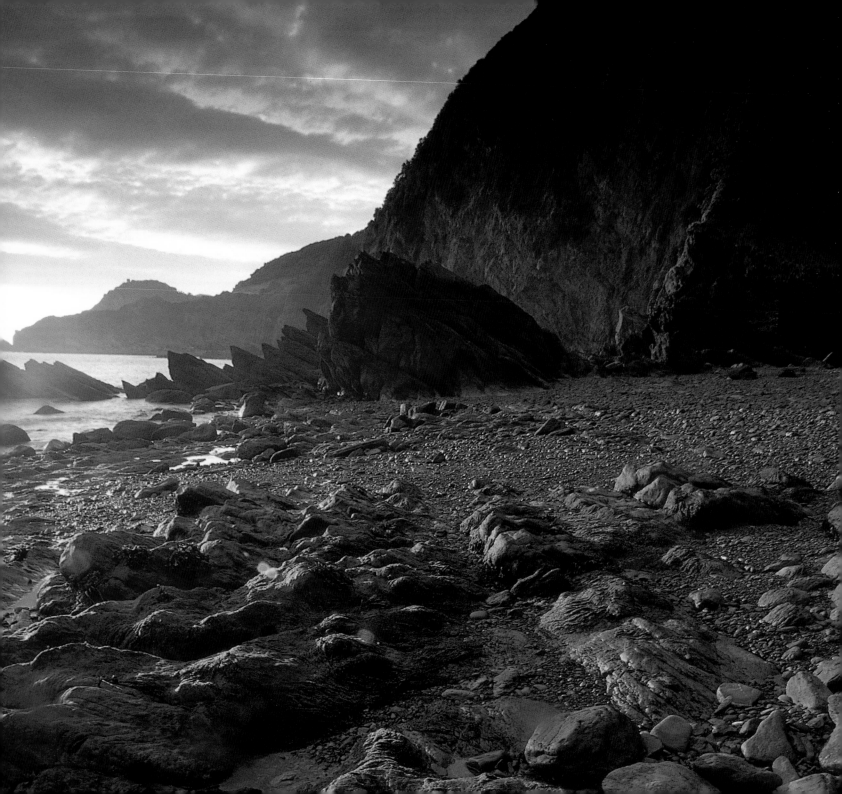

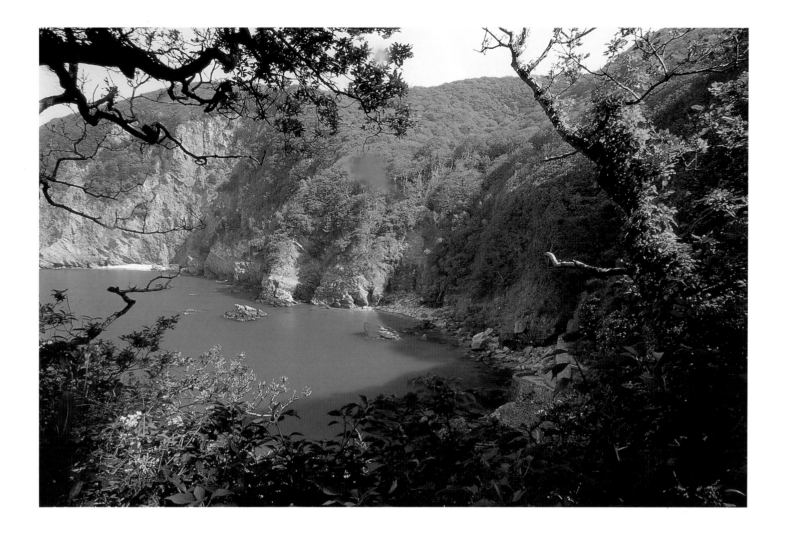

The north Devon coast, forming the western extremity of the Exmoor National Park, is particularly beautiful: a landscape of heather moorland, cliffs, deep wooded combes and isolated hamlets. WOODY BAY, (*above*) with its hanging oak woods swooping down to the seashore, has a secretive feel, yet once it was a port of call for paddle steamers plying the Bristol Channel. [DN] *Left:* The stump of a pier recalls its former bustle; now it is the haunt of seabirds like the fulmar and the kittiwake. [DN]

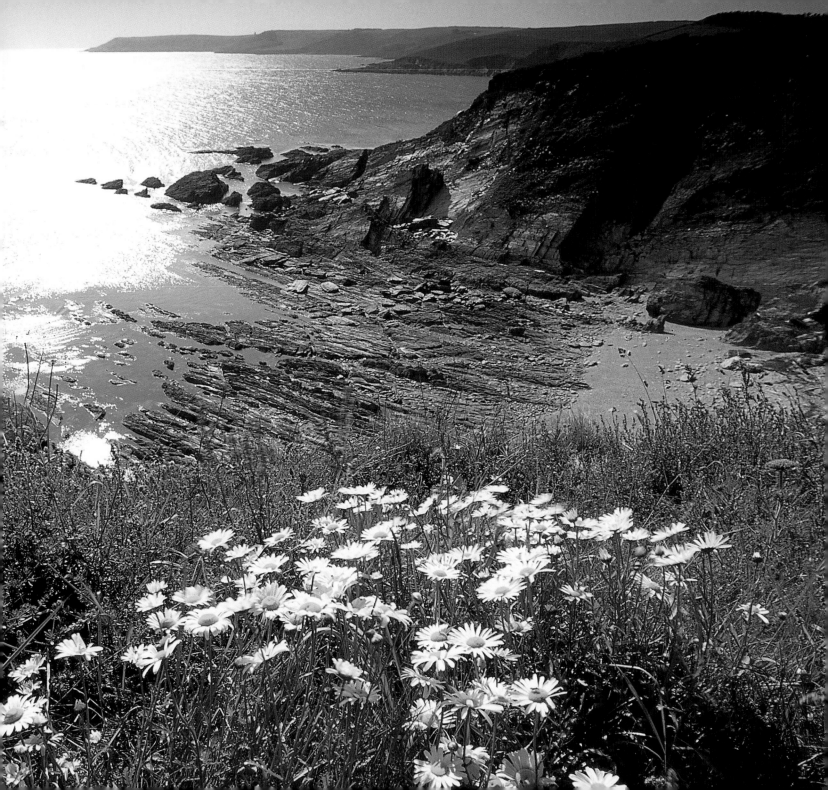

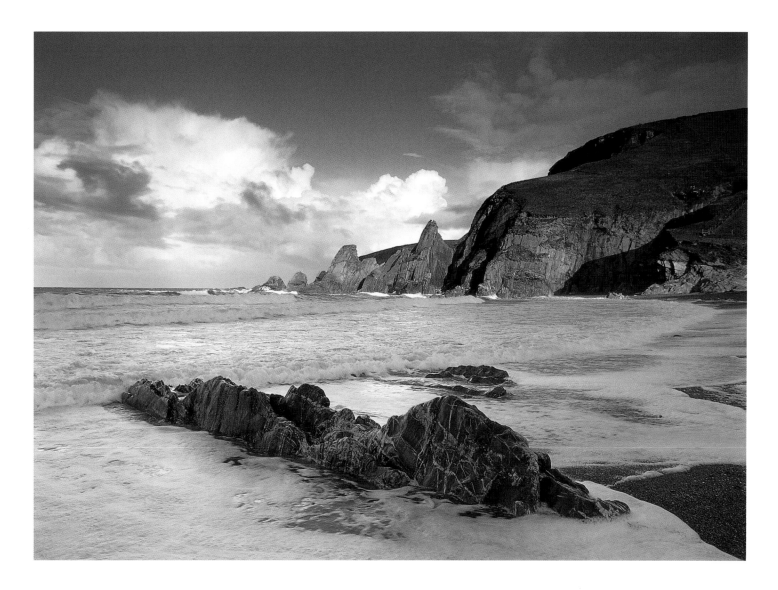

The vulnerability of SCOBBISCOMBE FARM near Kingston, south Devon, has been recognised for the past 25 years; indeed the Trust has made three previous attempts to secure it from development, each failing for lack of funds. Now, thanks to the generosity of Enterprise Neptune donors, a grant from the Heritage Lottery Fund and a magnificent bequest from the late Mrs Hornby, left to benefit her favourite part of the Devonshire coast, the farm, with its majestic cliffs and wooded combe running down to two remote beaches, is safe for ever. [DN]

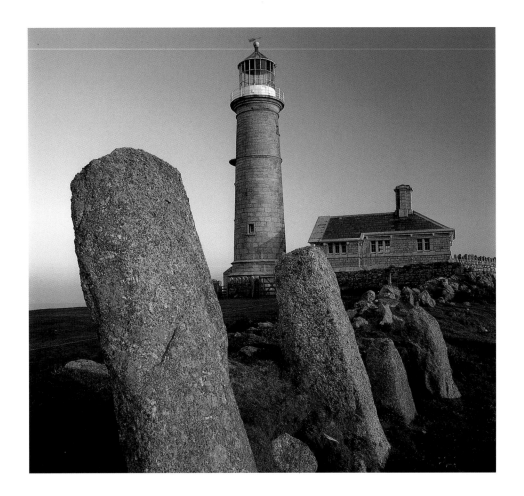

LUNDY is the top of an undersea mountain of granite, rising out of the Bristol Channel eleven miles north of Hartland Point on the Devon coast. *Right:* The west side of the island is the most rocky, and peeping out from the highest point is Old Light, a stone tower built in 1820. The fogs of the Bristol Channel obscured its beam to such an extent that ships were driven onto Lundy's reefs. [JC]

To counter this, two new lighthouses were built, the North and South Lights, at the foot of the cliffs at either end of the island. *Above:* Old Light seen through the grave-stones in the churchyard. [JC]

Lundy, England's only statutory marine nature reserve, was bought in 1969 for the National Trust by 'Union Jack' Hayward in conjunction with the Landmark Trust who manages it.

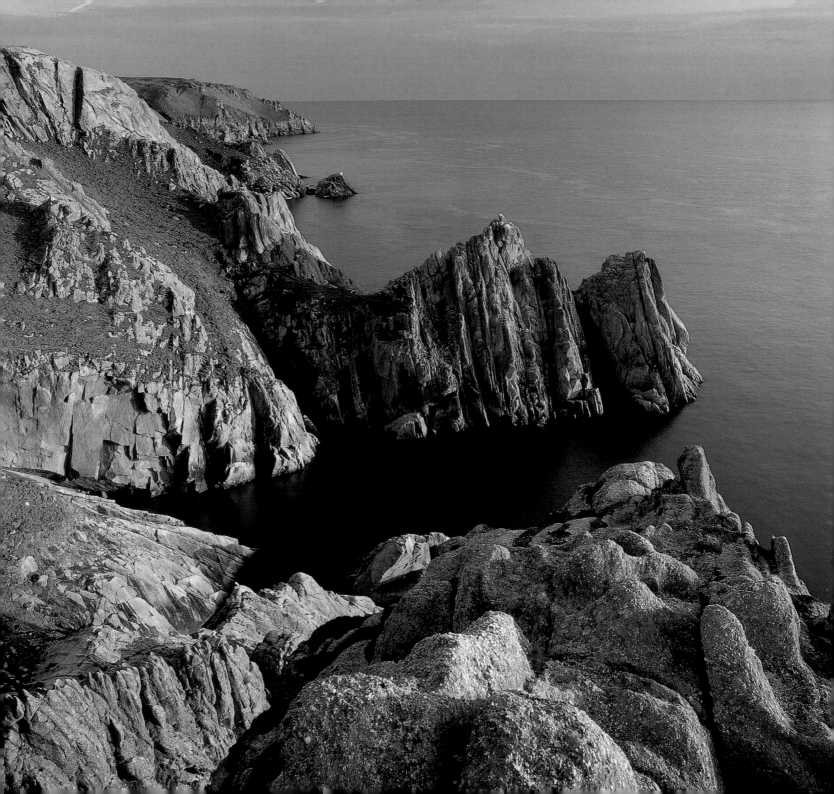

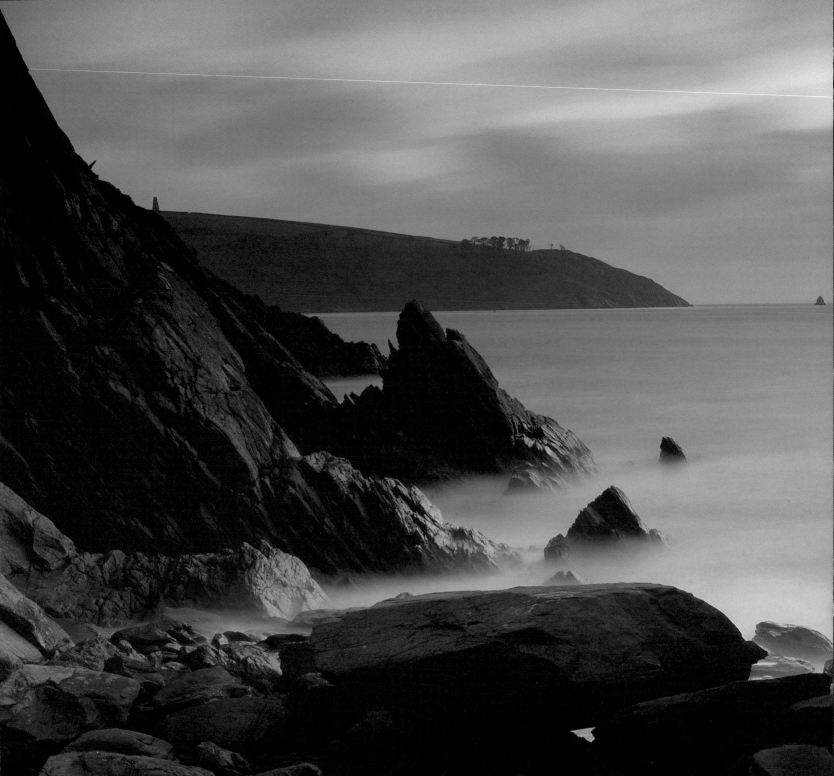

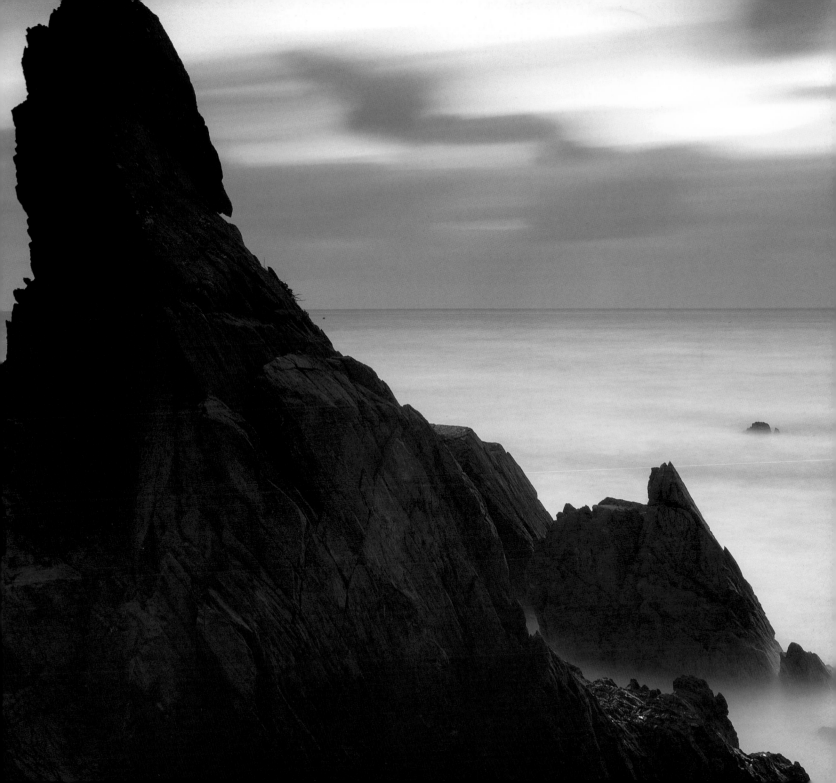

Previous pages: DARTMOUTH looking towards Coleton Fishacre on the south Devon coast. On the left is the day-mark set up by Trinity House to aid entry into the estuary. The Trust early acquired land along this coast to protect it from development of holiday towns, but there are still vulnerable areas: recently a farmer, refusing offers from housing developers, generously gave the National Trust Lower Halsdon Farm on the estuary of the Exe. [DN]

Right: SALTRAM HOUSE, just outside Plymouth, is a handsome early eighteenth-century mansion with rooms designed by Robert Adam and a fine collection of paintings, including several by Joshua Reynolds, born in Plympton and a close friend of the Parker family. The landscaped park lies along Plymouth Sound, with magnificent views over the water. The Trust is following a policy of allowing the River Plym to flood Blaxton Meadow through sluicing, and returning land to saltmarsh to encourage a brackish style of vegetation. [JC]

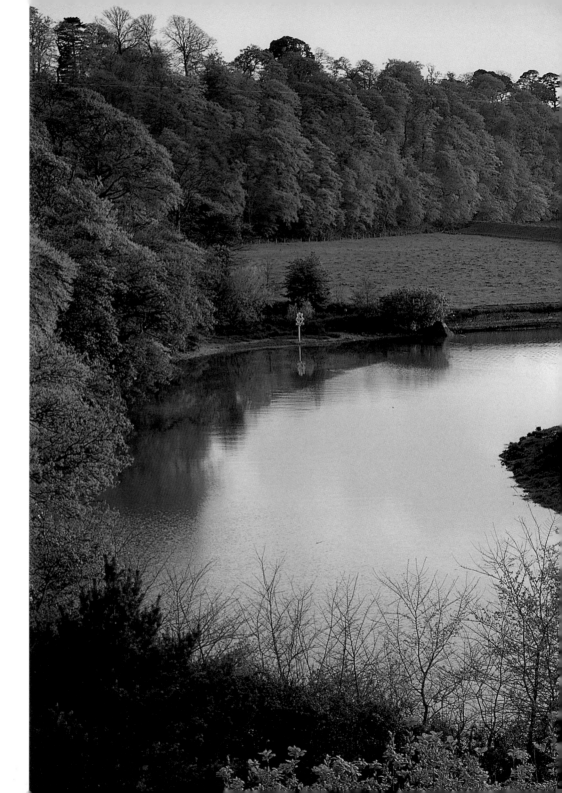

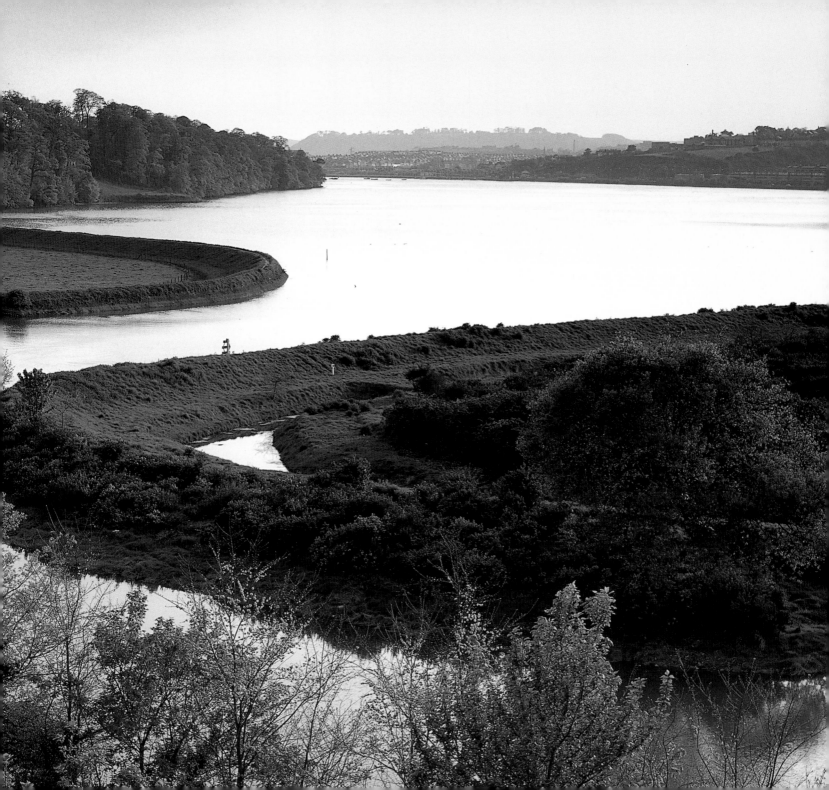

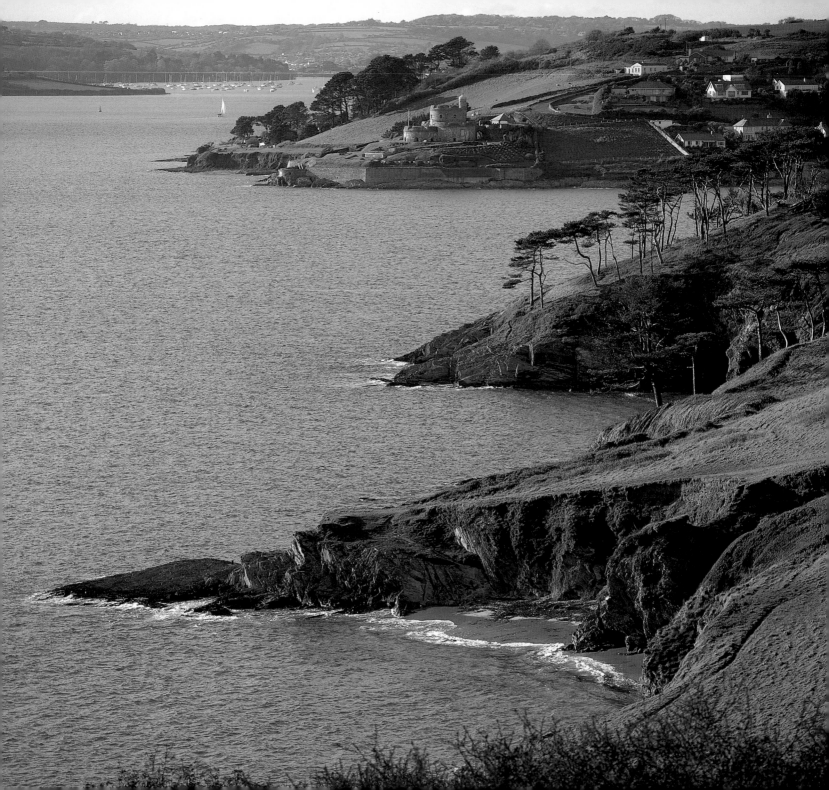

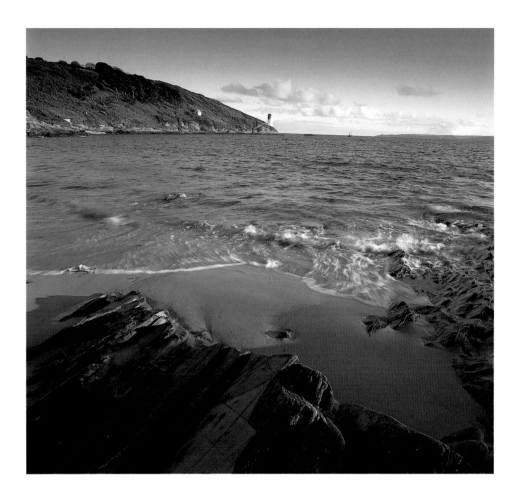

Cornwall is shaped like a bony finger pointing out into the Atlantic. This gives it a very long coastline, made even longer by inlets and headlands: indeed, Cornwall has more coast-line than any other English county. The National Trust protects forty per cent of this coastline, so this could be regarded as the heart of Neptune's kingdom.

While Cornwall's north coast is rugged and exposed, the south coast is much gentler, enjoying a kinder climate, producing a land-scape of flooded valleys that provide excellent harbours.

Left: The view from ST ANTHONY HEAD looking towards St Mawes. The castle set up on the cliff was built by Henry VIII as part of his defence of the south coast against French threats in the 1540s. With its sister castle, Pen-dennis to the west, it protects the entrance to the deep water channel of Carrick Roads. [JC]

Above: The view in the other direction, look-ing from Great Molunan Beach towards St Anthony Head with a lighthouse at its foot. This headland was fortified in 1805, the year of Trafalgar, and continued to be manned by a coastal artillery unit until 1957, when the Trust bought the land with generous help from the local community. [JC]

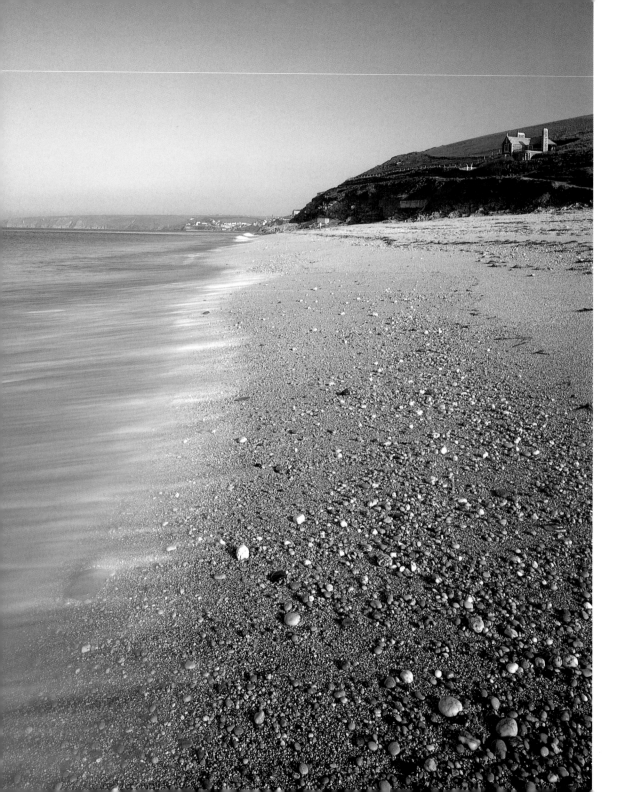

THE LOE is a freshwater lake over a mile long, separated from the sea by a shingle bar. Originally it was the estuary of the River Cober with the port of Helston at its head, but by the thirteenth century the bar had formed, rather mysteriously consisting of flint. Legend, however, claims it as the lake into which King Arthur threw his sword Excalibur. Today it provides a haven for wintering wildfowl.

Left: The Loe Bar that separates the lake from the sea, with Porthleven in the distance. [JC]

Right: Loe Pool, looking towards Lower Pentire, an eighteenth-century farmstead that has been converted into National Trust holiday cottages. [JC]

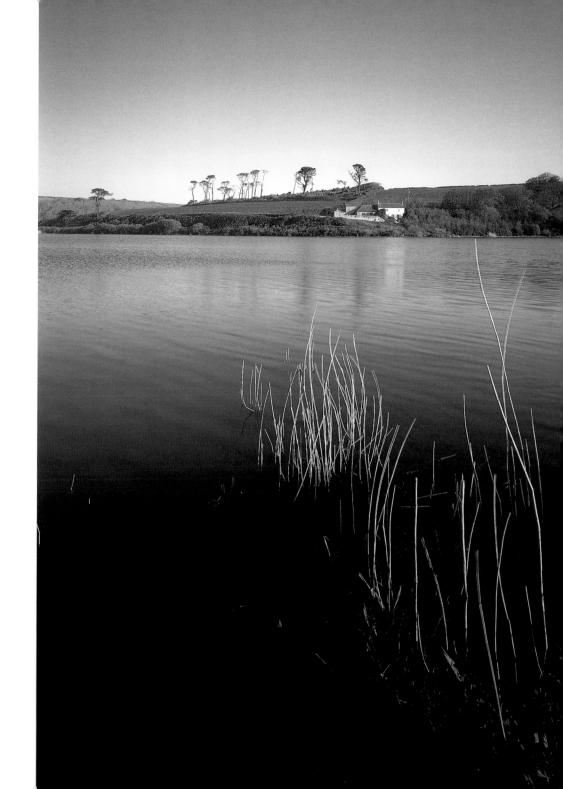

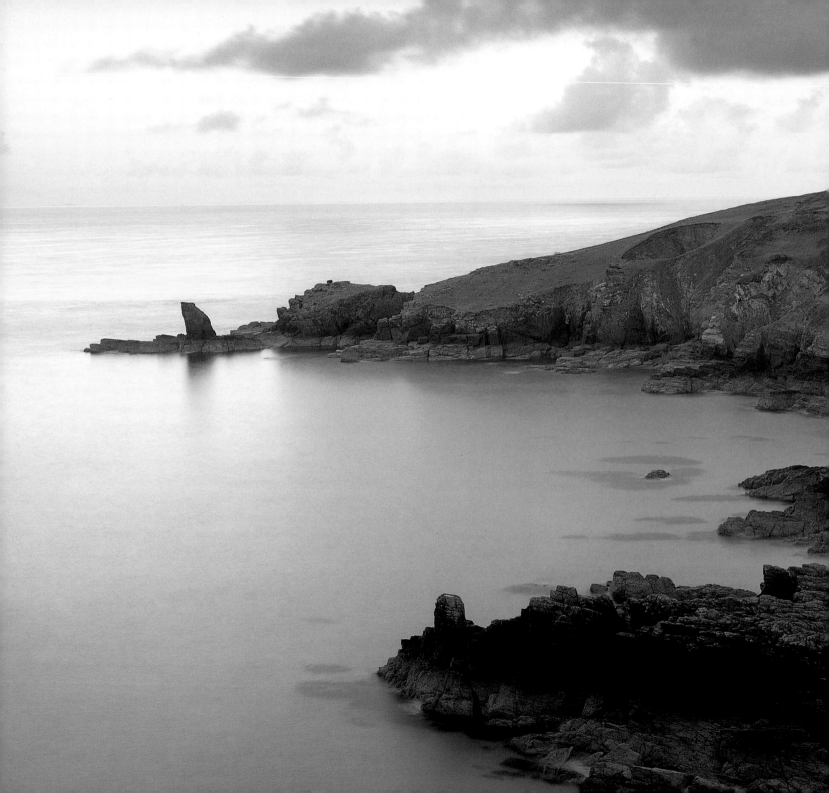

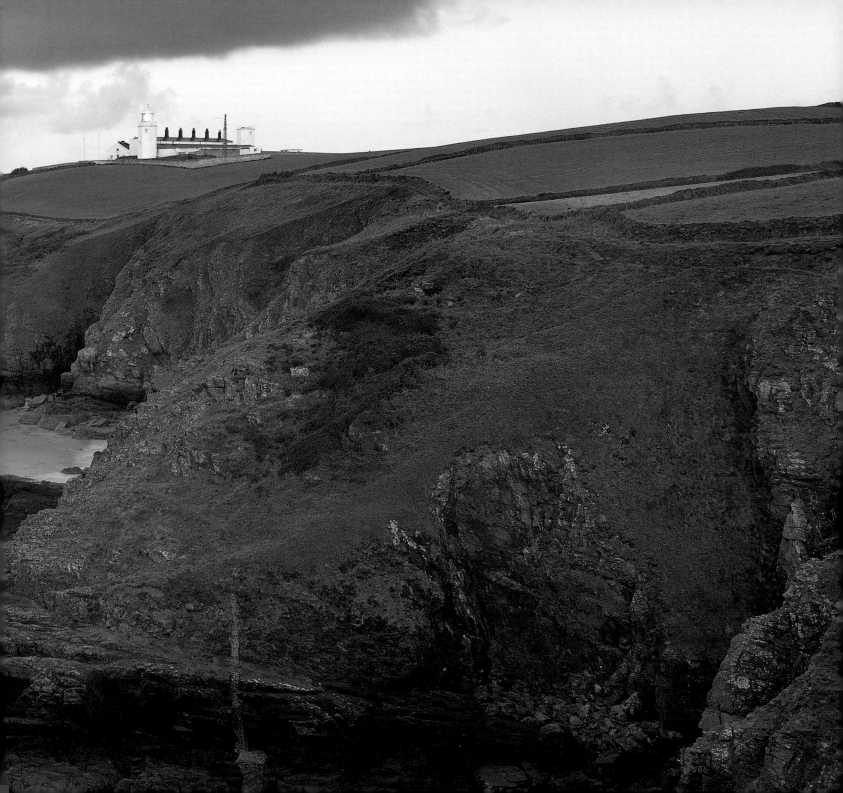

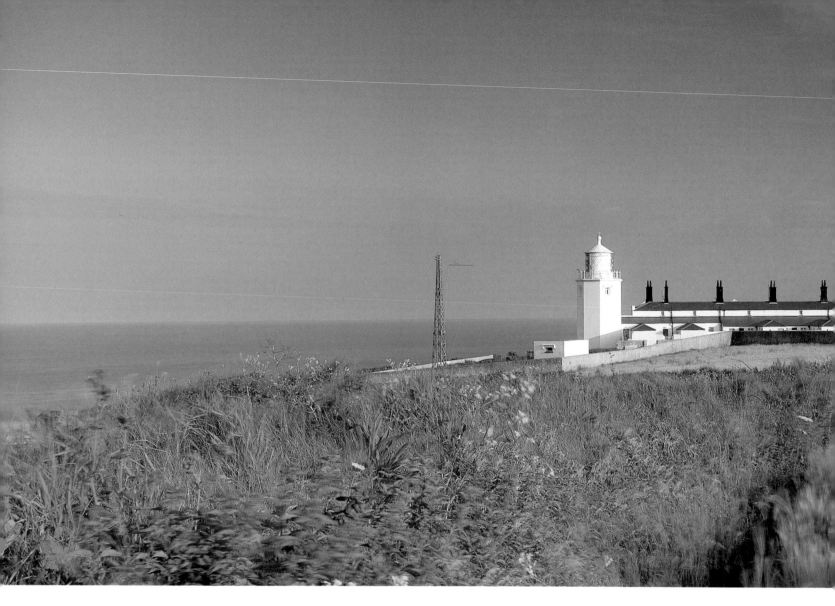

Previous pages: THE LIZARD is a broad, flat-topped peninsula terminating at Lizard Point, the southernmost extremity of mainland Britain. The two-towered lighthouse was built in 1751, with the light produced by burning coal. The 'overlooker' lay on a sort of couch in a cottage between the towers, using the windows on either side to view the lanterns. If the fires dimmed because the bellows blowers were not working hard enough, he would remind them of their duties by a blast from a cow horn. Now the lighthouse is to be automated and, it is hoped, will then pass from Trinity House to the care of the National Trust. [DN]

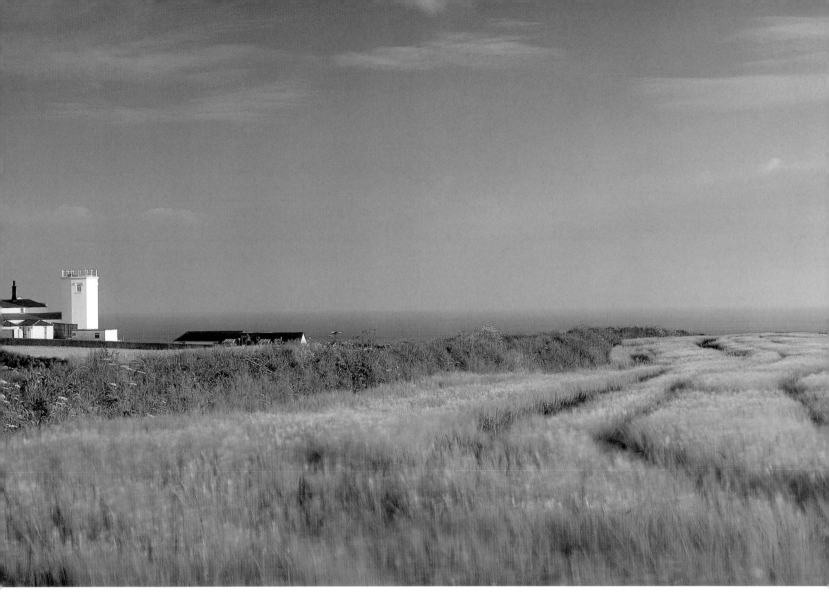

The underlying rocks of the Lizard Peninsula are of schist, gneiss, gabbro and serpentine. The last is a hard rock of reddish or greenish hue whose veiny texture reminded sixteenth-century geologists of the skin of a snake. Serpentine was once worked at Carleon Cove and, polished up, was used for fireplaces and ornamental urns. Today its use is reserved for small knick-knacks like model lighthouses, though stiles of serpentine can be found – and avoided in wet weather, when they become like ice.

This geology produces a rich and unusual botany, including the Cornish heath, a bright pink heather, the black bog rush, and very rare dwarf rushes. Some of the flora can be seen in the foreground of this photograph (*above*) in the traditional Cornish hedge that the Trust has built in local stone to overcome severe congestion of the road to Lizard Point. Pedestrians can now walk in safety along a parallel lane, leaving the road to wheeled transport. [DN]

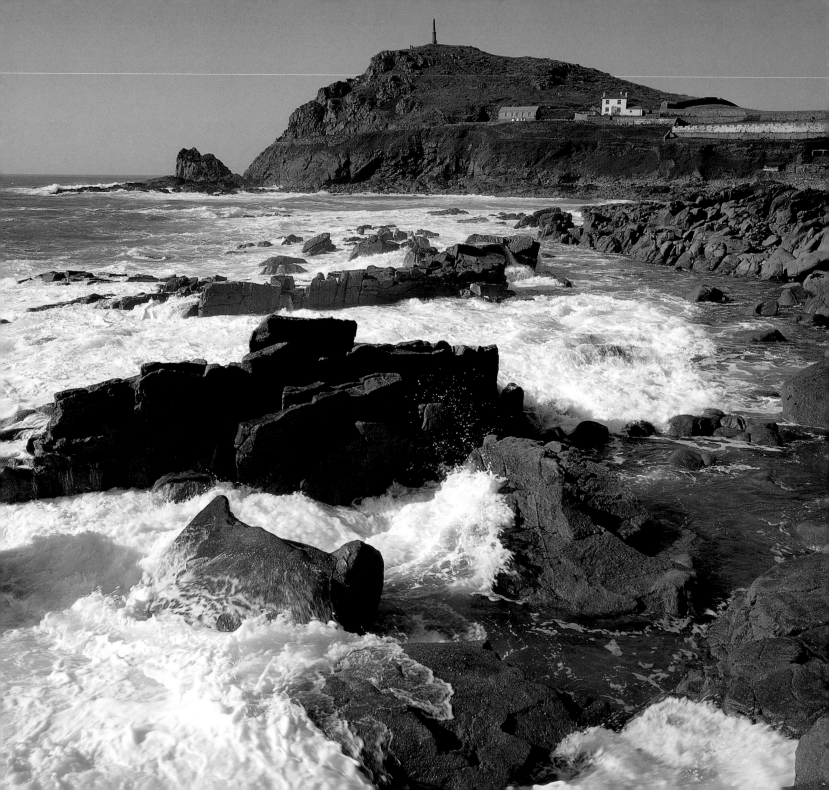

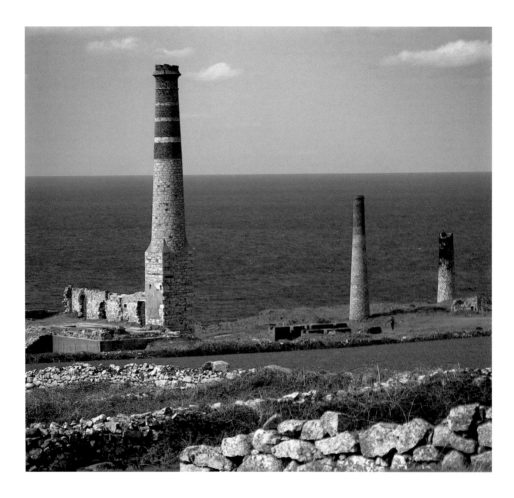

CAPE CORNWALL, the only cape in England, lies just four miles north of Land's End. It was given to the Trust by H.J. Heinz and Co. Ltd in 1987, as commemorated in a small plaque in the shape of a baked beans tin label set into the granite base of the chimney that can be seen on the headland. [JC]

WEST PENWITH seems to be a wild, isolated landscape, but reveals centuries of settlement: prehistoric field systems, cliff castles and burial mounds, engine houses and tin mines. Just to the north of Cape Cornwall is the mining town of St Just.

Over the past ten years, the Enterprise Neptune Appeal has helped the Trust to acquire some four miles of this coastline, thus protecting such beautiful areas as Kenidjack, Bollowall and Nanjulian Farm, and preserving important features such as the Levant Beam Engine. Until 1991, when the last mine closed, the rugged coast and moorland had been mined for tin and copper for over 2,000 years, and the remoteness of the area has enabled this extraordinary mining landscape to escape the pressures of development, instead decaying gently back into the 'natural scenery'. [JC]

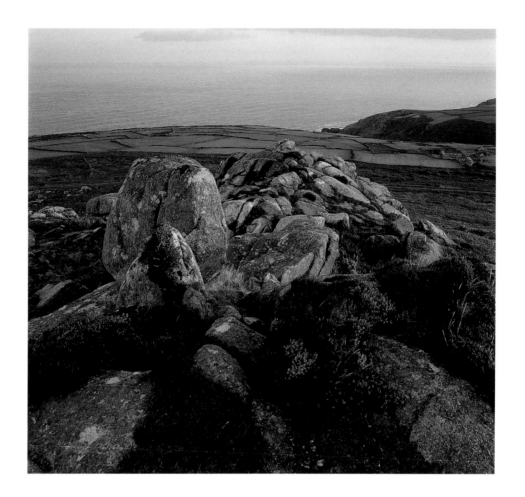

Looking down from Carn Galver towards BOSIGRAN FARM and the sea. The landscape of West Penwith is granite, giving a black soil that is surprisingly productive. Over the centuries farmers have painstakingly cleared their small fields and built up excellent holdings of beef cattle. The Trust encourages the tenant at Bosigran to continue to farm organically, grazing his livestock on the coastal heathland. [JC]

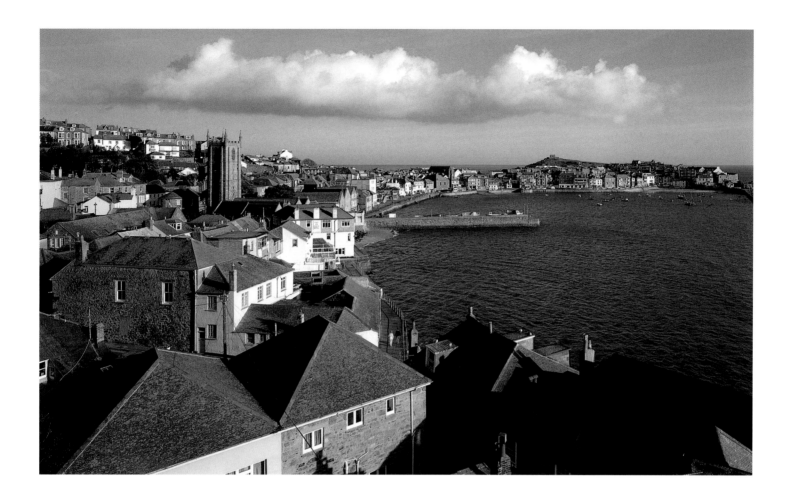

The seaside town of St Ives. In 1939 the sculptress Barbara Hepworth set up her studio in St Ives and found her inspiration in Penwith: 'I gradually discovered the remarkable pagan landscape which lies between St Ives, Penzance and Land's End; a landscape which still has a very deep effect on me, developing all my ideas about the relationship of the human figure in landscape – sculpture in landscape and the essential quality of light in relation to sculpture which induced a new way of piercing the forms to contain colour.' Other artists, such as painters Ben Nicholson, Peter Lanyon and Patrick Heron, and the potter Bernard Leach, joined her, creating the Penwith Society of Arts. [JC]

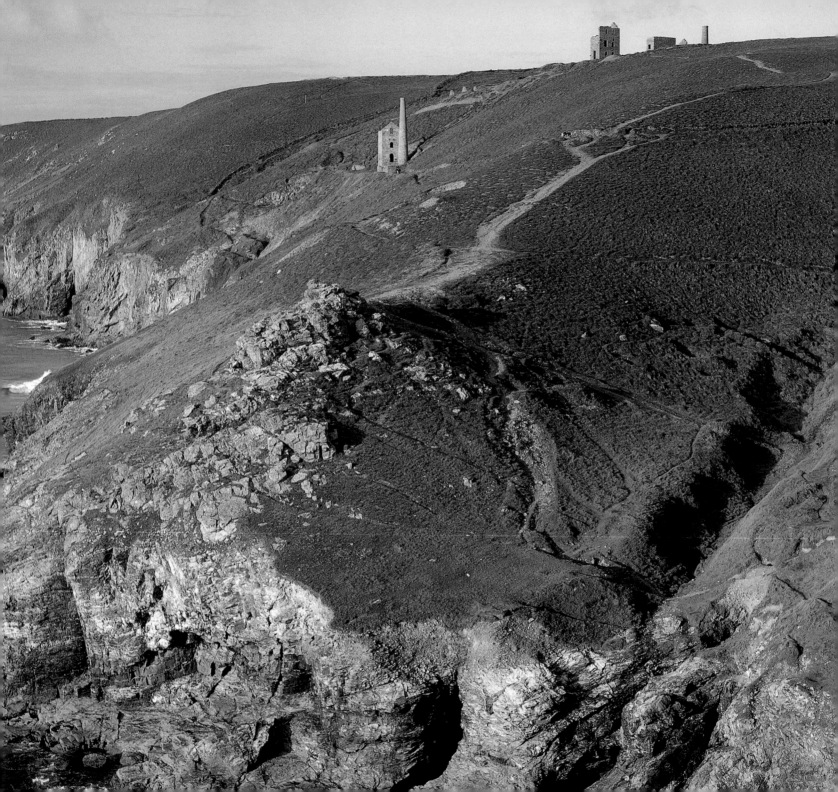

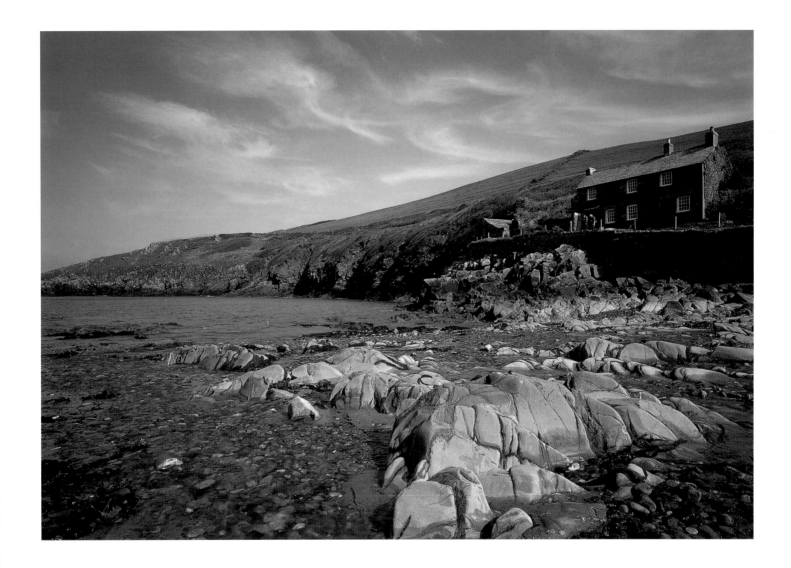

Above: In *The Making of the English Landscape* W.G. Hoskins wrote that Cornwall was 'the most appealing of all industrial landscapes of England, in no way ugly, but indeed possessing a profound melancholy beauty.' The roofless engine house and stack of the tin mine at WHEAL COATES, perched on the cliff-top above the narrow cleft of Chapel Porth. [JC]

Right: PORT QUIN, one of the centres for pilchard fishing in the nineteenth century. [JC]

Pilchards, known as Fair Maids of Cornwall, a corruption of the Spanish *fumedos* or smoked, represented an important industry for the West Country. But in the 1870s seine fishing collapsed, partly due to fall in demand, partly a change in movements of the fish.

When the pilchard industry was at its height, huge numbers of fish were dumped in the rectangular courtyards of fish cellars here and at Port Gaverne. Women 'bulkers' working at top speed would stack them between layers of salt along the cellar walls with their heads pointing outwards to a height of about five feet. The fish would remain like this for a month before being pressed into barrels.

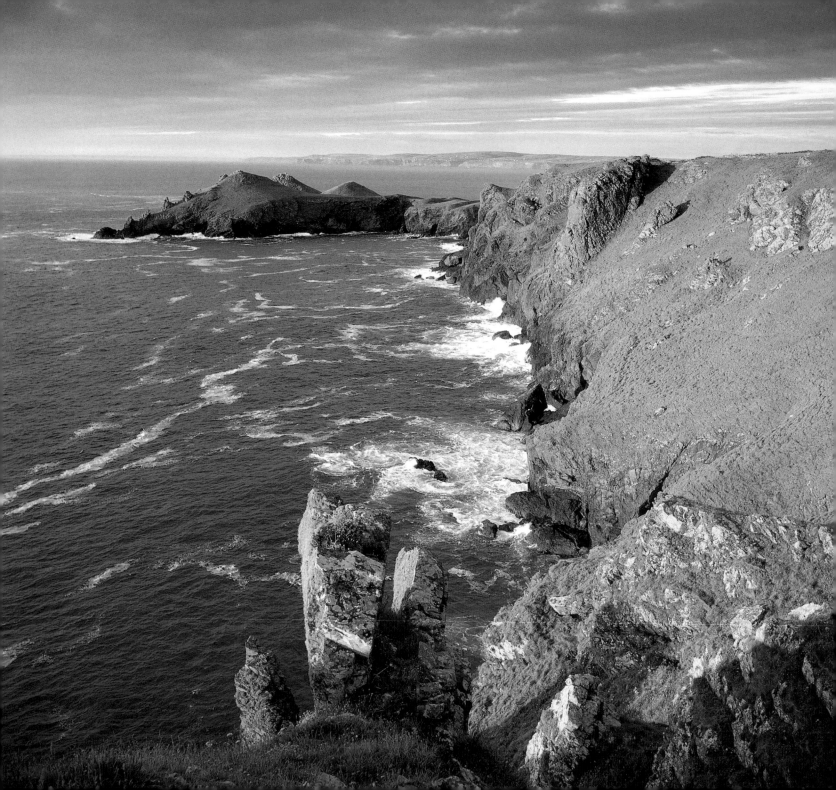

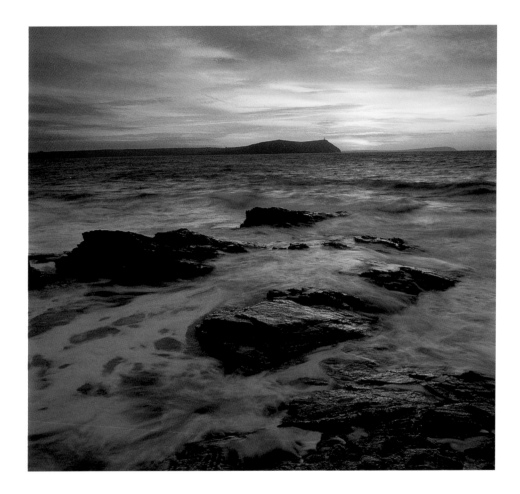

Classic north Cornish coastal landscape at PENTIRE HEAD. Constantly exposed to the Atlantic gales, the rugged headland supports hardy moorland vegetation.

Left: Pentire Farm, with the Rumps in the distance. A local outcry took place in 1936 when the farm was divided into building plots and put up for sale. A photograph was published in *The Times* and a benefactor was found to underwrite the appeal until the money was raised to save it. [JC]

Above: The view west from Pentire Head to Stepper Point across the Camel Estuary, with Trevose Head beyond. [JC]

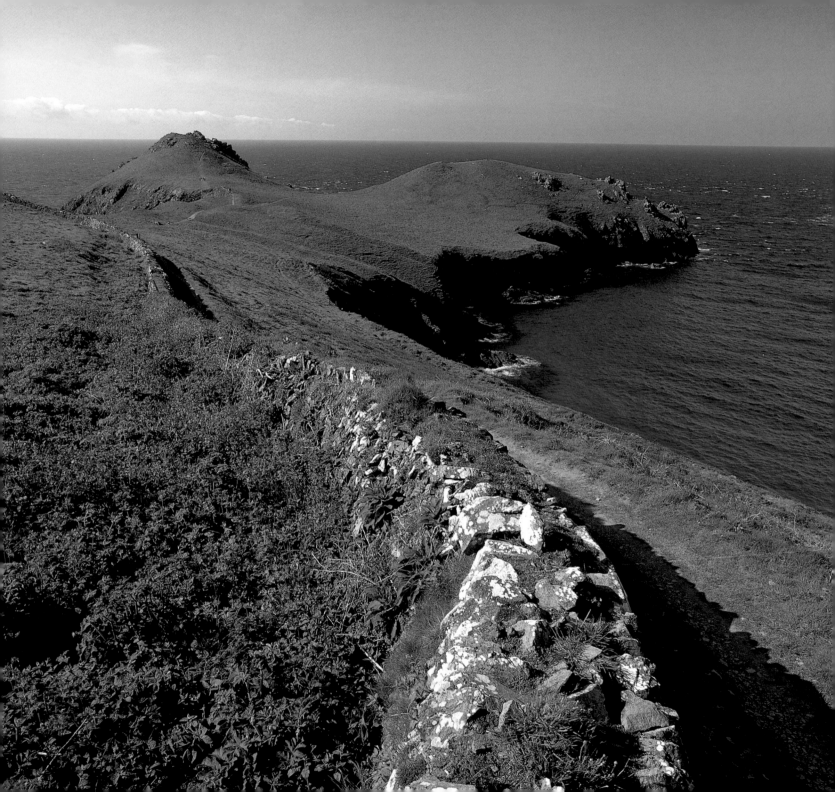

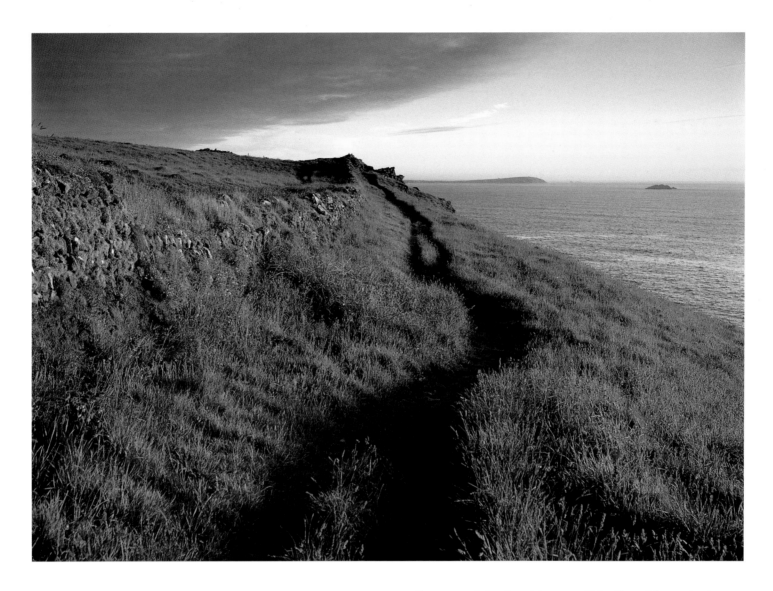

Left: PENTIRE HEAD looking towards the Rumps. [JC]

Above: The path between the Rumps and Pentire Point, forming just one part of the coastal footpath that leads the dedicated walker around the Cornish coast, 313 miles of dramatic changes in landscape. This is very much a stronghold for the National Trust, which protects about 130 miles, most of it acquired through its coastal appeal, Enterprise Neptune. [JC]

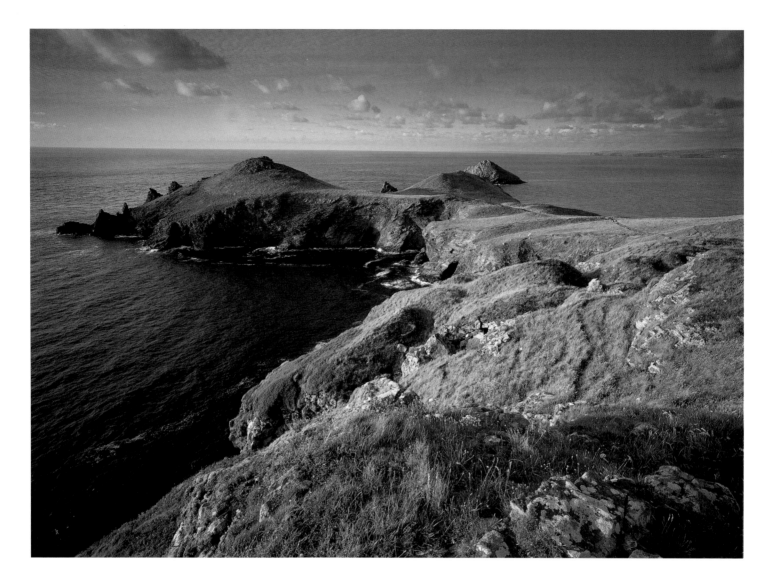

Above: Pentire Head, showing the Rumps, a tiny peninsula projecting from the northern corner. The neck of the peninsula provides a defensible site: in the Iron Age a castle was built here, and its fortifications can still be clearly picked out as bumps in the turf.

The walk out to the Rumps is one of the classics of the Cornish coast, the lie of the land changing with every step. Proceeding on to Pentire Point the greenstone and shale give way to pillow lava, the product of volcanic action millions of years ago. Here the walker is rewarded with stunning views. [JC]

Right: The rugged coast stretching from Padstow to Hartland contains only one natural haven, the fishing village of BOSCASTLE. Entering its harbour is still a hair-raising exprience on all but the calmest days. Sailing vessels could not get through the narrow strait without assistance from 'hobblers', boats with eight oars and men on either shore using guide ropes to keep them in mid-channel.

The inner jetty was rebuilt in 1584 by Sir Richard Grenville, the Elizabethan adventurer of *Revenge* fame. The outer jetty was blown up by a mine in 1941 but rebuilt after the harbour and its buildings was acquired by the National Trust. [JC]

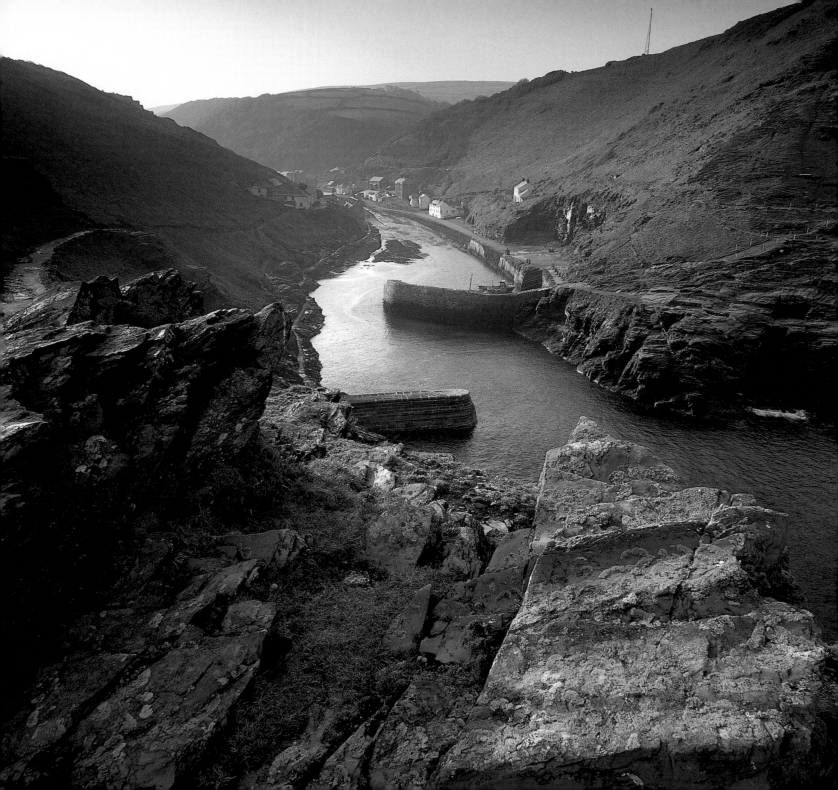

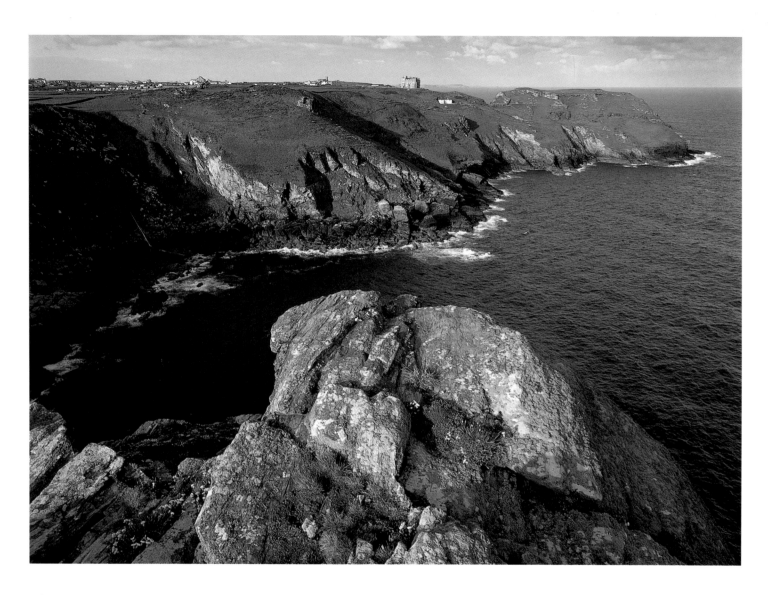

Above: BARRAS NOSE, the headland north of King Arthur's Castle at Tintagel. This was the first piece of English coast to be acquired by the National Trust in 1897, as a result of widespread concern about the number of houses and hotels springing up in Tintagel because of the Arthurian connections. One manifestation was the monumental King Arthur's Castle Hotel, built by the London and South West Railway. Almost all the vernacular buildings in Tintagel disappeared at this time, with the exception of the Old Post Office, a delightful fourteenth-century open hall house that was rescued by the Trust in 1903. [JC]

Right: Strangles Beach at CRACKINGTON HAVEN. Sinister by name and sinister by nature, for the waters of the Atlantic pour into the narow inlet at high tide, cutting off the escape of those who have tarried too long. [JC]

Overleaf: Low tide at dusk, Strangles Beach. The rock at Crackington is a particular type of shale. Wildly contorted by movement of the earth's crust millions of years ago, it is easily fractured causing landslips. To the left can be seen the screes leading up to a weird middle cliff of humps and bumps. [JC]

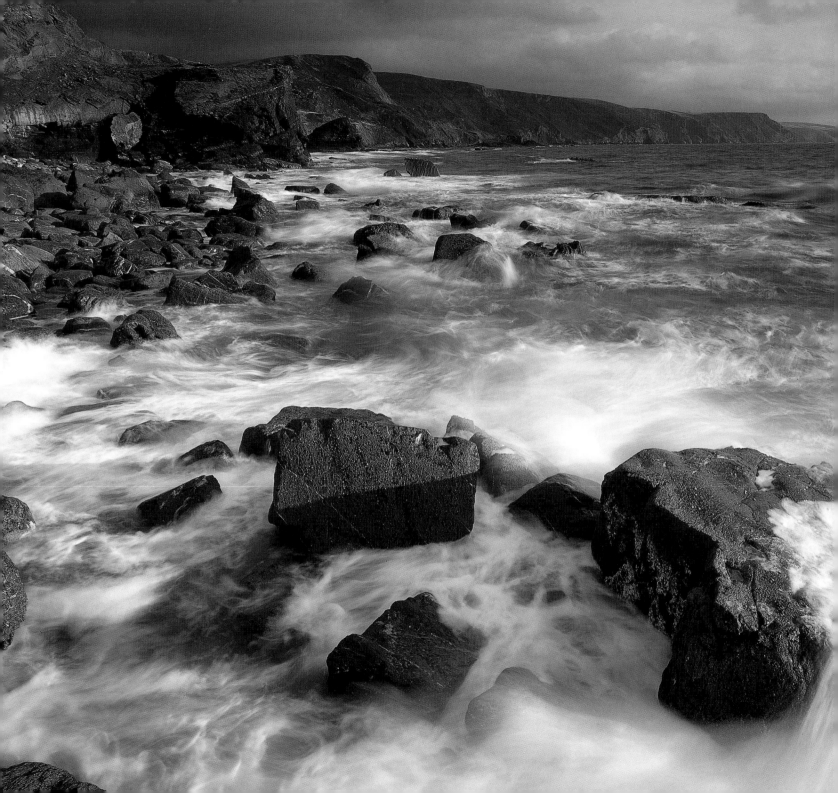

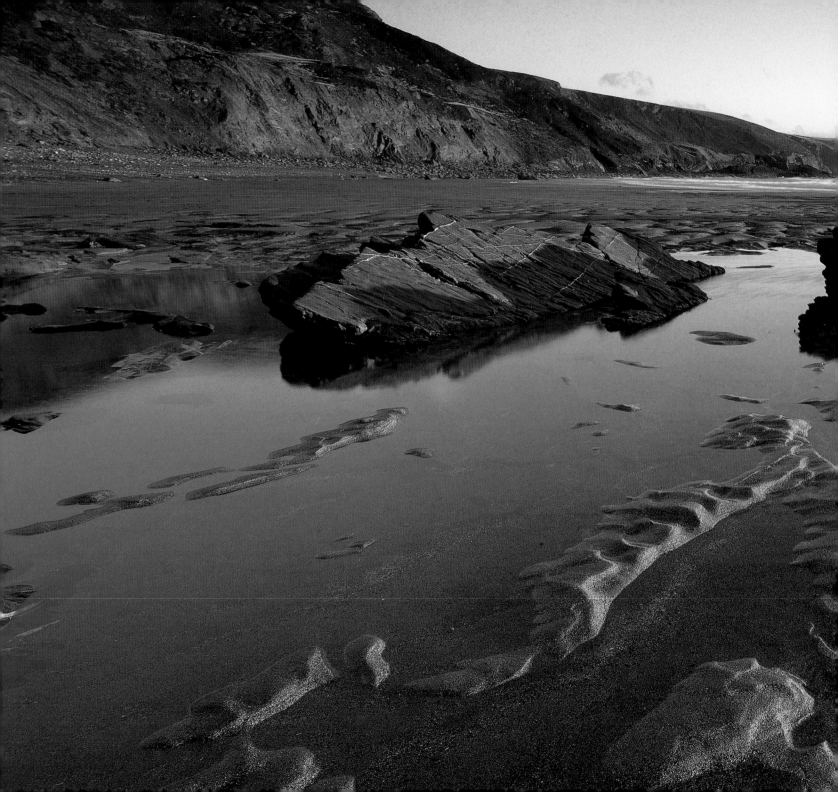

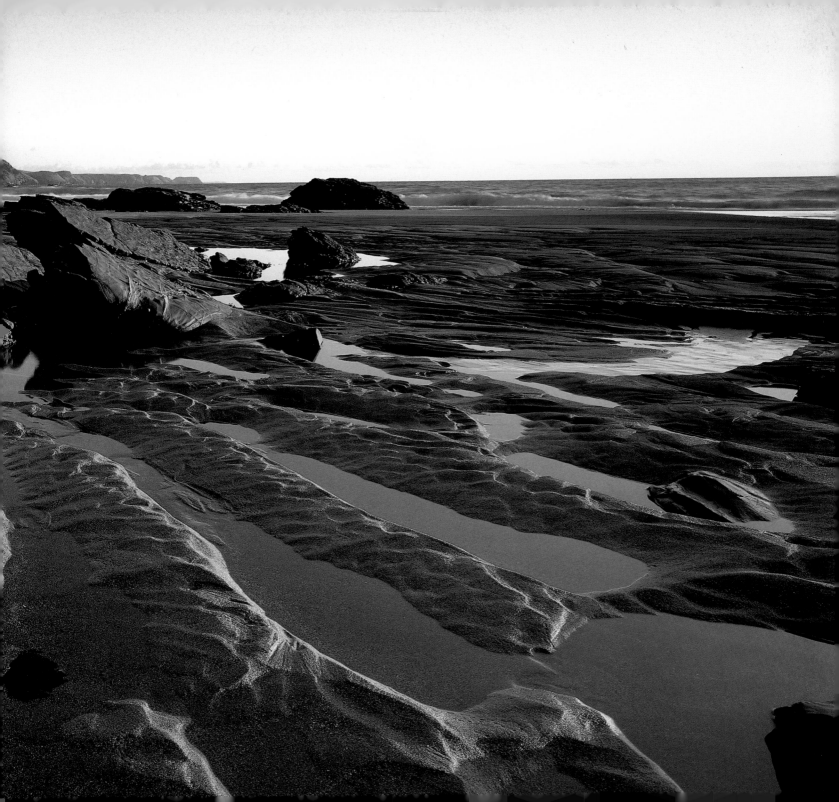

JOE CORNISH

Joe Cornish was born and educated in Devon, before studying fine arts at Reading University. He worked as a photographic assistant first to Mike Mitchell in Washington, and then with Dave Hart and Dale McAfee in London. His first 'clients' were actors and musicians for whom he did promotional portraits, but his customer list now includes many book publishers, magazines and organisations such as the Countryside Commission, the Cleveland Wildlife Trust and the Heritage Lottery Fund. The first book to which he contributed the photography was *Founders of the National Trust* published by Christopher Helm. He has also worked on books about France, Italy and several guidebooks for Dorling Kindersley. He now lives in North Yorkshire.

Originally inspired by family holidays spent on the north Cornish coast, he has come particularly to enjoy photographing landscapes. The work of American masters like Ansel Adams and Edward Weston has given him a reverence for nature and in particular unspoilt, wilderness areas. Britain, in fact, is virtually wilderness free, but he identifies the coast below the high-tide mark as offering an authentic taste of untamed nature, where the ebb and flow of the sea will always resist man's efforts to domesticate. The ancient mountain landscapes of western and northern Britain evoke for him a sense of age and history combined with textural and colour subtlety that is often absent from younger, higher mountain ranges, such as the European Alps.

Joe decided he would like to work for the National Trust's Photographic Library after his involvement in the book on the founders. To celebrate the twenty-fifth anniversary of the launch of the coastal appeal, Enterprise Neptune, in 1990 the Trust commissioned the write Charlie Pye-Smith to write *In Search of Neptune*, and Joe took the photographs. Since then he has travelled all over England, Wales and Northern Ireland for the Trust: 'To me, the Trust's landscape work is a force for our current benefit and for that of future generations. It follows therefore, that I feel my job is to express that work in the most evocative and positive way possible. Whenever I can, I take my photographs at dawn or dusk, exploiting the beautiful light conditions which tend to arise then if the weather is right'.

David Noton

David Noton was born in Bedfordshire but emigrated soon after to California. A peripatetic childhood spent in the UK and Canada was followed by a career in the Merchant Navy. His interest in photography began at sea, and in 1982 he returned to college in Gloucester. During his final year he sold Athena a range of images for publication as posters, which proved a springboard for going freelance. Initially his work was a balance of landscape and local commercial commissions for advertising agencies, design groups and public relations companies in the west country, from his Bristol base. By the 1990s his main activity was stock photography in the fields of landscape, nature and travel, and clients included NatWest, the National Grid, Ikea, the BBC Natural History Unit and the National Trust. He has won awards in the landscape categories of the Brisish Gas/BBC Wildlife Photography Competition in 1985, 1990 and 1991. He is now based in Sherborne, Dorset.

As a keen walker and mountaineer, landscape photography was perhaps a natural preference which has endured. The Scottish Highlands and Islands were where his earliest photographic forays took place, and is still one of his favourite places. He relishes the ambience and unpredicability of field-work.

Despite, or perhaps as a result of travelling all over the world, David appreciates the wealth of differing landscapes – from dramatic mountain ranges to pastoral rolling farmland – offered by the British Isles. Because of the northerly latitude and the changeable weather, the subtlety of the light is unique. Man's imprint on the landscape, for instance the dry-stone walling and farm buildings in the Yorkshire Dales, adds visual harmony: 'Straight off the plane from, say, North America the patchwork of green fields still hits me between the eyes'.

The National Trust's Photographic Library is his longest-running client, a relationship that started in 1986. The organisation is an obvious port of call for a photographer as it manages some of the most beautiful landscapes in Britain. 'To be able again and again to experience nature at its most enchanting at dawn on Derwentwater in the Lakes, or as storm waves crash on the rugged coast of the Lizard Peninsula in Cornwall brings home in no uncertain terms what a treasure we have in our landscape. I am committed to the work the Trust does in protecting these areas, and if in a small way my photographs help with that mission, it gives me great satisfaction'.

PAUL WAKEFIELD

Paul Wakefield was born in Hong Kong, educated there and in the UK, and studied photography at Bournemouth and Birmingham Colleges of Art. He started his career as a photographer by freelancing for publishers, design groups and record companies while still at college. He now works mainly in advertising, with clients like car companies, British Gas, Smirnoff and Jonnie Walker. His exhibitions include the Photographers' Gallery in 1984, Gallery of Photography Dublin in 1991 and the Saatchi Gallery in 1994. Publications include three collaborations with Jan Morris on the landscapes of Wales, Scotland and Ireland. In 1997 he was given the Gold Award from the Association of Photographers. His studios are based in London.